Volume

Writings on Graphic Design, Music, Art, and Culture

Written by Kenneth FitzGerald
Liner Notes by Rudy VanderLans

Princeton Architectural Press

New York

Published by

Princeton Architectural Press

37 East Seventh Street
New York, New York 10003

For a free catalog of books, call 1.800.722.6657.
Visit our website at www.papress.com.

Printed and bound in China

13 12 11 10 4 3 2 1 First edition

Editor: Becca Casbon **Designer:** Jiwon Lee

Typefaces: Proforma designed by Petr van Blokland,
Tribute designed by Frank Heine, FF Meta designed by Erik Spiekermann

Special thanks to: Nettie Aljian, Bree Anne Apperley, Sara Bader, Nicola Bednarek,
Janet Behning, Carina Cha, Tom Cho, Penny (Yuen Pik) Chu, Carolyn Deuschle,
Russell Fernandez, Pete Fitzpatrick, Wendy Fuller, Jan Haux,
Linda Lee, Laurie Manfra, John Myers, Katharine Myers, Steve Royal,
Dan Simon, Andrew Stepanian, Jennifer Thompson, Paul Wagner, Joseph Weston, and
Deb Wood of Princeton Architectural Press —Kevin C. Lippert, publisher

Library of Congress Cataloging-in-Publication Data

Fitzgerald, Kenneth, 1960–
Volume : writings on graphic design, music, art, and culture
by Kenneth FitzGerald.
p. cm. Includes index.
ISBN 978-1-56898-964-8 (alk. paper)
1. Arts, Modern—20th century. 2. Arts, Modern—21st century.
3. Graphic arts—United States--History—20th century.
4. Graphic arts—United States--History—21st century.
I. Title.
II. Title: Writings on graphic design, music, art, and culture.
NX456.F59 2010
700.9'04--dc22
2009045011

Contents

6 Acknowledgments
8 Liner Notes, Rudy VanderLans
10 Introduction: Words on Sound and Vision

Field Recordings

19 An Instructor of Concern
23 Adversarial Thoughts
28 First, Class
34 Designers Are Material
42 The Resistance
45 Designer X
51 Trenchancy
62 Buzz Kill
75 Quietude

Amplifications

95 On *Creem* Magazine 1970–1976
102 My Two and Only
109 12^2 Sound
116 Music for Markets
125 The Graphic Equalizer

Teleidoscopin'

137 Aerosol
139 The End of Design
141 The Importance of White Space
144 Pejoration
146 Form vs. Function
148 Light Turning
150 The Last Wave

Inference and Resonance

163 Eponymity
171 Be Yourself, Be Someone Else
177 Chaos Theories and Uncertainty Principles
183 Indiscipline
191 Seen and Not Seen
200 Skilling Saws and Absorbent Catalogs
227 Professional Suicide

Coda

241 Life in These Ephemeral States

247 Publication Notes
248 Index

Acknowledgments

I am indebted to the many people who have supported, complimented, or acknowledged my writing over the years: friends, colleagues, fellow teachers, students, artists, and designers. Each personal remark and professional mention was (and continues to be) immensely gratifying. There are many people who merit mention by name for their varied roles in my writing career. Foremost amongst them is Rudy VanderLans, who I can't thank enough for that initial invitation to write and for his ongoing guidance and friendship—plus his "Liner Notes." For providing valuable advice, critique, encouragement, inspiration, and opportunity along the way, my thanks also go to Sue Apfelbaum, Robert Appleton, Michael Bierut, TJ Blanchflower, Andrew Breitenberg, Max Bruinsma, David Cabianca, Jade-Snow Carroll, George Creamer, Liz Danzico, Michael Dooley, William Drenntel, Maya Drodz, Elliott Earls, Bryony Gomez-Palacio, Al Gowan, Steven Heller, Anthony Inciong, Catherine Ishino, Garland Kirkpatrick, Toshiaki Koga, John Kramer, Kevin Lo, Steven McCarthy, John McVey, Debbie Millman, Ryan Molloy, Derek Munn, Alice Polesky, Rick Poynor, Elizabeth Resnick, Stefan Sagmeister, Tina Horenkamp Simonton, Gunnar Swanson, Armin Vit, John Walters, and Robert Wojtowicz. Special thanks to Jennifer Thompson and Becca Casbon of Princeton Architectural Press for their enthusiasm and assistance. Extra special thanks to Jiwon Lee for lending his design talents and much more. Joan Henson and Marcella Stasa were always there, always rare.

Nothing I've ever done would have been possible without the support of Mr. Gerald and Mrs. Janet Fitzgerald, and my talented and challenging siblings (and families): Scott, David, Keith, Karen, and Kevin. My gratitude to everyone on the Hutta side of my family. Firstly and lastly, love to Emma, Leaf, and my Title Muse.

Support was provided by the Old Dominion University College of Arts and Letters.

Ellen, Ellen, Ellen, Ellen

Liner Notes
Rudy VanderLans

I remember one day sitting in Kenneth FitzGerald's office at Old Dominion University, where he teaches graphic design. The room was a standard-issue faculty office space—no windows and drab—except for the fact that Kenneth's room was wallpapered from floor to ceiling with hundreds of bits and pieces of printed ephemera such as postcards, book covers, flyers, posters, photos, clippings, announcements, labels, drawings, notes, you name it. And lined up along the walls were huge stacks of books and magazines on design and art and music. The place was a graphic design repository filled with printed artifacts of all aesthetic kinds. As I was sitting there listening to Kenneth talk excitedly about tenure, student evaluations, and other collegiate humdrum, I couldn't keep my eyes off this display, and I realized that if there was ever a collection of work that could answer the question "What is Graphic Design?" Kenneth's room was it.

What struck me most about the scenery in Kenneth's office was the lack of evidence of any particular hang-ups about graphic design. No preference for Swiss International style, no tendency toward idea-based design, no fetish for this or that designer. Instead, the selection of work showed a healthy taste for design culture both high and low. Here's someone who likes graphic design for all the right reasons, I thought. Not bad for someone who wasn't educated in graphic design.

Kenneth FitzGerald was well on his way to making a name for himself as a fine artist when he stumbled upon graphic design. He quickly recognized and appreciated the power of the profession as a cultural force, and was puzzled by graphic design's inferiority complex, particularly in relation to fine art. "Graphic design is pure culture," writes FitzGerald in "Buzz Kill," one of a number of essays that sum up both his fondness for the practice and his criticism of its practitioners. In his writing he often denounces ideas of elevating the profession through certification or renaming. To FitzGerald, these are misguided attempts by practitioners who fail to see that "graphic design is the public art" and that "everybody gets it," a position aspired to by all the arts.

I first encountered Kenneth when he sent a letter to *Emigre*, the magazine that I published. It was obvious that Kenneth was acutely aware of the major discussions swirling around graphic design, including the fact that the field is notoriously reluctant to embrace writing, especially the kind that's produced by academics or nonpractitioners. This topic alone became the inspiration for some of his most enlightened and wittiest writing to date. Graphic design embraces some great writers, but few display Kenneth's combination of bite, wordplay, wit, and overall pop culture knowledge. Perhaps due to his position as an outsider, he never pulls any punches. He questions and criticizes graphic design's greatest heroes without any fear of fallout: "I fear the anti-intellectualism frequently expressed by critics far more than being professionally blackballed," FitzGerald says in *Emigre* 38.

That letter was my first introduction to Kenneth's writing, and I've had the pleasure of reading many of his manuscripts in their original rough form as they came in to *Emigre*. I always looked forward to reading those unedited, straight-from-the-heart, stream-of-consciousness exorcisms. Essay submissions from Kenneth always held out the promise of any number of piercing remarks, sure to inflict discomfort on design's establishment. The writing seemed to come from an infinite reservoir of pent-up ideas about the state of graphic design.

Kenneth writes like a person who found his calling too late and is rushing to catch up. He once told me he does almost all of his writing between midnight and 2 AM, but his most lucid writing happens during his kids' afternoon naps. It's an interesting insight, although it doesn't answer how he produces so much in so little time. His output is prolific. And perhaps opportunistic, as FitzGerald quickly realized he hit upon a profession whose omnipresent output is inversely related to its scrutiny.

During that same visit to Old Dominion, Kenneth impressed me in another way. I was already familiar with his uncanny knowledge of music, but I knew I was dealing with a seriously compulsive music nut when he casually mentioned a number of Dutch bands that included Mouth and McNeal, an obscure 1971 one-hit wonder. Music is often a point of reference for Kenneth. As is art, architecture, life, and all of pop culture, a good sampling of which was pinned up on the walls of his faculty office.

When we stopped publishing *Emigre* magazine, not receiving a steady diet of Kenneth's writing was what I missed the most. I wasn't sure what he had been up to, writing-wise, since the time he wrote for *Emigre*. With the rise of blogs and websites where short texts reign supreme, there aren't many outlets left for the kind of in-depth essays on graphic design that Kenneth regularly writes. I imagined him busting at the seams, full of ideas. All dressed up and no place to go. So when I heard about this book, I was elated. Like when your favorite band stops recording—and then, years later, out of the blue, they do another album of new tracks, including outtakes and rarities. It's always a bit nerve-racking. You hope they'll live up to expectations. Reading this volume didn't disappoint, it only made me sad, realizing there aren't more outlets within graphic design for writers and critics as talented and prolific as Kenneth FitzGerald to ply their trade.

Introduction: Words on Sound and Vision

Culture isn't discrete. To talk meaningfully about culture requires describing convergences, cross-overs, and intersections. And within media, sampling, mixing, and mash-ups are the order of the millennium. If these hybrid effects aren't present in a creative work, it's likely noticeable in its manufacture or distribution (blogs, wikis). Common too are studies of this phenomena, from journalism to academia. If you're a critical writer, it's tough to stay home when addressing your favored contemporary topic. Everybody's in the house.

Few areas of culture escape notice and scrutiny. Some are scanned in near–real time for new developments. Art and popular music amass considerable attention. But a major cultural player, one that's on par with these two, remains largely invisible—graphic design. Ironically, this medium craves recognition as a discipline while operating historically on an ethos of transparency. Graphic design has simultaneously made its own heaven and hell, and perhaps ours too. Graphic design is loud and around: a visual surround sound. To its credit, it can often be an "ambient music" of imagery: as interesting as it is ignorable. And, of course, there's the downscale downside—optical Muzak. Graphic design is an ecology of scale. It's about the multiple—you don't have just one graphic design. And ubiquity, like famil-iarity, breeds contempt.

Declaring "uniqueness" in any aspect of design is considered a stretch. Walter Benjamin's essay "The Work of Art in the Age of Mechanical Reproduction," which sanctified modern production, looked toward film, not printing. Tens, hundreds of thousands, often mil-lions of impressions evidently evaporate aura. Graphic design is doubly voluminous compared to film. But despite the roar, no one's critically listening to or looking at it. It seems improbable that this far into the era of mass communication (and graduate and postgraduate education), something as omnipresent and influential as graphic design remains largely unexamined. Anything that proffers an image, text, or glyph has undergone an imaginative, deliberate process laden with history, theory, and intent. And as such, it is ripe for critical investigation. Graphic design presents a unique entry point to contemporary culture: it crosses everything. The complexities and paradoxes of commerce and culture are plentiful.

But despite its presence—or intrusion—in all aspects of society, graphic design remains a cultural bypass, an analytical flyover area. Practitioners are left to contemplate it—a group that's often the most incognizant of its import.

For the ambitious, there's an abandon, an enthusiasm when stumbling upon an area that's wide open, where you can (and have to!) make it up as you go. When that realm is also visu-ally rich, intellectually complex, and intersects every quarter of culture, it's a windfall. This is the province of writing critically about graphic design. Of course, there are very real downsides. Pragmatic and philosophical obstacles deter sensible observers. First, it's graphic design—

the field has no stature in academic, intellectual circles. It's scorned as shallow surface manipulation, the prostitution of art for commerce. Graphic design is seen as lacking intellectual "carrying capacity." It's the content problem: graphic design has none of its own.

An aspiring investigator should reasonably find little professional benefit in pursuing a study of graphic design. Even if that aspirant found merit, the regard likely wouldn't extend to journal editors and tenure committees. Graphic design is the nearest we have to a cultural untouchable. You're better off contemplating any obscure, marginalized, and microscopic segment of culture than graphic design.

Therefore, any critical writing on graphic design must include a spirited rationale for its relevance. On an immediate level, this is appropriate. Every argument demands proofs for its assertions. Take something for granted and you're dealing with faith, not criticism. But you must also confront the subjective rejections. To overcome these, you must tear down whole value structures. The primacy of art in cultural discussions is a given. Challenging that subjective dominance instantly consigns you to an irrelevant fringe, beneath regard.

Challenge must also take place within the graphic design field, which is popularly just as resistant to critical analysis. To gain significant regard in design as a writer, you must first have stature as a practitioner or hold a sinecure at a small pool of elite schools. There are markets for design writing within the professional press,

so it's possible to place copy. But to sustain a career, the nature of that writing must be brief, professionally oriented, and uncontroversial.

A design journal seems an unlikely forum to publish wide-ranging cultural and media studies. My fortune was the existence of *Emigre* magazine, and its decision to publish critical writing in earnest just as I began my postgraduate career. It was a unique forum that fostered an expansive and challenging view of graphic design. My discovery of the magazine in a favorite bookstore, tucked away in a corner, incited my interest in the field. Its encouragement of experimentation freed me to write at length and go where my interests led.

I already had a regard for graphic design products—record album covers foremost among them—but never encountered a forum that shared my enthusiasm for it as something substantive. The existing writing about graphic design was wholly professionally oriented. A boisterous and resonant contemporary art form was routinely made dull and stultifying. While trumpeting graphic design's importance, design writers—always practitioners—undercut the claims with historically narrow, commercial arguments that defied any integration with a wider critical literature.

In contrast, *Emigre* was smart, engaging, and fearless. Anything could be questioned. It was lively to read and look at. Though small, there seemed to be a network within graphic design where I might situate myself. By the time I was in the graduate design program at

Massachusetts College of Art and Design and facing a thesis, *Emigre* had moved full-time to featuring lengthy essays. Right place, right time. The writings that appeared in *Emigre* form the core of this book. Most take for granted the relevance of graphic design and move off into other areas. When considering specific works of design, my approach was to begin with a tight focus on the artifacts, then expand the view to situate them in the wider culture.

To write critically about art, literature, music, or graphic design is to ask the ultimate questions of culture: What does this activity mean? How do we assign value? Every creative production contains a tension between the individual and society, and the ensuing responsibilities. There is also the question of our societal need to preserve knowledge and advance it simultaneously. How do we balance novelty and conservatism in our expressions? Graphic design is arguably the most relevant contemporary visual setting for these dramas. It's the first contact people have with visual art of any kind. Before reaching fine art, we must first pass through graphic design and its representations. The omnipresent graphic design environment shapes our expectations and interpretations of all visual material.

More fine art has been experienced through the graphic design–determined media of catalogs and books than viewed directly. To believe that this mediation is irrelevant is naïveté stretching to critical malpractice. Such wholesale dismissal is contrary to the entirety of art criticism, which obsesses over comparably trivial influences upon art making and appreciation.

In these writings, graphic design is regarded as an activity of pure culture. This simply means that it works altogether subjectively. There are no objective measurements that can be made to determine the efficacy of a graphically designed artifact. What we can reliably say

about the usefulness of a particular approach rises out of an awareness of convention and circumstance, not from immutable scientific laws. Intriguing results have emerged from recent research into perception, primarily regarding typography. However, these don't alter the greater reality of design's subjective operation.

This stance immediately puts these writings in conflict with the prevailing theories of making and appraising graphic design. Parsing an artifact's form language is central to—if not the entirety of—standard design criticism. Quality is determined through an artifact's (or designer's) adherence to an approved graphic agenda. This is the influence of the Modern movement, which channeled all considerations through a predetermined formal structure. Good design wears the right colors, bad design doesn't.

The common claim of a design solution demonstrating "inevitability" implies that there is only a single possible resolution of a design process. This diagrammatic procedure isn't adhered to as dogmatically as it once was, but is still widespread. The range of possible formal approaches is proscribed, despite changes in culture *and* technology. Even if some latitude if given for the particular formal approach a designer could take—for instance, Swiss International style versus an eclectic historicism—the graphic design field values notable aesthetic achievement above all. Superior design is defined as high formal accomplishment, such as can only be realized through the patronage of elite cultural or commercial clients. High art and high design are joined in being the province of capital.

Despite the commissioned and collaborative nature of the design process, the designer's intent is privileged in critiques. Only rare—and usually unwelcome—influence may be credited to a client. Star designers are frequently considered ahistorical and celebrated for standing

apart from, or defying, influence. The formal accomplishments of these luminaries are considered proofs for their rhetoric about their work. Graphic design criticism is customarily celebratory and uncontesting.

My critical approach was improvised yet direct. The studies gathered here simply take a contrary view of claims made by practitioners for their work. I frequently question the prevailing conventional design wisdom held in and outside the field. Because practitioners have almost exclusively scrutinized graphic design, these basic actions deserve mention. Much goes unsaid in typical design discussions. Either conventional wisdom is invoked or various zones of inquiry are deemed out of place. The writing on design that I encountered in my research was typically unsatisfying from the perspectives of both the enthusiast and the aspiring critic. Starting with the paper requirements of my graduate study, I attempted to write the kind of things I'd want to read: engaging, informed, and irreverent.

I've long been an avid reader of music and literary criticism (record and book reviews), and these became my guides. At first, it was ad-libbed. But as I went further, I deliberately approached reviewing graphic design as I might popular music or television programs.

Graphic design is a form of popular entertainment. Design is out in the world offering accessible visual gratification. Also, the majority of its applications are for things that are frivolous, ephemeral, and disposable. The field has mixed feelings about this reality and frequently downplays it. But none of this is an obstacle to being relevant, profound, desirable, and useful. Respectable critics will unashamedly appraise practically any detritus of pop culture to profound ends. Why not graphic design? (Perhaps it's not trashy enough.)

Popular music appears regularly in this book's texts as simile and metaphor for design.

Parallels are drawn between their proc[...] products. This is most explicit in "The G[...] Equalizer," which proposes a critical model for graphic design that's based on a recording studio mixing board. In addition to further linking the creative practices, the essay seeks to provide a more comprehensive and practical view of production.

It's unavoidable to include music when considering many of the prominent figures and movements in graphic design. Design for music has set trends in the field for decades. Reid Miles's album covers for the famous Blue Note jazz label created a form language that suffuses all areas of design production. Many designers who employ Miles's stylistic features are unaware of their origin. Some writings here take music as their principal subject, reiterating themes present throughout the book: how to make and evaluate creative work in a commercial marketplace; mixing styles and meanings; creating alternate expressions and networks to distribute them. "On *Creem* Magazine 1970–1976" describes the influence of legendary rock critic Lester Bangs on music writing, and on my own efforts. Bangs swooped from high to low expression while insisting on the vital personal and societal choices inherent in creativity. "Music for Markets" is an extended meditation on the opportunities and limitations of independent music production in the era of file sharing and Pro Tools.

While frequent side trips are made into music, art, literature, and other less obvious areas of twenty-first-century culture (such as artificial food flavoring), graphic design is at the center of this book's texts. The issues they investigate are still alive, but these are also documents of a distinctive time in graphic design's history.

The 1990s featured vivid formal and intellectual ferment, comparable to design's formative years. Much of the upheaval centered

on the rejection of the modernist formal and intellectual agenda that was design's fundament. The definition of design as a commercially determined activity was fiercely challenged. Essential tenets such as "neutrality"—the ability and desirability of crafting purely objective representations—were disputed. In their place, new models of practice—designer as author, or as auteur, or as producer—were proposed.

The introduction of computer technology spurred formal innovations and arguments. Simply championing the use of desktop technology was initially a radical act. Type design and distribution could now be done by anyone with a Mac and Fontographer, an inexpensive type-design program. An unprecedented flood of new fonts poured forth, washing away old verities of stylization and usage. Suddenly presented with a mainline to the means of production, scores of designers initiated their own one-off projects, impatient with or uninterested in waiting for inspiring clients to engage them. A related trend was self-promotional impulses kicking into overdrive. Early in their career, celebrated practitioners put out bulky monographs that bled into social commentary.

Design education both echoed and drove these developments. A select few graduate programs initiated much of the innovation, becoming notorious and notable. Design academics sought to bring a rigor to their discipline, matching it with their peers in the liberal arts. The introduction of deconstruction and literary theory brought intriguing critical concepts but remain highly controversial (and commonly loathed) in the field. From all corners came the cry for a distinct, substantive design literature, though whether designers themselves would read it was uncertain.

As the writings included here appeared in design forums, I take for granted a degree of readers' knowledge about graphic design.

However, except for in essays such as "An Instructor of Concern" and "The Resistance," I didn't regard my readers as designers. I saw my primary audience as one that didn't exist—or wasn't aware that it composed an audience. I wrote for a multiplied me: culturally aware non-practitioners that didn't discriminate over labels and media. (While I have practical experience as a graphic designer—as a part-timer and freelancer—I fall short of the customary professional standing.) These writings were composed as introductions to the characters and concerns that make up design. Variation in the essays' style is an additional effort to offset complacency—the reader's and my own. It's my nature to try on different voices when writing, to reflect the topic at hand. This may be why I've gravitated to writing about design, an activity that calls for some chameleon abilities.

The writings are grouped in four sections: two verses, chorus, and verse. The first section, Field Recordings, looks at different aspects of contemporary graphic design practice and thought, such as origins ("Adversarial Thoughts"), the state of criticism ("Buzz Kill," "Quietude"), education ("An Instructor of Concern"), and the role of class ("First, Class," "Designers Are Material"). The essays in Amplifications prominently or exclusively address aspects of contemporary popular music, such as its packaging ("12^2 Sound") and means of distribution ("Music for Markets"), while also referring to graphic design's involvement. Teleidoscopin' contains fictions and short narratives on art, graphic design, and creativity. Inference and Resonance is the book's speculative/theory section. The essays offer overviews on topics of design, teaching, and creative identity. Rather than introduce new theory per se, I've sought to

unpack received wisdoms and release strictures. For instance, "Skilling Saws and Absorbent Catalogs" arose from my frustration with discussions of art and design from either side of the "divide." I consider essays such as "Skilling Saws," "Seen and Not Seen," and "Professional Suicide" to be hygienic. They deliberately follow standard propositions to their logical ends to highlight and root out dogma. Some of my own proposals are purely contrarian. Introducing countercurrents might break through the predictability of design discussions.

My hope is that this collection will simply expand the perception of what is considered culturally valuable, and show the connections between graphic design and more established, esteemed mediums. My foremost impulse is personal. A primary role of criticism is to clear space for new voices, both artists and critics. I write to map the congeries of my interests.

It's not my intention to increase appreciation for graphic design. While I feel that designers have received short shrift for their contributions, I don't consider them as possessing a greater grievance. Having many friends who are practicing graphic designers, I want to see them gainfully employed and recompensed. But I've not attempted to be an advocate for the profession. Economic forces play the crucial role in determining graphic design's capability.

High or low, I'm a devotee of the many manifestations of culture. I'm constantly astonished at the unlikely methods that people use to embody meaning. Processed light, modulated sound, regimented motion, standardized shape, pigment on fabric, ink on paper . . . to the same surprising, delightful degree, they're all improbable. It seems equally absurd that we discriminate among them. The revelation comes from describing their commonality. And in discovering and encouraging new means. Louder, brighter, sharper, braver, *more*.

Field Recordings

An Instructor of Concern

In my first year of teaching design, a joint task force of the AIGA (originally the American Institute of Graphic Arts, now the Professional Organization for Design) and NASAD (National Association of Schools of Art and Design) identified me as an instructor "of concern." I warranted suspicion as a recent MFA graduate with "little or no professional practice or teaching experience and whose master's may be their first degree with a major in graphic design." Guilty on all counts.

The alert came in a 1997 report, "Selecting and Supporting Graphic Design Faculty." It was a timely study. New design programs were proliferating and enrollment escalating in established ones. The economy was on a roll, giving designers even less incentive to choose teaching over practice. As a result, schools were hiring faculty whose engagement with design practice ranged from tenuous to wholly absent. I was teaching some undergraduates with more professional experience than I had.

Put forth as "analytical and consultative only," the report allowed for exceptions. But was I one? Am I now, years into a career and facing a tenure decision? I believe I can "do" design—yet don't care to. At least, not in a way the profession regards as significant. Experts in the field have yet to certify my work as noteworthy. With dubious professional credentials, scrutinizing design's educational values isn't a theoretical concern for me. Nor is it for the design field as a whole. What are the standards that define the nature and role of a design educator? Articulating

what makes a good design teacher describes the field's values as much as pronouncing what makes a good designer.

In place of a definition for a good teacher, design offers equivalence. A good designer is a good teacher. Of course, when you consider a specific individual's facility there are exceptions. But in general, the cliché is inverted: those who can do should teach. Professional repute equals teaching potential; designers of renown are the most desirable instructors. This assessment cuts across the spectrum: from full-time, tenure-track faculty to individuals whose primary dedication is to their practice. After that, design hasn't much in the way of objective standards.

There is logic at work here, but how much of a factor is notoriety? At issue isn't if practitioners bring a valuable perspective to education. They obviously do, and have done so throughout history in various disciplines, not just design. It's also proper to think educators might achieve and maintain esteem for performing the art they profess. With apologies for the pun, it's a matter of degree. Is professional achievement overvalued in education? Could the privileging of celebrity be holding design back from realizing its potential as a discipline—and shortchanging students? And could the incursion that concerned the AIGA/NASAD group actually be an opportunity? Do you have to be able—or desiring—to make something to know it's good?

If a designer's answer to that last question is yes, what does it say about their attitude toward clients? (Perhaps *they* are the ideal design educators.) If you cite the need to be formally sophisticated, then you've also said something that doesn't quite track with the rhetoric of design being problem solving.

Unsurprisingly, as I outline an alternative to the common description of a design educator, it looks increasingly like me. This is a problem with drafting guidelines: they inevitably resemble the drafter. At best,

they're idealized portraits—what we aspire to be. At worst, they're full employment acts and a rationalization of the status quo.

As design is engaged in pure culture, describing the specific skill set a master practitioner possesses is difficult. A music teacher, for instance, can exhibit an expertise with an instrument. In design, it's near doctrine that a facility with design-making tools (a flair with software) doesn't make you a designer. The asset that practice brings is experience. The knowledge of what has worked is significant. But does that necessarily lead to the capacity to speculate on culture—to imagine what might be? This means much more than hypothesizing about formal novelty. It's considering design's role in society: how and when it may be employed. We must also recognize that the majority of students will not go on to practice. Who might best provide for them? I don't know—but I can relate.

To craft meaningful guidelines for teachers, we must consider the nature of the process they'll be engaged in. Is it education or training? Both are worthwhile pursuits, as long as the institution proclaims which of the two it's providing. A program that claims to offer training for aspiring graphic designers should be weighted toward practitioners as faculty. Academia has dual, eternally conflicting functions. It's a place where knowledge is preserved and advanced. The former requires conservatism in its literal sense, while the latter demands challenging the status quo. Ideally, an educator respects and speaks to both these purposes. If not, programs should seek balance across their faculty.

Balance was an important and encouraging aspect of that AIGA/ NASAD report. It pragmatically advised combining the savvy with the inexperienced faculty. (And I can testify to personally benefiting from this arrangement.) It recognized alternative methods of research—things other than doing commercial design. Overall, the report remains a thoughtful and expansive view of design education. Of course, where it

raised caution, I saw an opening. Yet I will go further. As an interloper from fine art, I'm not far enough removed from design. The field has been absorbing my kind forever. Design must recruit more educators with backgrounds in the other liberal arts. The insights about design that I most admire, that illuminate how design is part of the continuum of culture, come from such individuals. Isn't this design's dream—that serious people take it seriously? And then, spread the word?

For all of us, standards must be an internal devotion. Being dedicated and inspiring is the minimum standard for educators. Finding new ways to encourage students to excel is what comes with the job. What more are we doing to further knowledge? How are we being tested? Before we ask students to challenge their preconceptions, to not be in thrall to celebrity and surface, we must, as teachers, do so ourselves. ✪

Adversarial Thoughts

Graphic design is popularly considered a commercial activity. This isn't so odd, as it's how mainstream graphic design has presented itself to the public. The omnipresence and sheer volume of graphic design material (print work, advertising, websites, motion graphics, and so on) churned out by consumer culture makes a definition of graphic design as a commercially determined profession seem natural. Linking design to business—with design in service to business—appears obvious. "Good Design is Good Business" (the title of a 1975 speech given by former IBM chairman Thomas Watson) is a legendary maxim in the graphic design field—which additionally inverts the equation with little trouble.

When examining the probable roots of graphic design, this view becomes problematic. Notable design commentators have proclaimed advertising as the "mother" of graphic design. With the omnipresence of commercially driven design in our culture, this argument has considerable authority. Constructing a lineage is almost effortless. The published histories that exist of graphic design also project this image of design as business-derived. The conclusions are reached first, then supported by evidence. One of the few areas of agreement in graphic design history circles is that the roots of contemporary Western graphic design lie in the soil of European avant-garde art in the early twentieth century. In seeking an anti-elitist, direct, and contemporary creative idiom to reform society, these artists turned to print. The processes and

strategies of graphic design were the necessary methods to carry out their populist and progressive agenda. Graphic design was an earnestly political activity—in both the medium and the message.

What is also generally agreed upon is that this utopian project (modernism) dissipated into a formal orthodoxy. Designers could advance the modern agenda solely by utilizing politically correct graphic elements. The purposes to which graphic design was put—the clients whom a designer worked for—were of little matter. Even staunch Russian socialists like El Lissitzky designed advertisements, considering commerce to be another populist activity. (Though he was designing for Pelikan fountain-pen ink, which allowed every person to create and join the social discourse.)

While the connection between graphic design and commerce contains many links, a major reason for the conjoining is self-interest. Both graphic design and corporate interests seek to promote themselves to the public. Though the power relationship has never approached equality, graphic design has regarded it as a mutually beneficial partnership. At its best, it has provoked statements such as Watson's, which arguably continues to fall on deaf ears and is impossible to confirm.

A prominent critique of graphic design's golden days in the middle decades of the twentieth century is that it created a facade for multinational corporations. Simply by adopting the approved formal livery, these companies attained and spread virtue—in graphic design's eyes. Critiques of this stance and the corporate determination of graphic design accelerated in the later decades of the century. Politically motivated graphic design had always been present, but became more assertive and visible. Graphic design work protesting the Vietnam War or promoting causes popular in the 1960s are obvious examples. Just as quickly as graphic design produced its first dedicated history text—Philip Meggs's *A History of Graphic Design*, in 1983—counterconceptions

were put forth. Meggs's book acted to solidify a graphic design canon that privileged corporate design—along with white male practitioners, Western practice, and a modernist aesthetic–based valuation.

As in the first decades of the twentieth century, its last two saw profound technological change (the development of the personal computer and attendant design-production software), formal explorations, and intellectual ferment. Graphic design indulged in investigations of literary theory's application to design, designer as author, design as liberal art, and designers' responsibility to society.

Instead of feeling delight when commerce quickly adopted the outwardly radical forms of the 1990s, graphic design found itself despairing the effortless consumption of its avant-garde. Questioning where the true avant-garde resided turned to questioning the need for one—and whether a graphic design avant-garde ever existed in the first place.

From obsessing over how a graphic design should look, the field began (re)asking why and for whom it was made. Design further confronted the economic, ecological, and cultural impacts of its operations. Along with other voices across society, graphic design interrogated consumer culture. These discussions, though furious at times, were largely unfocused. After a burst of inquiry in the past decade, an inexorable return to "business as usual" (as notably expressed by a design student, "The time for being against is over") is noticeable in the years just prior to and now following the millennium.

In devising and curating Adversary: An Exhibition (of) Contesting Graphic Design, I sought to gather together some elements and activists of the current graphic design counterforce to prevailing conceptions of design activity. It is a sampling of actions and attitudes against a strict determination of graphic design as neutral intermediary, apolitical profession, and commercial service. Graphic design's definition is

expanded to that of rhetorical process. It is seen not merely as the vehicle for content but as content: the surface is substance. The media of design have taken on a life of their own.

The designers included in this exhibition cover a range of positions within the field. For all, adversarial activities are firstly a personal expression of concern for culture and society—and design's role within both. A number of participants are academics, where these works also function as research. Some have professional design careers for which their adversary design takes place outside or alongside commissioned work. Often, the forms and sensibilities of advertising are used. Then there are designers who straddle the positions, creating commercial products where design plays a prominent role, or bringing new products to the marketplace, or making design work that is part of new, creative situations. The works challenge orthodoxy in their formal invention, their overtly political commentaries, and their use of design conventions to defy convention. They propose new working methods, new insights into culture, and enlightened making by all designers.

Admittedly, the presentation of graphic design in a gallery situation is also problematic. The power of graphic design is in its accessibility. A show that appears to beg status as Art will distract from the works' true import. Design exhibitions overall decontextualize their works, remaking them as aesthetic objects of contemplation. By necessity (economics) and choice (immediacy), Adversary's installation was meant to be flexible, direct, and portable. "Practical art" is a long-standing self-definition of design, and Adversary followed this in its choice of venues. Galleries offer obvious display conveniences. However, in the rhetoric of the exhibition design, Adversary attempted to suggest the desired life of its works.

Reclaiming the gallery space is but a side benefit of this exhibition. Ideally, these works would be prominently public. As the individual

pieces ultimately seek to spur viewers to action, so does the show as a whole. Making a difference, an adversarial work, and an exhibition is within everyone's reach, if you want it. ✿

First, Class

The secret narrative of graphic design is class. Its rationale for design activity cuts across and is consistent with all current and historic accounts. In an allegedly postmodern culture purged of metanarrative, class hangs in there, overarching like everybody's business. Perhaps the oldest of old-school thinking, it's infinitely adaptable and near impossible to eradicate—not that designers are actively involved in the attempt. No matter how inclusive a design approach is pledged to be, class eventually has its way.

Class gives the marching (and merch-ing) orders in America, a country mythically free from the social scourge. Paul Fussell showed otherwise, charting nine separate u.s. classes in his 1983 book *Class: A Guide Through the American Status System*. If designers accept Fussell's manual, they might consider themselves members of his outlying "category X": creative, irreverent, advertising-resistant types. However, even accepting this notion, if any social set has changed radically since the book's publication, it's this one—transmogrified into yet another caste.

A comprehensive examination of graphic design must admit to a confluence of objectives and consequences—intended or not. Class may not be the dominant characteristic, but its functioning should be considered first. Graphic design is, in essence, about differentiation. However defined, high-quality design is distinctive. Few design artifacts are intended as drift-net trawls, scooping up proles and patricians alike.

The finer crafted the work, the more targeted—and restricted—the audience. And even in an *American Idol*-ized, socially networked world, hierarchies still prevail.

Position on the graphic design class ladder is established through the interplay of clientele and aesthetic accomplishment. The utmost stature in the field is reserved for designers with regular access to substantial capital. Graphic design's highest professional focus continues to be formal achievement for its own sake, though performed behind a scrim of pragmatic and conceptual rationalizations. Currently, this ideal realization is attainable only through the benefaction of celebrity-oriented, moneyed cultures (fashion, architecture, entertainment, and the arts) on a national or international level. Fortunately, the interests of these customers coincide nicely with those of designers adept in formal indulgence. Graphic extravagance—by which I mean not a specific formal approach but an uncommon attention to styling and production beyond the means of standard resources—denotes the client-desired aspects of exclusivity and being "cultured" (in both senses, urbane and pearls).

Coding for class—high, low, and between—is the predominant effort in the graphic design process. The aspects of "good design" are synonymous with representations of refinement and rarity. The graphic design "canon"—espoused informally throughout the profession and illustrated in histories like Philip Meggs's *A History of Graphic Design*—is built upon exceptional productions, in budget, staffing, and resources. Common stock is simply that. To a degree, class coding is a moving target. Graphic designers must be attuned to the shifting subtleties of class and how to manifest this in form. An extravagant budget alone doesn't guarantee a high-class result. Managed poorly, the outcome will express the opposite. High-class design is ultimately contextual, though some aspects can be described and remain constant.

A crucial 1992 essay (not only because it's still rare) on the class aspect of graphic design is Keith Robertson's "On White Space/ When Less is More" (republished in the first *Looking Closer* anthology.) Robertson derives the origin, meanings, and function of the core—and somewhat paradoxical—indicator of class: "nothing." White space within layouts—extensive unprinted areas—"is used ... for values of presentation which transcend economic values by insisting that the image of what you present is more important than the paper you could be saving." Robertson directly points out the connotative class implications of design's most precious formal commodity: "Clutter has come to represent working class (just as white space identifies high class). Clutter clearly identifies a market in those who are immediately suspicious of white space and have no hesitation about what it means—that this publication is not for them/not of their class."

Upon this sparse but charged ground, graphic design constructs its narratives of class. These edifices, however, are composed of elements like typography that must be wielded with nuance to establish the proper class address. Identifying an upper-class-laden font is simpler than setting it stylishly. It's these fine distinctions that often elude and frustrate design students (and many professionals). They are of a kind with Paul Fussell's class distinctions. Perhaps a seminar on class within graphic design curricula is what's required to sensitize students to form. Revealing graphic design's professional class structure may be an enlightening first exercise.

Moneyed cultural workers have ascended into graphic design's firmament in the decades since the 1960s. Up until then, the captains of corporate identity and advertising rode high—men like Paul Rand, Saul Bass, and Massimo Vignelli. As corporations lost their societal luster (becoming associated less with efficiency than with environmental damage, social duplicity, and heedless profit mongering), "cool" migrated

to exponents of youth and high culture—as did a new generation of aspiring trendsetters.

Graphic design theoreticians and critics have steered away from class-based criticisms. First, such as graphic design critics/theorists exist, they're practitioners first, and fully vested members of the upper caste described above. Intellectually, parsing class smacks of Marxist analysis and is therefore stodgy and archaic—something we exhausted and moved beyond long ago. New theorists prefer launching new theories. But constructs like "critical making" never extend to questioning how top designers inexorably migrate to servicing high-culture consumption.

Those benefiting from class will not support an oppositional stance or challenge the economic order fueling the hierarchy. Critique of the status quo is regarded by leading critical-making lights as contemptibly naïve. Confrontation is only acceptable on the job—the ostensible insertion of "critical" content into elite design products. Churn out another award winner, collect the paycheck, declare your conceptual potency, and—best of all—realize no change. A class critique is also discomforting for privileged designers, as they envisage themselves as working outside of, transcending, or besting the common commercial realm. They regard their work as idealistic, in that it derives from heavily cerebralized, abstract principles. Graphic designers need make no apology for working within commerce. The problem is defining from the extremes: making consumerism the total determinant of design activity or shunting it aside completely.

Class is an unstated, unintended component of every proposed schema of design activity. According to writer and Walker Art Center design director/curator Andrew Blauvelt (from a 2008 article, "Towards Relational Design," published on the Design Observer blog), graphic design history can be divided into three phases or waves. Though he doesn't advance the notion, each coincides with class. His first phase

still shapes much of graphic design thinking, "a search for a language of form . . . a visual syntax that could be learned and thus disseminated . . . universally." It originated the creeds of white space and modernist class indicators. The second wave, beginning in the 1960s, "focused on design's meaning-making potential." This advance caused some disturbance in the field, as its formality lacked known class markers, rendering it beyond evaluation for mainstream practitioners. But the eagerness of the high-class realm to acquire "progressive" indicators brought its exponents on board (this second wave also marks the transition period of class leaders described above).

"Relational design," Blauvelt's declared current wave (not to be confused with the "relational aesthetics" of French curator and writer Nicolas Bourriaud) is "an era of relationally-based, contextually-specific design." On its face, relational design's mission statement—it "explores design's . . . effects on users, its pragmatic and programmatic constraints, its rhetorical impact, and its ability to facilitate social interactions"—is indistinguishable from existing rhetoric about graphic design's intentions and potentials.

Blauvelt's differentiation is that relational design "[defies] conventional working models and processes" and has no set formal expression. While it's debatable whether relational design describes an actual, discrete phenomenon, class already is its main component. Since the "relations" of this design are unspecified, a long-standing one like class is ready to fill the void. In addition, the majority of artifacts Blauvelt cites as examples are unique or rarified products. It's peculiar to assert the transcendence of formal concerns—and exclude class aspiration—when a Karim Rashid artifact (the Dirt Devil Kone vacuum cleaner, which "looks so good it 'can be left on display'") is prominently cited.

Class is the oxygen of design theory: nourishing and invisible. When Blauvelt—or, for that matter, practically any design writer of

repute—refers to "design" and "designers," reference is being made not to the majority but to the persons and actions of a renowned strata. It's a shorthand that shorts the greatest share of practitioners. Their role is to envy and hope design fortune trickles down. Emulation is economically unattainable and conceptually suspect.

Discussions of class are predestined to conclude with a call for revolution. A sufficient act of insurgency is to simply contemplate class when critiquing graphic design. Particular clients and works are understandably more sought after for the creative and financial opportunities they offer. And all designers aren't equal in ability. But should some design(er)s be more equal than others? Are the terms of graphic design achievement transparent and accessible to all? Of course, one could reject the class premise entirely. Or argue that it exists but plays no role in design, or has negligible effect. A positive statement on class would be refreshing. Right now, class is dismissed, and we still have much to learn. ✹

Designers Are Material

Class is the third rail of graphic design. The potential peril of grasping it manifests differently depending on where and how class is being expressed. Class operates in two ways within design: as the impetus for the formal choices designers make everyday, and in how the profession constitutes and represents itself. Acknowledging the central role of class in the field immediately contradicts claims of it being a meritocracy. However, there are ramifications beyond the insular concern of bruising the egos of individual designers.

In the rare instances when the topic of class crops up, the design audience either starves the discussions of attention or the author fails to adequately nourish the argument. Either way, it's briskly swept off the table. The United States famously considers itself a classless society, so it's touchy to broach the subject here. When considering the design field, it's especially sensitive if prominent individuals in the field are suggested to benefit from or perpetuate a caste system. The result is cursory or incomplete assessments that neither fully engage the issue nor dispel it.

The most recent effort to bring up class in design was "Graphic Design is Immaterial" by Matt Soar, published in *Voice: AIGA Journal of Design* in 2006. The essay (originally presented as a conference paper) intended to "challenge some of our most cherished assumptions" about design. Soar is an associate professor of communication studies at Concordia University in Montreal, and a member of the editorial

board of *Design and Culture*, a recent peer-reviewed design journal (a still-sparse category). In his critical writings, Soar has exhibited a rare toughness and independent sensibility. Simply suggesting the topic demonstrates his nerve.

The essay begins promisingly; the author succinctly and directly outlines the class reality occupying graphic design. Foremost is the recognition that a "class hierarchy" is at play in the field: design is not a "meritocratic free-for-all." To achieve repute, "it's not just what you know but who you know and where you come from."

"It is of course an enormously tasteless game to play," Soar states, "but one could begin to build a map of who, among today's cadre of famous designers, trained with or began their careers working for yesteryear's famous designers or famous design studios (quite aside from famous design schools and their famous tutors)." Soar rightly indicts design discourse (broadly defined as spanning books to blogs) for rarely engaging class as an element of design activity. Such dereliction is serious: a skewed playing field distorts our ability to honestly judge achievement. Citing a credible need for brevity in his essay—and exhibiting a curious delicacy—Soar pulls up short. He doesn't fully detail the areas where class functions in the field. Nor does he identify the tutors, schools, or studios involved.

Proposing the existence of an unofficial design hierarchy isn't as rare a topic as Soar suggests. It's a common anecdotal discussion—from grousing about the predominance of New York–based designers to the inordinate attention given to the products of a handful of elite graduate programs. However, the subject tends to evaporate when the discourse goes formal. The only reason identified for this absence is taste. That specificity would be "tasteless" immediately raises obvious questions. What makes it offensive—and to whom? Should taste be a *critical* consideration? Whose sensibility is at risk if we detail what is evident?

Only an abstract investigation seems permissible—one that falls short of specifically illustrating its subject. The well-dressed emperor insists upon his nudity, and this time, that little boy will be shushed. That criticism should be subordinate to manners is a surprising *critical* demand. But it's not a surprising *career* concern. Certain professional aspirations are inconsistent with exploring the topic.

Broaching the subject of class appears to be only a strategy to insert alternative "cultural and social theory" into design. Dismantling the class structure he outlines isn't Soar's goal. He will nudge the assumptions with his toe, but "not . . . trample them in the dirt." The status quo remains safe. Significantly, at no point does Soar explicitly state that the existence of a hierarchy may be in any way detrimental. His only potentially aggrieved party is newly minted designers, who face disillusion. And it's possible that the ultimate point is not that the naïf suffers discrimination. Kids just need to wake up and smell the ranking.

Soar's modesty is understandable. Graphic design is a small world, and a class provocation couldn't go unnoticed. And, arguably, compiling that map of links would serve no substantive purpose. (Though it would make a delightful information graphic—where's Edward Tufte when we need him?) Anyone with a cursory knowledge of the field's players could compile their own scorecard.

The fundamental problem with Soar's illicit map is that it's an incomplete guide. To accurately navigate class in design, a wider range of connections must be included. These are the tangle of discussion forums (blogs, magazines, books), awards, exhibitions, and conferences (such as DesignInquiry, on whose board Soar sits), where the same round-robin of notable names are cycled over and over. Through its self-referentiality, graphic design's hierarchy has created a perpetual-motion machine of renown.

Since graphic design styles itself as a profession—as opposed to a discipline—commercial values determine how stature is obtained. Designers working for wealthy clients in moneyed culture (the arts, architecture, fashion) occupy the highest class. They service patrons who, for their own marketing ends, require finely styled graphics that generate a social coding of high class. And who possess the capital to fund that design.

Designers deem their business as highly (often harshly) competitive, requiring "street smarts" in concert with a finely honed aesthetic sense. Achievement is deemed absolute: fortune plays no significant precursor role; luck is made. Alternative routes or models of success are suspect, secondary at best. Elite practitioners, who perceive that they have fought their way to prominence due to exceptional ability, have reduced regard for those not on the same career trajectory. Risen cream prefers not to mix with wheat chaff. There is an exchange of ideas across classes, but mostly in the form of leaders lecturing from podia and the subsequent audience Q&As. The profession and its concerns wholly encompass graphic design. For a time, there was a semblance of an avant-garde, which quickly co-opted itself. Methods differed in how and why to make design, but not in the existence of a firmament of stars.

The strife seen in the graphic design field during the 1990s continues to be regarded as having been a style war: Ugly Cultists versus Modernist Zombies. However, the formal and conceptual disputes masked the real conflict—a seething class war. Lividity bloomed from an establishment witnessing its class structure become upended and muddied. Amateur designers of obscure specialty magazines were being heralded. Untested graduate students drew attention for impractical, speculative projects. Dues were not being paid; upstarts were cutting into line. (And they weren't from New York!) With verities of class

out of the picture, design work, incredibly, might have to be judged *on its merits.* Unequipped to objectively evaluate content, the profession thrashed about, attempting to restore equilibrium.

Tempers cooled, and the insurgents were welcomed into the fold, when the new boss clearly indicated he was same as the old boss. As early as 1994, critic Rick Poynor noted in "Ugliness Is in the Eye of the Beholder" (*Eye* 15) that "even within the ostensibly open and non-judgmental field of experimental design a value system obtains." Poynor was commenting on the selectivity of a group of Cranbrook Academy of Art graduates who were countering Steven Heller's infamous "Cult of the Ugly" article. Heller was an equal-opportunity scold of designers he deemed offensive, irrespective of academic pedigree. When they disputed Heller's article, the Cranbrook graduates failed to articulate the characteristics of their value system. They championed only their fellow alumni, resulting in an incoherent counterargument.

No matter. The quality of the argument is always secondary to who makes it. The design profession esteems the top schools as much as their graduates. After all, it's where many of the upper class of designers "teaches." The graduate programs of Yale, School of Visual Arts, Cranbrook Academy of Art, and California Institute of the Arts are the primary farm teams feeding the moneyed culture industries. In their research, conference and lecture organizing, and curating, the perspective is distinctly myopic in favor of immediate and extended school chums.

A cursory look at the limited roster of participants circulating through conferences and workshops reinforces class. The reasonable inference is that design offers a paltry number of thinkers. An alternative—and accurate—theory could be forwarded (one also mentioned by Soar): that designers will only tolerate being lectured to by a few, celebrated figures. And they're happy to do so—repeatedly.

The predictability in the awarding of honors in the field also reveals class in action. A small circle of designers passes honors among themselves, with few (if any) electing to drop out. The question is when, not if, a member of design's upper class will be named a Legend, featured in the Cooper-Hewitt National Design Museum Triennial, or presented with a National Design Award. There will be no surprise honorees from a little-known small or moderately sized practice in the Midwest.

For years, the only suspense has been what some oft-celebrated award junkies will do when there's nothing else to be feted with. The Cooper-Hewitt Triennial makes sense as an action to forestall such an apocalypse. Though supposedly a showcase for the nondesign public, it practically functions as a graphic design hall of fame. The exhibition's curatorial criteria remain opaque. No voices were raised to question the propriety of the triennial's curator including her husband in the second iteration of the show. What had changed over the intervening three years to eliminate the previously admirable desire "to avoid any appearance of conflict of interest" remains a mystery. That the designer selected is a Pentagram partner—the most prominent design consultancy in the world—may render the choice beyond explanation.

Highly placed design practitioners are also deemed the best design writers and critics. The status automatically conveys, however clumsy the prose or self-aggrandizing the opinion. In fairness, graphic designers are practically the only people interested in writing about design. Still, anyone outside the realm of reputable commentators goes to the back of the line.

Celebrity is also the founding principle of the Winterhouse Writing Awards. Established in 2006 to recognize "excellence in writing about design," the effort proposes notoriety as the ultimate reward and motivation for writers. Class differentiation is unavoidable in competitions—"winners" and "losers" are arbitrarily created. Celebrity

also frames the selection process. Judges are drawn from media and design industry stardom—academics, for one, are notably absent (though when they are called upon to serve, they will undoubtedly be drawn from the elite design programs). With, once more, no stated criteria for "excellence," judges will turn to their own subjective experience—their personal success stories—to make determinations.

Design's ranking writing anthology to date is the five-volume *Looking Closer* series. Once more, criteria for inclusion were as unclear as for the triennial. In the fourth volume, the editors—ubiquitous class leaders in the field—identified design writing's pressing problem to be the reduced amount of writing coming from the field's privileged class of commentators. A cursory mention of emerging voices and growing fresh talent was belied by the stock reliance on established names. With the editors freely inserting their own writings into four of the five books (one was dedicated to historical texts), the set serves primarily as a self-promotional vehicle for their practices and products. Engagement in such literate activity provides affirmation to their sophisticated, cultured clients that the designers are beyond mere style merchants.

What emerges from this class structuring is an unavoidable equation: good design=$. Imperatives of conceptual acuity or wider public benefit remain rationalizations for design achievement that has limited viability beyond the affluent client. At the risk of seeming like a "hand-wringer"—a term that, in design usage, is defined as "anyone who makes even the mildest claim that everything may not be perfectly hunky-dory"—about the state of design, this may not be the most progressive scenario for our most common art form. Responsibility for this circumstance spreads throughout the design profession. Designers across the board are mostly content with the arrangement. The "lower" classes are too busy getting things out the door to care. It's a luxury to regard design as anything more than a job. The "middle" largely

anticipates their potential ascension and won't rock the boat. Otherwise, designers are generally risk-averse and suspicious of the new.

Pointing to the upper class's evident talents or the substantial effort that brought them to their position is irrelevant. Talented, hardworking people abound. At issue are standards that fall short of being egalitarian, transparent, or readily attainable. To those benefiting from raised class status, we must also credit a measure of selflessness. They've used their resources to create initiatives that have expanded opportunity for designers overall. While we can credit design's elites with filling a vacuum, care must be taken that they not consume all the oxygen.

Design may be immaterial, but designers are the matter. They're entirely material, physical, and subject to the insularity, cliquishness, and tribalism found in all communities. The first remedy is to have honest and open conversations about class in design. Right now, all that designers are comfortable saying about class is that raising the topic shows you have none. �

The Resistance

As no military plan survives contact with the enemy, no design concept survives contact with the client. Both situations feature laboriously (if not lovingly) crafted plans blown away by reality. The endgames differ in that designers define victory as gaining that initial approval.

Ideally, the design proposal would emerge unscathed. As if. Among themselves, designers acknowledge the possibility of having to deviate. But capability statements prominently tout variants on the term "strategy." Designers may cite adaptability in their skill set. However, having to exercise this ability isn't popular. It's bad enough when it's just due to stuff happening, like technical glitches. But to change course because of someone's uninformed opinion can be galling.

The favored client is one that gets out of the way. Otherwise, for designers (and generals), resistance is to be overcome. Minimally, it's an irritant. The role of opposition obviously isn't well-regarded. However, it's one that bears reappraisal. Clients generally do need to be more sophisticated. But the reasons and results aren't what one might assume. And while strategy is vital, flexibility needs to move up in the hierarchy. The ability to change course effectively should be valued just the same as charting a course, then following it unwaveringly.

Good work is usually thought to occur despite, not because of, client involvement. In most descriptions of designer activity, the client quickly disappears after demonstrating the good taste of selecting the designer. If they reappear during the process, it's usually to impede the

designer by offering an opinion that interrupts the smooth execution of the strategy. Preferably, they only reenter in the last act to embrace the solution with near-orgasmic glee or congenial admiration for a newfound peer. This narrative is most prevalent at the elite levels of design. Notoriety in the field arguably comes from a designer's ability to regularly avoid concession—or have it be negligible. Such purity is rare. But given the choice, designers would overwhelmingly opt for an unfettered practice.

The necessity of compromise, of adapting to circumstances, makes design difficult to practice. This is especially true if practitioners doctrinally follow particular formal and/or conceptual approaches. To avoid concession, designers attempt to "educate" clients out of obstructionism. This amounts to launching a PR campaign for old tactics rather than actually changing them.

Though compromise is a fact of life, it's a troublesome topic in our individualistic culture. Graphic design's stature as art to its practitioners (however strident claims to the contrary may be), and the popular view of art as "self-expression," makes compromise akin to selling out. What else could explain the popularity of Ayn Rand's *The Fountainhead* among designers? It ain't the prose style.

Designers do make a strong case that their way is best, as they dedicate their time and livelihoods to mastering visual rhetoric. Even if designers merely manipulate graphic grammar, they're the most adept at it. Educated clients should realize this and give designers latitude. Design eagerly anticipates the emergence of these patrons and the nirvana to follow. However, the educated client may not be the savior designers presume. Their appearance will signal not the start but the end of a golden age.

Contrary to conventional wisdom, designers—especially at the elite level—largely have their way. Clients regularly concede points and

power. They're susceptible to personality and patter. Legendary designer/client relationships, such as Paul Rand and IBM's, set a bad precedent. They distorted the roles and raised unrealistic expectations.

A new, sophisticated client will ask informed questions and expect substantive responses. Those answers may not be forthcoming. Designers have limited experience facing a worthy opponent. So far, clients have failed to mount a substantive challenge to designers' spiel. If design is (as often claimed) gaining stature, challenge may come soon and often. Will designers be prepared? Practice might be gained from some in-house resistance in the form of criticism. Unfortunately, this has been marginalized, driven underground. (It's design's version of "Don't ask, don't tell.")

Design's lack of notoriety and respect as a substantive cultural activity (such as journalism or architecture, to name two) is due in part to the lack of productive resistance. Identity is significantly shaped by the quality of one's opponents. They can serve as a hone. That sparks fly isn't always an indicator of trouble.

The state of design cannot be attributed to designer or client alone. It's a dynamic that may be adversarial and advantageous. Clients need to be given their props as contributors to good design.

The right way to produce the sophisticated adversary is an open question. Designers may have little or no influence. But they can modify their attitudes and behaviors. Too often, client input is regarded as a de facto detriment, irrespective of content. And freewheeling, personal aesthetic achievement is regarded as design's highest prize. True collaboration and accommodation, not simply its rhetoric, should be the goal. The result will be a process that can truly be called the good fight. ✴

Designer X

I think I found a gem in big tittied sites online, it's called DDF Busty. From the first glance on the tour I was not impressed, specially by the design of it but that quickly changed ones I started checking out free samples. Fuck good design, if you have amazing busty babes that's all I care about and boy they do, over 150 hot models with 70,000 hq images and over 600 movies inside.

—Anonymous website testimonial

It's very easy to shock people. There's nothing to it, especially in America. We could just try to make nude photographs of every graphic designer we like and put them in center spreads.

—Rudy VanderLans

And of course, there's the ongoing dilemma of where can these grad students [from Cranbrook and CalArts] go if they don't want to teach, intern at *Emigre*, or work at *Hustler*?

—David Carson

The obligatory comment to make about graphic design and pornography is that the term "graphic content" colloquially means that subject matter is explicitly sexual. Having your professional pursuit used as shorthand for smut isn't a cause for celebration. It's a downer in two ways: for the unflattering association and for the fact that only graphic designers really pick up on it. Designers might think that it was worth it if more people recognized the double meaning. That would mean that design had made some inroads into the public consciousness.

Pornography, meanwhile, jams the roads of the public consciousness—either by being indulged in or feared and loathed. For consistency's sake, graphic design may have to lay some claim to it. After all, it *is* graphic content, no less than any other printed material design has annexed. When you have Steven Heller, one of graphic design's most prominent figures, plainly and admirably discussing his *Screw* past, shouldn't the field as a whole follow suit?

Irksome as it is, graphic design could exploit the association for its benefit. Not by being tied more closely to pornography in content, but by testing pet theories against it. Considering pornography when evaluating some concepts would provide essential insight. It isn't even necessary to actually *view* any porn—simply acknowledging its existence within a theory is sufficient.

Pornographic media is partitioned off from the mainstream in magazines, literature, web, and film. (The art world doesn't have a shadow marketplace; it just converts objectionable content into more content—e.g., Jeff Koons's products with former wife La Cicciolina.) Critiques of pornographic works occur in separate, parallel venues under related and specialty criteria. This separation is an understandable social convention that realistically puts work out of sight but shouldn't exclude it critically. It's here, it's severe—think about it.

Graphic design considers sexually explicit content through a commercial lens—the field's near-exclusive focus. Sex's utility for business usage is the only critical question that's investigated. What results is a repetition of the ultimate rhetorical question: Does sex sell? The answer, of course, can only be *quite well.* You could make a little poem. Yet this query is repeated constantly, as if it will prompt another conclusion for what should be self-evident. So why keep at it? Besides satisfying a prurient interest in researching the topic, there's a fundamental misunderstanding on the part of every questioner. They're asking either an incomplete

(incorrect) question or not looking in the right place for the answer.

The correct—and only—place to look is pornography. *That's* sex, and it sells to the—estimated 2006 worldwide—tune of ninety-seven billion dollars, which was larger than the profits of the big three television networks combined, or the revenues of the top technology companies combined (that includes Microsoft, Google, Amazon, eBay, Yahoo!, Apple, Netflix, and EarthLink). Instead of going to the source, however, the curious seekers analyze material that only *gestures* toward sex. The sex has been ameliorated, tamed, mixed with other concerns.

The real question is: Does sex sell something else? Can sexual content synthesize desire for something tangential or unrelated? This may be pointless specificity. It's reasonable to say that the question as asked is shorthand for the true inquiry. However phrased, it's a good question. Others follow: Won't using sex to sell just end up increasing demand for sex? Is anything powerful enough to eventually draw attention *away* from sexual content? If not, using sex to sell is a fool's errand as it results only in selling sex, too. Before deciding if and how sex can sell something else, how does sex sell itself? It would also be a telling discussion to attempt an answer to the "Does sex sell?" question as literally asked. With content as powerful as sex, does graphic design matter at all? If it does, what role can it play in framing or interpreting the content? If it doesn't, is there any other negating content?

Carrying out such a study would require a close examination of pornography. We'd likely have to settle for as close a scrutiny as the field offers other design artifacts. Discounting occasional exercises like "spot the phallus" logo overviews, examinations of sexually charged design artifacts address only rare or upscale works. This is in keeping with graphic design's usual predilections. Commonplace design artifacts don't yield enough formal gratification to engage the interest of practitioner/critics (a class that's the near entirety of design writers extant).

Even a cursory examination of pornographic websites reveals a graphic world parallel to the mainstream. The design framing the imagery utilizes the same formal tropes and expressions found everywhere else. What's notable about porno-graphics are their mundanity. Diversity and levels of formal achievement are discernable in the graphics, which reflect the brand of the pornography. Porn isn't all the same, ranging from the coarse to the stylized in emphasis (particular sex acts, fetishes, body parts) and photographic technique (referring both to technical skill and staging/scenarios presented). Graphic design's role in pornography is to first establish and reinforce the class coding that's going on in the imagery. The "higher" the class of the site, the more refined and restrained the typography. Gone are the omnipresent gluey, bulbous, carnival letterforms (most pornography graphics can be read as putting forth a knowing, winking humor; unsubtle, middle-fingered salutes to propriety). As in mainstream graphics, there is a mix of idiosyncratic style choices and dogmatic applications of established graphic approaches. Overall, pornographic graphics mirror the mainstream. For graphic design, it's all the same: women's athletic shoe store or Black lesbian foot fetish site.

Mainstream attempts to examine sexual content in graphic design have occurred. Heller edited *Sex Appeal*, an original essay collection in 2000, and *Print* magazine published their "Sex Issue" in 2004. Pornography surrounds and suffuses the various articles in both but is never directly critiqued. It is only viewed in reflections off of artifacts hoping to borrow allure. All the articles present formally accomplished, inside-the-pale products, even when sex-related (e.g., *Playboy* and *Eros* magazines). Actual pornography's graphic expressions must be inferred from work costuming itself with "edginess" (a term that's easily defined as flirting with pornographic content).

As is always the case, everyday working designers go unmentioned

and the products of their labor are unexamined. It would be interesting to hear how designers in the pornography field go about their business. How do they interpret their message, regard their audience? Mainstream graphic designers indulge in grousing over uninspiring subject matter and tedious work. How does designing for pornography rate? Best or worst design job ever? Or one just like any other?

Beyond the design concerns inherent in designing for sexually explicit material, there are the human costs. Arguments against pornography frequently claim corrosive emotional and behavioral consequences from repeated exposure to the material. Designers in the porn industry constitute an identifiable audience that's only once-removed from consumers. Do they manifest the described negative effects?

If graphic design can be a test of theories about pornography, the inverse is also true. Graphic design theories have historically offered totalizing declarations. The premises they're built upon, however, are derived from a specialized segment of design practice. For instance, the predominant typographic theory first articulated in Beatrice Warde's 1932 essay "The Crystal Goblet or Printing Should Be Invisible" descends from usages found in rare books. What relevance does Aldus Manutius's 1499 edition of Fra Francesco Colonna's *Hypnerotomachia Poliphili* (a "masterpiece of graphic design," cited by Philip Meggs in his *A History of Graphic Design*) have for contemporary packaging, advertising, or even editorial designers? The book's subject matter (note the *eroto* in the title) helps advance this essay's premise, though.

Pornography might be considered a specialty segment, also—but only if you ignore its staggering sales figures and broad audience demographic. If graphic design is a commerce-based, public art, pornography trumps every other form that meets the criteria.

How can pornographic imagery test design theory? The early modern assertion of photography's inherent neutrality and objectivity

would have instantly been dismissed had it been tried first with porno-graphic imagery. As a thought experiment, imagine the layout and typography of high works of the Swiss International style combined with pornographic imagery of the same time. The same can be said for the computer-friendly, literary theory–inspired, "deconstructed" graphics of the 1990s. How much ambiguity is there in a money shot? However, it initially appeared as if this new work would willingly and aggressively engage with explicit sexual material. P. Scott and Laurie Haycock Makela were prime providers, most demonstrably with their—tastefully blurred—cover image for their book *Whereishere* (which also includes a countering image by Stefan Sagmeister that demonstrates the ability to be both explicit *and* assertively contraerotic).

Pornography both drives and keenly mirrors culture—as does graphic design. What can be said about the current, dominant themes of pornography can also be said of graphic design. Prevalent are depic-tions that are denuded and depersonalized: synthetic, technologically enhanced, polished perfectionism that is a Kabuki dance of passion. The characters change but the scenarios and poses are mechanical and proscribed. This is offset by a reality movement of amateurism, fostered by widespread access to the means of production combined with a DIY attitude, one that is writing new rules of representation through ignorance and an active, strategic disdain for professional standards.

Graphic design theory shouldn't arbitrarily wall-off work with sexually explicit content that's in service of itself. Design's theories are frequently totalizing without confronting the entirety of graphic possibilities—and human experience. Graphic design's claims of commercial, interpretive, representational, mediating, or relational ability should plug pornography into their critical equation . . . and solve for X. ✸

Trenchancy

Call Me Up

When I read the words "down-in-the-trenches design," I release my safety. Not to press an attack, but in self-defense. I sense a threatened exposure when this cliché flies, of being identified as an enemy. When DITT (war metaphors deserve militaristic initialese) is deployed in design today, a distinction is being made—between real design and the speculative. A battle-hardened vet is dressing down some desk-jockey or summer soldier. You hear the phrase all up and down the line: theory and practice. Two things. When I hit the border and they check my papers, I know how those documents will be interpreted. If you lack stripes on your forearm, you'll gain them across your back.

Talking trenches obviously implies a war. Who are designers fighting? The clients? Usually. Each other? Definitely. Someone else . . . ? Once upon a time, everyone was fighting the fight and trench talk was a bonding exercise—directed outward. Now, DITT is a weapon used within the ranks—the fragging option of choice.

Design does a lot of separating out, hairline-splitting differences imperceptible to outsiders. True divergences, however, are rare. The form(al)er radical wants nothing more than establishment approval. (I can read the ad copy now: "In *Graphic Design: The Movie*, David Carson *is* Paul Rand!") There are heated debates about quality but everybody still gets called "designer." Or do they? Is it possible to do design and still be regarded as "other"? Examining any group's other always provides

an essential perspective. Who is left out of discussions or considered unreclaimed? What is really going on when distinctions are made— between amateur and professional, practical and theoretical? Is there a common dread for all the insider factions?

If there is, it's the hack. As with the master, the appellation is on a sliding scale, depending upon your antipathies. The basic definition, however, is agreed upon, as is the disdain. Hacks are mercenaries indifferent to aesthetic or cultural significance. They trade in surface style emptied of meaning, lowest common denominator derivation. Being a hack is a touchy subject for designers. Some began their careers in positions where such appropriation was necessary; it was the job description of sorts. Many others concede that what they do now is hackwork and—resignedly, bitterly—they are trapped beyond hope of rescue. They see themselves as being in those trenches, often under friendly fire.

Intellectually, at least, many designers have climbed out of the trenches and become strategists in the design wars. Much of the strategizing is claimed to be for the trenchers left behind. But what is being done for—and to—them? Consideration of the spectrum of design activity from Massimo to MacTemp usually focuses on the upscale. What relationship do these worlds have with each other? Is it that common antagonist—the client? As a habitual schemer, I have to wonder if I'm devising victory plans or bugging out.

It's Their Factory

When examining design writing, it's worth noting who's writing and what their circumstances are. Usually, they have enviable titles: partner, professor, owner, curator, director, editor. They aren't punching MacClock. Many once held humble jobs but have moved on. A specific argument aside, there appears to be a significant absence. Where are

those down-in-the-trenches designers? Don't they have any theories? Design writing seems the province of a small, intense group—usually talking to themselves. It's reasonable to ask if this separation influences what's written.

As previously noted, most writers have trench experience. My major tour of duty only reinforced my expectations about who might be interested in any theorizing I cared to do. In my trench, all the popular design publications were readily available but mostly went unread. They were, of course, kept as visual resources—somewhere from which to lift ideas when the muse missed the meeting. Even for those interested in reading, who had the time? Long, unrecompensed hours marked the job. Theory was limited to how am I going to get this out on schedule? With time to read at a premium, writing was unthinkable. I know it isn't easy for anyone in design to write, even when you're so inclined. To want to write and be able to is an indulgence. It's an ambition apart from the job; it's a different job. Reading's another. When the staff designers finally got to go home, they hardly wanted more design. Particularly from some fortunate son lecturing them on niceties they recognized but were powerless to implement.

Compared to what I read and thought about, I wondered if my trench work could rightly be considered design at all. It was the graphic trade. In their own ways, everyone in my trench cared about their work and took seriously all the classic design considerations. Many might claim they expressed themselves in their work, at least by being reliable in that it would be done on time and to expectations. However, aesthetics didn't rule here—deadlines, economics, technology, and clients did. Under the circumstances, few—if any—writers on design had something to say to this experience. It wasn't just your postmodernist design theory missing the mark, everyone and anyone's theory

had little relevance. If there was a guiding theory, it was a functional modernism, established through inertia.

What would an entrenched designer write about? To hear the voices of the anonymous majority one has to scan the magazines' letters pages. It isn't uncommon to encounter a reply to some thoughtful article bemoaning, for instance, the fading of good typography skills. I agree with everything you say, the respondent will write, but it fails to take into account my everyday reality. It isn't a failure of will, knowledge, training, or appreciation. It's the job.

Here is the reason why good design—however defined—doesn't happen. Designers aren't in charge of the workplace, whose pressures determine how design is done. The commercial structure, which brought design into being, constrains it from ever reaching its supposed height. Critics rarely address this reality head on. Design writing often resembles malcontents discussing the utopia after the revolution comes. (Oh, the typefaces we'll use! Or refuse.) No one, though, is explaining how to make that revolution happen. That would really require turning the world upside down, more than employing a grunge typeface in an annual report. It's much easier to debate formal minutiae and accuse people of educational, intellectual, aesthetic, or moral failures.

For this reason, articles critical of the state of design frequently lack substance. The writers are usually outside the circumstances that shape everyday design. The writings aren't irrelevant but lack a crucial relevancy. The realm of the writers is that of the uncommon designers and readers. Shifting into anonymity, a curious thing happens. Your common designers become your common readers. They're one and the same! Shouldn't these be the people expounding with real authority on issues involving the average person? Ironically, they are silent and silenced.

Damaged Goods

Design writing currently falls into three broad categories: management, showcase, and escapist. Particular magazines can be cited for primarily offering content in one of the classes, but overlaps are common.

Management (as in crisis) writing is representative in *HOW, Critique, Step-by-Step Graphics*, and the like. Here, the nature of trench life goes unquestioned. Stories focus on the practical aspects of making design products. The workplace as it's currently constituted is how it has been and ever shall be, amen. Occasional genuflection toward the "good design is good business" icon promises some deliverance. This despite overwhelming evidence the operative deity is oblivious to invocation.

Showcase publications reside nearby: *Graphis, Communication Arts, I.D., Print.* These journals feature individuals who have, through some combination of fortune, talent, and determination, risen above anonymity—at least temporarily. The premise is that exemplary work will improve your immediate circumstances and maybe everyone else's (read: the client's). The world may stay the same but you'll be on top of it, design-wise.

Escapist literature—as usually found in *Eye, Emigre,* and *Design Issues*—are speculative forums that proffer outs to the workaday world. The majority design experience is one from which to flee or study safely at a distance.

The increased blending of the three categories in many magazines does indicate a desire to connect the strategists, tacticians, and soldiers. However, design writing lacks a dedicated transformational literature. This writing would address the socioeconomic structure of design activity for the majority and advocate change. It would link design work with other occupations in a greater struggle for fairness in the workplace. Along with establishing its unique history, design

would join with existing social history. Rather than seeking respect for design by isolating it from other activities—claiming it as something special—this writing would explore commonalties. The lack of regard for design activity echoes the contempt displayed for most nonmanagement, creative occupations.

Having failed to gain legitimacy by sucking up to business and adopting its politics, maybe it's time for design to make a challenge. All of the modernist, postmodernist, non-ist posturing won't alter the fact that the commercial structure calls the formal shots. Working conditions are the major influence on how things look and are made.

Examples of transformational writing are rare but present in design writing. Denise Gonzales Crisp's "Ways of Looking Closer," published in *Emigre* 35 (1995), explores the overwhelming influence of the client and capitalism on design in a critique of the *Looking Closer* anthology. Crisp succinctly notes how this landmark collection of design writing fails to address design's most pressing determinant. Milton Glaser's "Design and Business: The War Is Over" (first published in the *AIGA Journal of Graphic Design* 13, no. 2, 1995) advocates a "new narrative for our work . . . a new sense of community" to counter the crushing effects of "entrepreneurial capitalism." While Glaser may not desire the reordering I consider necessary, he clearly indicates where the contest must be played out. Both articles assert a fundamental fact: it is impossible to consider design activity without confronting the politics of the workplace.

History (It Fails Us Now)

As design struggles to form its own history and theory, it borrows liberally from existing models, frequently adopting the most dubious aspects. From established studies of history, particularly art history, it has paralleled the obsession with exemplary individuals and their

activities. These great practitioners and their products define practice, though they work under rarefied conditions.

A reading of history teaches one important lesson: that it can be influenced. Small, intense groups determine what is noteworthy and deserves canonization. The process is far from objective. Graphic design acknowledges this but hardly acts to change it. For instance, Lewis Blackwell and Neville Brody's 1996 anthology of design work, *G1: New Directions In Graphic Design*, nodded toward this inequity—then reinforced it. The book began with a listing of "Possible reasons for inclusion," starting with "Accident" and ending with "Your work was seen by somebody who knows somebody who worked on the book." Curiously, the last reason for noninclusion is "Fame/notoriety." However, all the named, included designers have status in the field. To supposedly put all work on the same level playing field, names of designers are placed in the back of the book. The "vernaculars," though, have their artifacts reproduced but are kept anonymous. Is the work almost uniformly accomplished? Yes. Does the book do anything to break any boundaries between high and low? No. Lack of notoriety may not keep your work out of books but it'll sure strip your name.

The result is that—as usual—a narrow, specialized activity and its activists are celebrated while the majority goes unrecognized. Gestures of inclusion inexorably lead to self-aggrandizement of a design elite. Theory and history continue to focus upon exceptions, aberrations. A willful blindness sets in, as does a theoretical distance. In art history, a great master will be selected and a proclamation issued that this person represents art of a particular period. In truth, what is required is to take all the artists, masters and hacks alike, study the entirety of their activity, and theorize from there. We need a variant on the Olympic scoring system: throw out the best and worst marks, then average the rest. There's a recipe for a unique compendium.

Controversy marks all branches of history over what and who is deserving of study. Recognition is still uncertain for social histories, which only began gaining attention in the 1970s. These histories focus upon "common" people and outsider groups (women, indigenous peoples, minorities), exploring their experiences and artifacts. From these studies, we may derive a true picture of the times. What is gained is a fresh perspective unknown in the chronicles of Great Figures. Traditional historians frequently scorn the social history approach, asserting political history to be the only reality worthy of attention.

This disregard can be seen in design writing, which abstracts and shuns the majority's activity, while claiming it as its concern. Determined to erase design history's art-director's-war-story past, critics dismiss personal experience as irrelevant. All but a few "experts" are effectively ignored. Design will supposedly improve if designers learn from Great Figures, listen to their betters. Evidently, the ideas of the exemplary will trickle down and transform the marketplace. This does happen, but only in formal aspects emptied of meaning and recycled as surface style. Critics disparage this action, while compelling its occurrence.

What We All Want

The influence of the personal computer has spurred an interest in who is doing design, not merely how design is done. It is an overdue awareness that is still mired in fear of the hack. All those untrained nondesigners fouling the culture. All those colleges installing Mac labs then advertising design programs. How do we maintain standards? Again, the focus is swiftly moved to the doing and away from the doers. There are legitimate concerns, but are the corrective methods effective?

Recognizing the economic and political origins of bad design, what steps might be taken to promote the good? A major advance might be if organizations such as the AIGA reconstitute themselves as unions.

Admittedly, overcoming the compromised image of unions would be a challenging task of brand relaunch. However, this move may prove more successful than current appeals in swelling the ranks of these organizations. It would also provide a put-up-or-shut-up challenge to prove the actuality of design's influence. The question is: Will partners, professors, owners, curators, directors, and editors stand shoulder-to-shoulder with the anonymous majority and fight for our rights? Are we really for good design for all—good lives for all—or for our own careers? Will we investigate and honor the names of the vernaculars as much as our own?

Rather than fearing and loathing all those clerical workers forced to become design-machine operators, why not claim them? You're one of us. Wouldn't this raise design's stock in the portfolio of the average person? Just embracing the acknowledged but anonymous designer has been problematic for the field. The discovery and celebration of "vernacular design" does not extend to wanting to work in that world. The vernacular realm is considered somewhere to harvest inspiration from but not aspire to. The labor of thousands of individuals is treated like a natural resource—there for the appropriating. When design attempts to celebrate the vernacular, it resembles (and often refers to) the patronizing, ghettoistic fine art construction of "outsider art." Big name designers trading on their celebrity while identifying themselves with "outsiders" is at best embarrassing—at worst, exploitive.

There is plenty of work to be done within design regarding values. First is a reassessment of constant upward mobility. To be significant, you must be recognized, at the top of the field. How realistic a measure is this? Rather than concentrating upon theory, we should examine the true motivator—ambition. Design ambition always leads out of the anonymous, vernacular realm—where most people toil. "The cream always rises" is the functional cliché. However, it's usually one of the

current creamery operators doing the talking—and the separating. The process and meaning of rising is rarely questioned and if it is, it's in terms of formal excellence. Is it that the work is excellent or that the designer managed to get it printed and into the honor system? Every designer has examples of great ideas that didn't fly. It's the top trench-talk topic. Obviously, something else is at work.

For instance, why isn't Carolyn Davidson, the designer of the ubiquitous, all-powerful Nike "swoosh" being lionized? Instead of being feted, the creator is marginalized. The logo's power is praised but not the designer. The mark's effectiveness is attributed to marketing, not formal genius. If it was something else for the swoosh, couldn't the same be said for all our other great logos?

Is design recognition open and accessible to anyone? A design-specific social Darwinism is at work, where attaining positions of power counts more than actual brilliance. If you don't parlay your product into a particular career, you're (non)history. Who knows the talents that have been lost—and are currently overlooked—in this evaluation? I always allow generous space above and among the recognized leading lights, because you never know. The person one cubicle/trench over may have been the next Alexy Brodovich but for some circumstance. Maybe they didn't want to study in Bloomfield Hills, live in New York, flog Italian fashion, start their own type foundry, or spend as much time promoting their genius as doing their design. To say we can't help what we can't know only avoids the issue. All design discussions are speculative. We're all guessing—about everything. We're long overdue for an honest appraisal of the available options for and expectations of designers.

He'd Send in the Army

Does progress come from pressing the fight or deserting? Can I save only myself? Significant respect must be given to those who leap from the

trenches and strike out on their own. But if you're going to talk trench afterwards, isn't there a subsequent responsibility to those pinned down under fire? Is a trail of crumbs (interviews, features, lectures, workshops) the most we can expect? The trenches aren't going away anytime soon. Isn't it better to stop the fighting than to transmit dispatches from behind the lines?

To promote DITT disarmament, I propose a Peace Corps. Usually, it is the young and inexperienced that make up this organization. A seasoned, articulate force, however, would be much more effective. I suggest sending the established—and particularly the vocal—off into the minefields and trenches. There's plenty to design and a crying need for excellence. The next partner in an international design consultancy or flash hotshot that pontificates on improving design gets shipped to Nowhere, North Dakota, to run the art department at Amalgamex Consolidated.

No one achieves prominence in design without paying dues. The dues for theorizing (or anti-theorizing), though, are unclear. It could be that it requires a constant payment of some kind. The dues of staying close to the ground, dug into it, getting dirt ground in our ears. While design theory must move beyond war stories, we mustn't go deaf to the everyday experience of the many. Rather than bonding—modernist and eclecticist alike—against the hack, we should listen up and take names. Before gaining another theoretician (or superstar), we might want to produce a Studs Terkel.

Now everybody—give peace work a chance. ✵

Buzz Kill

For business wants him [the designer] to help create an attitude about the
facts, not to communicate them. And only about some of the facts.
—*William Golden*

Design is an attitude.
—*"Breaking Rules," 1987 Adobe Systems typography poster*

Life in the Hive

Bill Golden nailed it decades ago. Design is about attitude, having
it and giving it. Despite its long-standing semiscientific conceits,
graphic design is pure culture. No one possesses an instrument to
quantify good design. We might describe with a degree of certainty
how design will function in specific situations, but it's another thing
altogether to proclaim that that function is a physical rule of nature.
By incorporating theories such as gestalt, design has long attempted
to do just that. But in retrospect, the idea of gestalt fits comfortably
into the tenor, the attitude, of the times. It may not be objective, but
it gives that sense.

'Tude is fixed in the social lexicon, and culture's attitude of choice
is "cool." As described in the 2001 PBS documentary *The Merchants of
Cool,* the search for cool drives culture relentlessly. Design, a creature of
culture, is right there in the mix. The manifestations of cool morph as
we move across subcultures (the documentary focuses on marketing to

teenagers, but every demographic has its cool), but there are constants. A fundamental is the aspect of being plugged into the zeitgeist. The designer claims to be able to read then write to culture. It's the designer as cool hunter, gatherer, and chef.

Designers must be simultaneously—or cyclically—intuitive (divining cool out of culture) and intellectual (conceptualizing cool into culture). This requirement puts a lot of pressure on designers. They're deranged from the attempt to satisfy the objective imperatives of the business world while wrangling with the ineffable. (The grandiose and near-mystical promises of branding experts may rate highest on the psychosis scale.)

The soundtrack of cool is buzz. Buzz is as it sounds: an undifferentiated, massed chorus of voices in constant locution. It's the audio of Brownian motion. Buzz imparts a sense of activity, of words being passed. However, those words are indistinct. There's just an impression of repetition, of the same resonance issuing forth from all quarters. If you can pick a discrete voice from the mass, it's merely echoing the group.

Buzz is often an end in itself. The perception of substance becomes the reality. If everybody's talking about something, it must be worth talking about. Buzz is a self-perpetuating wave front, constantly circulating in culture's fishbowl. Design is an exercise in generating buzz. In this, it's similar to any culture-related field, from popular music to politics. Within design, buzz plays a greater role in style-related work. It's all attitudes in fashion and pop music. In the near absence of any regular critical review, buzz is the means by which design establishes value. Buzz makes taste. Ambitious designers recognize how the field operates and they shrewdly modulate the hum. If you want to have a career, you need to create your own buzz. Just get people talking. The goal is to synthesize a reality of your own importance. This makes

a majority of designers temporary, but fervent, postmodernists. The collapse of verities is a positive boon to crafting your own identity.

All that's needed is that first murmur. Aiding the process is the industry of commercialized celebrity. Design publications need to fill pages with superlative designers. A constant supply of new models must be rolled out, and established brands extended. Once a designer is featured in *Communication Arts* or *Print*, the din begins. In parallel is the plethora of design competitions—often sponsored by the media or vendors seeking their own buzz. Associated with competitions are conferences and workshops, similarly sponsored by magazines and vendors. We then have AIGA chapters with their need to present guest star lecturers. Often, they look to each other, the big groups landing the big fish.

There's nothing necessarily mendacious about this. However, it goes to illustrating the tight loop of renown that's ideal for inventing buzz. The process becomes the justification. The inflated encomiums penned for the laudatory essays, lecture fliers, and workshop prospectuses become truth. Eventually, everybody knows the featured designer bleeds graphic design.

While I have begun by discussing buzz in magazines, it likely could start with an AIGA chapter or a competition. It's the cool feedback loop: does the media make buzz or pick up on it? It's both—the reality of buzz is that it's often tough, if not impossible, to locate its source. Buzz provides its own background noise.

Despite its conceit of strategic making, design continues to indulge in and seeks to perpetuate the reign of buzz. The rise of design blogs has unfortunately served only to amplify buzz, in the sense that discourse resonates more noisily with received wisdom and specious claims.

If we regard design activity as buzz generation—and individual designers' need to be buzzed about—we explain much of the field's

continuing aversion to critical writing. Criticism is the big buzz kill, the weigh station on the infotainment superhighway.

The agitation instigated by 2003's *Emigre* 64 (the "Rant" issue) has, obviously, been telling. As most essays in that issue (and the following two) were meant as deliberate instigations, choleric retorts are to be expected. What has been most noticeable is the pointed refusal of respondents to engage the substantive points of any critical argument. True, there's little real substantial discussion going on anywhere about anything. But design is particularly mired in a stylish pretense.

This is a necessity of buzz maintenance: to deflect any exploration beyond the superficial. Go into details, start a conversation, and people may stop buzzing to actually listen. If you can't refute the message, disclaim the messenger's credentials. Denying legitimacy to the critic dispenses with the necessity of actually arguing merits. Secondarily, designers dispute the relevance of the critical process the critic supposedly employs. Very often, respondents bounce back and forth between the two, making up objections as they go along.

The most popular critical dodges are easy to catalog. What follows is the fantastic four of critical avoidance. I guarantee that each one is used regularly by designers of all ages and standings within the field.

The Lay Nay (Practice Spake Perfect)

If you're not a practitioner, says the designer, you have no standing to criticize me. Design's obsession over credentials is emblematic of a discipline in its infancy. The field seems quaint, clinging to a creed that its activity is inviolable to outsiders. The notion that only working professionals are qualified to offer criticism should be met with incredulity. ("I'm sorry, Miss Sontag, unless you can show me you can take pictures, your essays in *On Photography* have no relevance. Maybe you should work some weddings to give you insight.")

A lesson design should take from architecture is an acceptance of autonomous critical review. Admittedly, it wasn't an effortless transition there either. In his 1998 book *Lewis Mumford and American Modernism*, Robert Wojtowicz quotes an architect's lengthy screed from 1931, against the eminent critic. The architect protested Mumford's rebukes with a jibe against his lack of training. Mumford's response still resonates today: "I am not at all won over to [the] notion that the fact that I cannot design a building disables me from passing on the results. I am not able to lay an egg, either, but I can tell by testing it whether it is good or bad."

When design attempts to disconnect itself from lay criticism, it contradicts some of its core declarations of import. Design vaunts itself as an accessible art. It doesn't require burdensome theory. Design is the public art—everybody gets it. Unless, of course, issue is taken with the designer's claim. Then, you obviously don't get it. The client a designer dreams of isn't a knowledgeable one, but an acquiescent one. Shutting out nonpractitioners will squelch any worthwhile external appreciation for design practice. Are designers disingenuous with their pleas to be taken seriously?

Designers infrequently declare the particular arcana of their practice that cannot be apprehended elsewhere. The most forthright will propose it's the ability to empathize, articulate nebulous concepts, meet deadlines, and respect economic and technological realities. All of these skills should be part of a capable design practice. But none are its sole property. Nor is it alone in requiring such a range of talents. A related occupation that calls upon those supposed design-specific abilities is writing about design.

For argument's sake, let's accept that a critic must also be a practitioner. The next question must be, how *much* of a practitioner? What amount of design experience is adequate? Answering this question

brings us headlong into another long-running dispute, over "untrained" designers. We must also squabble over the collaborative nature of design and who gets credit. (Are art directors designers? Production people?) If design can't come up with a test to certify design practitioners, what luck will it have licensing critics?

The preferred criticism is by practitioners or journalists firmly embedded in the field's journals of record. Affirmation, not contention, is the prized perspective. Boats aren't rocked; names aren't named—except to extol. So far, simply writing more than one article about design qualifies the commentator as a "critic." That seems refreshingly egalitarian. Until you notice the 500-point asterisk excluding nonprofessionals. Maybe it's just squeezing out any competition. Tacking "critic" onto your resume provides some serious buzz. As long as you are not stupid enough to actually *criticize* another designer.

Middle-Age Dread

Citing the age of the critic seems obligatory for a younger respondent. "A bunch of depressingly middle-aged complaints" or "middle-aged whining" has been written so often that the phrase must be programmed as a function key. This knee-jerk dismissal is an objective-seeming score. If you're over forty, you're over forty. The substantive failing of such generalization should be obvious. (A special irony has been added when users have complained that younger designers are stereotyped by the older generation.) Rather than a middle-aged mindset—the habits of which are never described; they are obviously self-evident—what is exposed is an insecurity about one's own position. Generational envy is normal. Generalizing is timeless.

A related misconception is to extrapolate nostalgia from a contemporary critique. If a middle-ager points out a concern about current activity, it's interpreted as automatically prizing the "good old days."

Absent a specific comparison, such a claim exists only in the minds of the reader. If any group is currently sentimental for times past, it is the younger generation. In a May discussion on the Speak Up blog entitled "The Olympians" ("I thought it would be fun to engage in some unapologetic hero-worship") the overwhelming majority of design gods chosen by the youngsters were safely into their middle age. So much for failing to respect your elders.

A younger design sensibility in opposition to the old has also been proclaimed. But it remains as undefined as the one attributed to the middle-aged. If every generation thinks it invented sex, every new design generation believes it has contrived practical, theory-free, service-oriented design. The "changes in the graphic design movement" cited by "just starting out for the last 15 years" James Waite (from *Emigre* 66's letters) are the rote doctrine of mainstream design. Only through ignorance of any time but the present could Waite's "manifesto" be regarded as anything but banal. (But his insight on Picasso being a shrewd exploiter of trends, rather than a transcendent genius, is first rate.)

Waite is correct that critical writing has little relevance for him—or most designers. A joy of culture is in its not being a monolithic experience. And when I sit down with the contractor to discuss my bathroom renovation, I may find it engaging but extraneous for him to cite Mumford (I may also fear what his estimate will be.) However, if it is to have any relevance to the oft-cited "real world," design must engage the wider culture. And—who knows?—regarding it as such may, in even the humblest cases, inspire a designer to "transform my work and make it better."

The more substantive new writers have made a welcome call for a closer examination of the uses of design. However, this has been mistakenly framed as opposition to a middle-aged fixation with "form and style." Critiquing the meanings attributed to form—and how

designers deploy form—hardly constitutes legislating an approved formal vocabulary. And countering this perceived extreme by declaring such critiques irrelevant is no improvement.

Meanwhile, other writers are employing the agenda of moving beyond "form and style" to reaffirm the professional determination of design. Eric Heiman's article "Three Wishes," in *Emigre* 66, dismisses all the writers in the "Rant" issue as merely expressing "frustration" rather than "illuminating paths to follow." However, Heiman's answers are the rote "responsible" programs and rhetoric promoted by professional design. Warhorses such as "user-centered design" are presented as fresh initiatives.

Many of the institutions and individuals Heiman promotes to counter the professional emphasis in design represent the field's status quo. Buzz-laden and self-serving projects such as Bruce Mau's Institute Without Boundaries are given approval in the face of the "design education establishment's slow pace in evolving." These "graduate programs" aren't so much educational innovations as brand extensions for their principals. The final irony is when Heiman finds the antidote to the fixation with style in the pages of *Communication Arts*.

With a minimum amount of homework, Heiman could have found examples of the "Rant" writers directly articulating the concerns he accuses them of ignoring. Instead of exposing adversaries, Heiman slurs his allies. One essay doesn't constitute a worldview. Buzz, however, lives wholly in the moment. Obviously, you risk stripping away the sense of origination—and revolution—if you engage history.

The Burden of Prof

Before even their clients, designers save their sharpest scorn for educators. The clueless, inapplicable, and sham concerns exhibited by these teacher-charlatans begs explanation of how any managed to find gainful

employment. And they sure couldn't get a design job, right? Some even hold positions of authority at internationally recognized institutions of learning! Surely design education stands as the greatest farce ever perpetrated by academe upon society. Such hyperbole barely does justice to the contempt heaped upon "academics." The combination of design's "school of hard knocks" arrogance and society's prevalent anti-intellectualism is a potent brew to spew. Designers delight in a "trenches" mentality. Criticism from "sheltered" and "snobbish" professors is likely regarded as a type of fragging.

For a succinct litany of the sins of design academics, consult Adrian Shaughnessy's *Eye* magazine review of *Emigre*'s "Rant" issue. The only hackneyed charge he leaves unspoken is "those who can't do, teach." Essays are "lofty," "disdainful," "take little account of the real problems of designers," "reveal a preoccupation with the theoretical and offer little engagement with the practical," and are preoccupied with "arty practitioners."

Like Waite, Shaughnessy accuses academics of lacking "street savvy." What's entailed in this Artful Dodger–like aptitude is never explicitly defined. Are designers out busking brochures on the sidewalks? Were client meetings at Intro—Shaughnessy's former design firm—held in alleyways amongst the perps, skels, and humps à la *NYPD Blue*? The similarity of "street savvy" to "street walker" raises an unfortunate, and perhaps unintentionally accurate, admission of what designers may really be up to. Alleging a street-smart capability to design lends a gritty edge to the finicky exercise of selecting the right font for an espresso menu. Otherwise, the street wisdom most designers master is grabbing a parking space near the bar.

With evident seriousness, designers will actually mention tweed jackets, pipe smoking, faculty clubs, and ivory towers when describing academic life. How long has design been taught on the set of *Goodbye,*

Mr. Chips? As laughable as this stereotyping is, it's similar to the depth designers reach when exploring their clients' reality. "Research" is skimming for rationalizations upon which to hang your formal preconceptions. When designers opine about academia, they reveal only their ignorance of the subject.

As an academic, I can only dream of my vocation being a flight from reality. If anything, it's *too* real. Like real-world design, academia is a compromised activity where all the tensions within society are played out. Students, fellow faculty, and school administrators are all very real people with differing agendas. All have a direct impact upon the academic product—as do design professionals. Deadlines and financial pressures abound.

Try constructing a curriculum under the typical academic budget and the curious mix of faculty skills and sensibilities to be found in the typical art department. *Then* tell me how academia is a compromise-free zone of real-world disengagement. Like design, art academia is a brawling farrago of idealism, aesthetics, financial imperatives, technological wrangling, and cutthroat politicking. A designer who thinks client meetings are tough hasn't set foot in the typical faculty meeting.

If designers feel it's valid to reject criticism from "unpractical" educators, they should recuse themselves from critiquing academics based upon their lecture, workshop, or night-class gigs. Or is academia's role solely to invite buzzed designers on campus to trumpet their achievements?

It's not that academics don't get it, they understand only too well. Design professors continue to be drawn almost exclusively from the mainstream design world. Since design is a studio art, professors must demonstrate design products for credit toward their research. (Writing is considered the province of the art historians. A critical writer on design in academia is as odd a beast as in the field.)

There's plenty to rail at in how design is represented and taught in universities. But few designers have the insight, interest, or stamina to engage the day-to-day reality. However, perceptively analyzing academia is never the intent. Scoring cheap buzz points with the drones is. Instead of initiating pissing contests over who's "real," designers might recognize the "them" is us.

On the whole, designers seem to have suffered a collective trauma from their experiences in art departments and schools. This was given excruciating voice in Chip Kidd's novel *The Cheese Monkeys*. Drilled by their merciless profs; mocked by their artiste peers. It's payback time! At some point, designers need to just *get over it.*

The Conjecture Rejecture

The most damning term in the anti-critical arsenal is "theory." Any proposal by academics—due to their disengagement with the real world—is considered "theoretical." In this usage, it's a synonym for "fantasy." Buzz-wording an argument as "theoretical" is the designer's magic wand. Wave it, and pesky, unanswerable criticism disappears! In his seven-paragraph *Eye* review, Shaughnessy uses the term "theoretical" thrice and (in case you missed it) concludes with "theorist." No other term in the review is so used. Or abused. From its persistent invoking, the "Rant" writers must have been proposing the wildest design ideas ever. Were they fifty-foot-tall annual reports? Anti-gravity inks? Synesthesia-inducing layouts? Boustrophedon text all around? Unfortunately, Shaughnessy offers no specifics.

How or to what degree a commentary is "theoretical" never gets explained. Theory is, simply, a speculation on what might be. Every art director's instruction to a junior, every firm's capability statement, every competition juror's decision, is by definition theoretical. Each involves a qualitative choice based upon conjecture on what *may* be

better. Criticism is a deliberative process that compares what was done with what might have been done.

To label criticism as being theoretical asserts nothing more profound than pointing out it is composed of words. There can also be no "theory-free" design, a logical impossibility. All work is guided by some debatable assumptions. Only in the sphere of cliché or derivation can we have any assurance that a given design will function as supposed.

That criticism is theoretical by nature is not at issue. What is arguable is the specificity and suitability of the critique. To determine this, details are of vital relevance. But it's these fine points that are routinely omitted when designers protest the theoretical nature of a criticism. The fine points aren't enumerated because there aren't any. Attaching the "theory" tag is the total intended response. Simply slap the label on and the "practical" design narrative does the rest.

Parading the straw man of "sharp-brained theorist" in front of a design audience is like bellowing "liberal" before Republicans. The stench of French literary theory is wafted over all criticism, even if the j'accused critic couldn't name a Derrida text on a bet. (Unfortunately, a segment of designers have abetted this parody by insistently equating such writing with theory. All knowledge should be our province, but it's time to see more of the world.)

We must to turn to conjecture to determine the type of speculation that designers consider bizarre and untenable. Clues may be found in Shaughnessy's review when he defers blame for all the concerns cited in "Rant" to "the boardrooms of the corporations and into the dark heart of the mass media." Accountability, he insists, cannot be placed upon designers (except for those "arty practitioners" championed by academics) but resides with "brand managers."

Proper theory, therefore, gives designers a free pass for any of the consequences of their work. Further, they may disclaim any requirement

to stand by their theory about their work. Once again, designers get to have it both ways. You can write grandiloquent capability brochures touting your powers. But when you're taken to task for the puffery ... plead impotence.

A "theoretical" criticism is evidently one that takes a designer to task for anything. Except, of course, the kind of practical stuff those designers really love to talk about—like kerning. When a designer says "practical," what is meant is "absolutional." Freed from any but no-names-please, professionally determined criticism, value in design is set using the most cynical measure. The client bought it; it must be good. If I sold it, everything I say about it is true. Buzz is all. Now, *that's* a theory worthy of impracticality.

Hum Bugged

And what of "critical buzz"? Some designers' careers were made when their work was featured in *Emigre*, *Eye*, and books like *The Graphic Edge*. This gives all the more reason for enunciation and explication. Fight fire with fire. In any critical literature, dissent can be found. Rather than instilling conformity, an honest, detailed criticism promotes diversity of opinion. It's democracy in action. It's clearing a space amidst the humdrum for your voice.

But the spectacle of otherwise-bright practitioners attempting to parse whether or not some writer is a designer, instead of answering the charges ... that I can do without. And so can the field. Don't buzz: learn the words. ✪

Quietude

It's a pretty, subdued time in design. Passions are running low—or are highly affected. Design continues to be a busy but overly placid, pleasant surface. There are few signs of what, if anything, lies below that surface. Our pond remains small and shallow. Anyone hoping for waves is waiting for someone else to make them. There was some disturbance before, but the breakers seem to have settled out—and settled in. Have we arrived at a transition or a terminus? Is this a breather or an expiration? A perpetual revolution (if that's what it was) is tough to maintain. Design might be a process but there needs be a product. What have we produced?

That nonconformist forms were readily absorbed into the mainstream shouldn't have come as a surprise. It's the life cycle of style. The once-rebellious designers who have joined the establishment are not necessarily hypocrites. Often, that label was applied by the established. Co-option is natural, though humdrum.

The rhetoric—and the work—of the past decade did get overheated. But design actually ran a temperature for a time. Now, the field has resumed its disdain for passion. Due either to remnants of modern objectivity or to professional control, ADS (art directors) insist on an AC heart.

With heat came light. Design mattered, as it hadn't before. Or it mattered to me, who had previously dismissed it. What was exciting about the striking work was that it was accompanied by an intellectual

agitation. It struck matches, not just eyes. And it's that adventure—that promise—that has gone missing.

Present and accounted for is a lot of sumptuous work that follows routes charted during the ferment. It's also everywhere: both on diverse and unexpected artifacts and wherever there's a design industry. A curious realization of the modern dream—a cross-cultural international language of form—continues to be fulfilled. Only in our here and now, that language is appropriated, not apprehended.

If aesthetically pleasing product is what design's all about, things are good. However, the call that cut across all the strata of discourse was that design needed some meaning. A content all its own. And that perpetual longing: respect as a substantive activity.

A permanent insurrection is an impossible brief. Somewhere along the line, though, victory seems to have been declared. Or the battle map was redrawn. A dialogue "daisy cutter" hit us and sucked all the oxygen out of our cave. Design was supposed to surge from this dark, Platonic netherworld. It must have been too bright out there, since we've all ducked back into the studio. The illumination is evidently better from those expensive light booths. Enough talk . . . that was fun—back to work!

If you won't take my word for it, take Rick Poynor's. He's still prodding design to allow for a real criticism. With his insistence that design is worthy of an accessible, expansive, sustained, and discerning inquiry, he may be the person who most believes in design. His provocations for a critical journalism are theses nailed on design's front door. Sadly, no one's reading them. Maybe he doesn't use enough imagery or needs to do his own typography for design to notice. I admire Poynor's optimism and persistence. I've simply given up on a critical writing ever developing in design. If it evolves, it will be from the outside, likely an aspect of the ongoing hybridization of media. Also, art may continue to drift into design in its slow absorption of all cultural production.

That would be unfortunate, as design writing could take what's best about art criticism—its intellectual rigor—and inject social and cultural relevance. It could also squelch its ardor for architecture's status and theory. Both art and architecture are overwrought and value megalomania, excessive capital, and grandiosity. ("Oh, Rem, it's so big!")

The demise of discourse is due to neglect. Designers vote with their eyes and look away. And there isn't much to look away from. No market exists for critical writing. The major publications know what their audience wants—and it's not criticism. The desired report is brief, written by a professional and professionally oriented. Anything of subtlety, depth, and breadth is ignored. Profiling a designer with some connection to celebrity and capital prevails over a think piece every time.

The passing of the intellectually tepid critique symbolizes design's disinterest in anything approaching inquiry. Only the pretense of deeper readings exists in current magazines. The AIGA *Journal* transformed itself into the bookish *Trace* (now defunct), but its articles remained mostly trivia. The fussy, homogenizing design displays detailed photographs of various mundane objects as if promising a similarly methodical examination of design issues. Instead, both only addressed the surface. Engagement with any serious topics was left to (surprise!) Poynor or the token profiled fine artist.

Eye magazine seems to have read the lack of writing on the wall. It has faded from intellectually vital to commercially demonstrative. An aggressive marketing campaign and a busy layout attempt to fill the void left after the departure of its founding editor and his successor. Quantity reigns over quality in the contributors and the reviews. It's heartening that *Eye* is featuring lesser or unheard voices. But so far, the newer writers are indistinct and the product often immaterial.

Meanwhile, many well-known design voices are now making design full-time. As in art, design's practitioners/writers prefer the

former role. It's a problem for design when just a few people leave the field and a chasm opens. This intensifies the need for design to develop an independent body of critical writers. That still doesn't exist, and the potential is dim. In the twilight, design continues to evade any substantive internal critique. If you're a designer with a book and haven't been overly contumelious, you're good as gold.

Design has no heritage of or belief in criticism. Design education programs continue to emphasize visual articulation, not verbal or written. The goal is to sell your idea to a client and/or a hypothetical audience. Design in relation to culture and society is rarely confronted.

There are also some all-too-human dimensions. Design is still a small, small world. Friends are often writing about friends. While design isn't alone or first in closed-circuit critiques, it's there. Even when writers I respect discuss designers I admire, I wonder what a less connected account might offer. That said, the paucity of critics means that fewer articles would be written if we limited such connections.

In addition, there's professional courtesy. You don't dis your peers. Sharing a dais on the next stop in the design conference round-robins might get a tad uncomfortable. And since the outside world doesn't take us too seriously, we must stick together right?

The insularity only reinforces the indifference to design outside its own borders. And even if that's true, it's not the real problem. Luminaries desire an imprimatur. Instead of enlisting critics on the order of Hal Foster or Dave Hickey, sympathetic insiders are tapped. Why not? It's bad business to cast doubt on your talents in your own book. Whatever the rhetoric, design monographs are promotions, period. Client testimonials continue to serve as substantiation. Though we've seen a shift from CEOS to progressive musicians or philosophers, critical intent is absent.

It's arguable that many of these books are undeserved. We cook a microwave history by beaming intense eminence on excellent but

short-careered designers. What nuking does to your leftovers, it does to the quality of scrutiny: scorched on the surface, half-baked to partially crystallized inside. It's ultimately irrelevant if attention is unmerited. I don't have to buy the book. Unfortunately, with design's failure to commission critical audits, the market is the only check on hype inflation.

Despite the brief and ironic "No More Heroes" movement (more twitch than movement, really), design craves celebrities. Stoking the desire is the publishing industry's need for product. Magazine pages must be filled; books must spew from the pipeline. To move the product, the blurb and inside text better gush. Our current quaalude interlude has served to inflate the size of the volumes and the praise for their producers. Against a featureless background, every detail magnifies in enormity. It's not enough to be an exceptional designer; you must be a latter-day Geoffrey Tory with the contemporary sociological acumen of Marshall McLuhan, or a virtual one-man Bauhaus, complete with their self-promotional vigor.

Recent design monographs reveal what the field values. Also on view are themes endemic to design: the rationalization of personal indulgence into a societal benefit, that mimesis is comparable to creation, gesture can substitute for action, formal facility proves conceptual acuity, and popularity equals profundity.

Leo Lionni crafted an unintentional fable of design in his children's book *A Color of His Own*. In it, a chameleon despairs of ever gaining a distinct and stable identity, as he is forced to blend into his environment. Graphic designers often display similar crises and adopt the mien of their clientele. Often, they go them one worse. Witness corporate designers deporting themselves as ultra-businessmen. Or pop musicians' graphic roadies styling themselves as rock stars.

Bruce Mau clearly wants his book *Life Style* to rest comfortably among the high-culture works he regularly collaborates on. Mau is

an outstanding designer, valuable for his exacting craft, and for being unapologetically intellectual. *Life Style* is welcome just so it can be dropped on the massed digits of design's "I think with my hands" crowd.

In comparison to other highbrow titles, Mau's designs for Zone Books leap out as vibrant, enticing artifacts. However, for all the talk of serendipitous, experimental, content-driven, and contained design, Mau exhibits a formulaic approach to his productions, no matter the medium or forum. As he keeps to a narrow range of clientele, his strategies (restrained typographic palette, appropriated imagery—usually from fine art and technology, exhaustive reproduction/documentation, abecedaria and indices) may be repeated appropriately. Mau does ask authors and editors to accept more design than they're used to. But while introducing some imaginative and expressive aspects to a staid genre, Mau hardly violates classical conventions. Rather than expanding the role of design-as-livery, his productions are like finely tailored, stylish suits.

Life Style is enlightening when it directly addresses design. Mau's conceptualizing on culture, though, is discomfiting. His writing is far less adept than his form giving; he adopts his patrons' sweeping generalities and abstruse prose. The majority of concepts that Mau engages have been in play for many years among media theorists. His engagement with and restatement of these themes are germane. But a sense of déjà vu hovers over the book as similar or identical images and ideas encountered in books such as *Perverse Optimist* and *Pure Fuel* reappear.

The central notion that's unique to Mau is design's need to reclaim a substantial, empowering meaning for the term "life style." Instead of resisting the common depiction of design as a styling process, Mau embraces it. However, his "style" isn't superficial: it's a positive, life-generating operation. Mau hastens through his argument in a few brief and recondite paragraphs then dashes off to other theories. How this new life styling practically differs from the old isn't explained. We

can only assume that Mau (and by extension his clients) practices the virtuous version.

Mau links his proposition with Guy Debord and the Situationists to provide it with a radical, anti-capitalist attitude. The inversion is obviously alluring for designers as it converts stigma to sheen simply by proclamation. But absent a proof, it's wishful thinking. The authority for Mau's position apparently rests with his having worked on books like *Society of the Spectacle*. However meritorious the design—or having read or published the book—may be, such contact doesn't inoculate the principals.

Rather than being "gutted of meaning" in Mau's estimation, the notion of life style was hollow from the start. The term deserves disdain because it ultimately bases fulfillment on consumption. You are what you own, not what you do. Designers are complicit in this process, as they regularly craft veneers of "status value" for products.

Mau and his clientele produce commodities uncertain in use value but high in status. Their own consumption and life styling—lusciously detailed in relentlessly name-dropping "Life Stories" sections throughout the book—is privileged and conspicuous. Redefining the term "life style" becomes imperative, as their behavior is materially identical to one Mau labels "vacuous." His life style allows you to indulge in and consume surfaces (Mau acknowledges his reputation was established by his formal innovation), while asserting you're actually involved in a "philosophic project of the deepest order." You can debate which cover of *Life Style* you fancy without feeling shallow.

Rationalizing your activity as critically acute while servicing privileged interests takes an agility that may be appreciated but not encouraged. Mau is hardly alone here. That our valued practitioners inexorably gravitate toward moneyed culture—fashion, architecture, high art establishments, and so on—reveals their absolute priority: who

can best bankroll my career aspirations? That Mau found a rewarding practice within the jet-set intelligentsia is his good fortune. Offering it as a cultural imperative is something else entirely.

Life Style suggests a critical statement on the "global image economy" but one never materializes. Mau presents it as a spontaneously generated phenomenon that we should "exploit" with "critical engagement." No guidelines are given for what critical engagement is or which design feeds the "downside" of our cultural situation. What we do know is that *Life Style* is surfeited with repurposed imagery and lists at seventy-five dollars.

Life Style is another design spectacle and status asset—a fashion accoutrement like the Rem Koolhaas collaboration *s, m, l, xl*. Mau unintentionally confirms this by twice including a photo of that book being used as a pillow. The image falls flat as wry irony or self-deprecation. *Life Style* is for and about designers realizing their most grandiloquent contrivances without guilt. The ecological, economic, and cultural impact of every similarly motivated artist, designer, or architect pursuing such dreams goes unexamined. Spending twenty-five thousand dollars to reprint a book cover (or having alternate ones) can be regarded either as a "heroic enlargement of work to an ethics" or a flagrant waste of resources. Yes, it happens in design every day. But what is *détournement* without a difference?

Design loves attestation of its heroes and ideology. When designers bring in celebrities to testify to design's import, both get extra credit. Preeminent people who walk into our temple on their own to kneel at the shrine receive our full attention—even when they have little to say. John Maeda puts forth his beliefs simply, pleasantly, and earnestly. Under the aegis of his position at mit's Media Lab, they play as objective, scientific truth. *Maeda @ Media* 's very title asserts he is media. However, for someone touted as a seer, Maeda is a curious throwback

to simplistic motifs on art, design, and technology popularized decades ago. Those themes are duplicates of Maeda's intellectual and formal mentor, Paul Rand.

Maeda @ Media is the book equivalent of a Hollywood blockbuster: long on special effects, short on characterization. Those special effects are somewhat tedious. Maeda utilizes the computer exclusively as a pattern-making device. When used insightfully, repetition can have a deep emotional resonance (hear Steve Reich and Philip Glass). Maeda has the instrument but not the sensibility. His design work is acceptable but undistinguished, adorned with variants of warped grids and default sans serif typography. Rather than announcing new directions, they evince nostalgia.

Maeda's achievement may be injecting sentimentality into the "neutral" grid. Neither his generic printed work nor his derivative conceptualizing offer anything for the cultural artifact that is design. To illustrate the computer's emotive potential, Maeda musters sterile, programmed ornamentation. His posting at MIT speaks more to the Media Lab's inbreeding and comfort with hardware than an ease with and perception of culture. The witty, visually delightful, and politically trenchant work of Amy Franceschini and Josh On of Futurefarmers proposes far more for digital media when it is in the hands of enthusiasts—and everybody else.

Graphic design loves inspirational guides. Case-study tutorials clog the bookstore shelves, most asserting (despite claims to the contrary) that design innovation is reducible to a formal recipe. Even the ostensive monograph frequently turns to delineating how its subject reaches apotheosis, so that others may follow. It is an eccentric conceit of the field that ultimately condescends to its audience. In art, such documents are either obvious parodies or the province of the reader of *American Artist.*

At 1,064 pages, Alan Fletcher's *The Art of Looking Sideways* is design's most massive self-help book yet. The author seems to recognize the messy, transcendent dynamic of inspiration—yet is still moved to represent it in print. To elude this conceptual paradox, he adopts a formless approach. The book is a data-dump of quotations, aphorisms, diagrams, reproductions, commentaries, and folderol. Excess is evidently success.

The patronizing aspect is Fletcher's assumption of massive illiteracy among designers. He obviously believes the average practitioner's ignorance could not only fill a book but necessitates one as thick as a cinder block. The professional blinders widely sported in the field can be maddening, and a broader awareness would benefit design. However, *The Art of Looking Sideways* seems a wild overcompensation. In its enormity—a one-stop cultural supermarket—it suppresses, rather than encourages, individual exploration.

The book's underlying concept, dressed in bang-up graphics, is hoary: inspiration should result from mere exposure to great art, music, or texts. The selected stimuli in *The Art of Looking Sideways* are of the customary motivational genre, presented as one size fits all. The lack of concrete contextualization—how any of this material practically performed in Fletcher's work, or may in anyone else's—makes the choices arbitrary. They function the same as incantations.

Successful people frequently burnish their image. Some elite designers, casting off the stereotype of glorified ad men, posture as scholar-artists. They abstract their process as pursuit of an intellectual purity unaffected by mundanities like clients or careering. Creative genius is all. It is both egotistical and disingenuous to proffer such a selective construct. Though unstated, that's the premise of *The Art of Looking Sideways*, as its existence rests entirely on the author's reputation.

Erudite designers abound (though many are in hiding). A thousand books as worthy as *The Art of Looking Sideways* could be produced. Will

Phaidon publish every one? Or, like Fletcher, will the authors need to commission themselves?

In his book *Fast Food Nation*, Eric Schlosser profiles flavorists—a discreet group of chemist/artists who design the taste of most foods. Their intervention is necessary, as processing destroys inherent taste. Using "natural" and "artificial" flavorings (the definitions are slippery), the flavorists graft a taste onto the food. Schlosser points out that it's just as easy to make your burger taste like cut grass or body odor as it does beef. Graphic designers are often flavorists of print. They inject a factitious aspect of attraction to achieve the natural. Interest can be synthesized and applied indiscriminately to anything.

Stefan Sagmeister's *Made You Look* could bear the title *Every Trick In My Book*. The monograph is a fatiguing compendium of almost every optical, production, and advertising-creative artifice devised since Gutenberg. By deploying nearly every special effect (he refrains from die cuts, possibly as a show of restraint), the pages are full-bleed with desperation to clutch a reader's attention. As the audience is designers, Sagmeister knows they're here for a rush. Boisterous pieces set within a hyperactive presentation make *Made You Look* pure designer crack.

As it promises, the book is a "traditional show-and-tell graphic design book. No revolutions or big theories in here." So begins a running thread of commentaries marshaled to deflect every attempt to probe beneath any of the surfaces. In its infinite regress of self-referential feints, *Made You Look* is graphic design's *A Heartbreaking Work of Staggering Genius*. Both authors wield formidable technical skills to ingratiate and distract from their meager stories.

Sagmeister is a self-proclaimed, old-school, "big idea" designer. If there's an analog to which he's digital, it's Bob Gill. His "STYLE=FART" motto alleges a position of conceptual prepotency over formal-driven practitioners like David Carson and Neville Brody. In the role of

exposition man, writer Peter Hall also credits Sagmeister with initiating a "turning point for the design profession, away from aspirations of digital perfection toward a higher appreciation for a designer's personal mark."

As with other claims of Sagmeister as innovator, this is creditable only if specified to the point of being meaningless. Designers' scrawls are common, and Ed Fella's have proven far more influential and individual. Art Chantry crafts completely handmade work and has been on the scene far longer. And April Greiman flashed us mid-1980s. There are numerous signifiers of "personal" in *Made You Look*, but nothing that is unmasterly or that disturbs the membrane of professional detachment. The emotional exposure is in inverse proportion to the amount of flaunted skin.

Sagmeister is naughty by nature—never transgressive. The big ideas are frequently obvious or hackneyed metaphors tweaking mainstream taste. That their visualization delivers a jolt points up the timidity of most designs. Though Sagmeister doesn't promote a distinctive formal style, his reliance on visual joy-buzzers becomes style in its own right.

His hanging with rockers and the burgeoning back-to-business mentality in design fueled Sagmeister's notoriety. It is his disconnection that endears him to his primary clientele—and the design profession. Rather than exhibiting the demeanor of a "creative crazy person," Sagmeister's work is always controlled and separated from the raw and real. Rock stars must also affect emotion every night on stage and synthesize it piecemeal and repetitively in the studio. Musicians like the Rolling Stones and Lou Reed are consummate showmen who understand how to generate a veneer of passion and get the job done. Sagmeister fits their bills. And he is completely deferential to his clients' wishes—no artiste tantrums here.

His AIGA Detroit poster, where the copy is etched onto his chest, is a signature work. The image is another stratagem that mocks what it purportedly honors. Sagmeister literally only scratches the surface—he'll itch for his art. The box of Band-Aids he grasps is a stagey wink to us: this is only a graphic design. It's a contrivance artificial as anything spawned by software. Supposedly, the image compels because it shows the maker's hand and provokes an "equally physical response." However, an intern was pressed into service to etch the carefully placed, calligraphed marks when Sagmeister balked at cutting himself. The cojones thrust into our face in *Whereishere* are for display only.

The heartbreaking aspect of *Made You Look* is the designer's plaintive quest to answer the question "Can graphic design touch someone's heart?" Curiously placed last on a "to do" list, it's presented as another career aspiration, not a moral absolute. The structure of the question undermines its answering, stipulating medium before effect. It's the difference between having an idea expressed graphically and a graphic design idea. Sagmeister excels at the latter: his concepts grow out of established graphic design expressions. As such, those conventions will always be in the foreground, like a label stating "artificial flavoring." Shortening the question to "Can I touch someone?" may be the needed natural ingredient.

All art and design is a known construct. We may examine the most disturbing imagery because we know it's false. The most affecting work suspends or interrupts that awareness. Sagmeister's virtuosity is his greatest obstacle. He is constantly pulling his own curtains aside so we may view the machinations of illusion.

The relentless questioning of his work's affectiveness while asserting its effectiveness makes Sagmeister and *Made You Look* schizophrenic. Talking passion is hip; exhibiting it uncool. Are the works he rates as "is" in the index examples of "touching design"? Or

does having his "touching" essay as the book's coda—and going on a highly touted sabbatical—mean he considers all his designs to this point crowd-pleasing failures? (If meant as a purge, the book makes a lot more sense.) Or, as is often the case with graphic designers, is he trying to have it both ways?

Usually, an expressed desire to do touching work means the same ol' design—but for a high-profile charity. Sagmeister's talent is such that we should hope he finds The Way rather than just a United Way.

There have also been monographs that indicate healthy routes to a criticism. Poynor's study of Vaughan Oliver, *Visceral Pleasures*, is a lucid and stimulating text. It establishes Oliver as a rare designer by the quality of his work and his willingness to undergo this analysis. Poynor argued for, and received, a restrained presentation from Oliver for the book. While the approach is debatable even if you don't require graphic fireworks (Does restraint actually allow an objective, considered view, or does it adhere to a convention of seriousness?), the resulting book is a powerful convincer, as it should be. At the least, it's a refreshing respite from over-stimulated—and ultimately insecure—offerings like *Made You Look*. Oliver may be the one contemporary designer with the right to proclaim that he's a fucking genius. *Visceral Pleasures* also proves he's the bravest.

Julie Lasky's *Some People Can't Surf: The Graphic Design of Art Chantry* is a "traditional show-and-tell graphic design book," only with assurance and professional standing. Chantry's work is original and rich enough to support deep inspection. However, considering its maker, the book's appreciative yet straightforward approach is fitting. Lasky provides illuminating background on the designer and for individual works. Chantry's book design allows that work to speak for itself, and reflects his sensibility. *Some People Can't Surf* is succinct and profound.

The appearance of the "attempted magazine" *Dot Dot Dot* is another encouraging sign that design writing can be eclectic, thoughtful, and imaginative. The journal proves there's plenty of unexplored territory for design investigations and the forms they may take. *Dot Dot Dot* provides what *Trace* promised. The question is if the magazine can find the audience it deserves.

We may be at a stage when all formal innovations have been exhausted: postmodern postscript time. There is no dominating formality or ideology to produce design. A congeries of theories and practices transcends physical borders. This leaves us with the final and central concerns of improving design, which are extra-design. For the majority of designers, their activity is a job, a service. To change how they do design, you must change the conditions under which they work. A renovation of capitalism and consumer society is not on graphic design's agenda.

Debate briefly arose around the revisitation of the "First Things First" manifesto. The original, Ken Garland–penned declaration was issued in 1964 and signed by twenty-two British designers. *Adbusters* magazine initiated a restatement in 1999 with thirty-three American and European signatories. The manifestos advocated a change in designers' professional priorities, toward a socially conscious practice that challenged rampant consumerism: "We propose a reversal of priorities in favor of more useful, lasting and democratic forms of communication—a mindshift away from product marketing and toward the exploration and production of a new kind of meaning." (FTF 2000)

The turbulence provoked by the statement demonstrates that actual questions were asked. The manifesto was confined somewhat by being a top-down action; however, it's incontestable that the signatories could exploit their talents to greater profit. And *Adbusters*'s addition of a webpage where anyone could sign on brought it to the trenches.

The swift passing of the debates over First Things First is its most disquieting aspect. For many, to raise it at all was an annoyance. Outright dismissals of the manifesto as naïve, elitist, or (at best) impracticable were unsurprising. When you're gaming the system, there's little incentive to change the rules. A startling cynicism was often exhibited under the guise of critical limpidity or pragmatic sobriety. It sadly dovetails with the broader societal conviction that idealism is for chumps.

Every assertion should undergo critical scrutiny. But responsibility accompanies dissension: the duty to advance discussion and promote increasing dialogue. Only if you've announced your support of the status quo—and a disinterest in the lot of the less fortunate—do you get to hit and run. Directing a discussion is seemly, squelching it isn't.

The change of *garde* in design has been recent; folks are barely getting settled in. And there aren't many of them. Add to this the fact that you can't control how people interpret what happened. In design, the surface is all that counts.

Design could be a significant agora of discourse, more so than art or other creative disciplines. It's situated closest to the intersection of culture and commerce, the individual and society. What seems at first unwieldy—trying to forge a criticism to reconcile, let's say, Elliott Earls's *Catfish* and a bus schedule (or an annual report or a brochure or any familiar artifact) is design's potential. Sometimes it's realized and it's a revelation to the eye's mind.

The friction between personal investigation such as *Catfish* and public practice (e.g., information graphics) alone is daunting. Positions are frequently staked in one or the other camp and pursued as ends in themselves. Rather than endpoints on an axis, they act across a field of activity that is design. A considered contemplation of how they inform, inspire, and rely on each other is required.

The ultimate disappointment today is that a campaign for critical thinking must again be mounted. We might remember an admonition of Socrates, "The unexamined life is not worth living." An unexamined design isn't worth doing, or seeing.

In the quiet, strange things happen. We think we hear endless, thunderous applause, and steadfastly congratulate ourselves. Breaking the silence could make us realize we're hearing only the roaring of blood in our ears. ✦

Amplifications

On Creem *Magazine* 1970–1976

Since *Creem* was a rock 'n' roll magazine, you know the risk I'm taking here in celebrating its 1970s glory days. That's right—the boring old fart factor. Some aging guy swoons over an artyfact of his bygone youth, boring an audience with different, often younger, experiences. He imbues the love-object with enough aura to outglare the noonday sun—which then toasts and warps all those headed-to-trade-in LPS stacked in the backseat of his car. The ecstatic wax starts flowing, but for you, the illumination is no better than candlelight. I know the way by heart; you're all stumbling over mental furniture. While I promise this isn't a complete nostalgia trip, the essential argument is personal.

I won't be placing Creem on any sort of pedestal for you to admire. If anything, it's the stray trash blowing 'round the foot of the pillar. I'm only mildly regretful at tossing my old copies. But it immediately came to mind for this article. While one prominent, obvious reason for the choice presented itself, there had to be more. I began writing this as much to discover why I chose *Creem* as to explain.

The foremost reason I value 1970s-era *Creem* magazine is that it was the first home of writer Lester Bangs. When people list rock 'n' rollers cursedly cut down in their prime, I always include LB. And right up at the top, too. He's alongside those flawed heroes he so insightfully and movingly eulogized: Lennon, Elvis. That's how important he was for critical writing on popular music and the culture that surrounds

it. To write about music culture is to write about our entire culture, and he pegged it regularly. Read "Where Were You When Elvis Died?" (published not in *Creem* but in the *Village Voice*—he had moved on and upward) and you get a succinct and insightful description of the postmodern condition in human terms.

I would direct anyone who loves great writing (and/or music) to Bangs's posthumous collections, *Psychotic Reactions and Carburetor Dung* and *Mainlines, Blood Feasts, and Bad Taste.* In their introductions to the respective volumes, editors and friends of Bangs Greil Marcus (author of *Lipstick Traces*, a landmark consideration of music and culture that owes a great deal to Bangs) and John Morthland contribute more comprehensive portraits of Bangs than I could hope to provide (plus, we now have Jim DeRogatis's excellent Bangs biography *Let It Blurt*). Mostly, the books contain a cross section of writing that is unmatched in its passion, insight, and honesty.

When I'm writing—particularly something like this—it's Lester Bangs's echo I'm chasing. Our lives are entirely dissimilar but there are aspects of his personality with which I strongly identify. One is a conviction that you must give everything a hearing—especially "low" culture detritus like pop music. Lester said it was okay to find profundity here and regularly revealed it. He expressed how and why these rattles and hums generated by frequently tawdry, egotistic, arrested-development cases add vital elements to life. And yeah, may even provide life's meaning. (See . . . rock 'n' roll isn't so different from design.) What I emotionally connected with in Bangs's writing was—unsurprisingly— his irreverence. Unsurprising because he was the king of rock 'n' roll disdain for pompous charlatans and going-through-the-motion hacks. His bona fides in this area were impeccable: banishment from *Rolling Stone*'s review pages for six years due to insufficient respect for the lower-case lords of the new church.

Mocking rock star conceit provides ready, crowd-pleasing material (see *This Is Spinal Tap*). However, Bangs, though pessimistic to the point of occasional fatalism, wasn't a nihilist. He impressed upon me that irreverence contained reverence. It was because we loved these things so much that we questioned them so closely. You needed to keep a check on your passion so you might see clearly . . . and guard your heart from the disappointment that often comes from worshipping mere people. With the adulation of millions, your heroes may forget they're human, but don't you dare make that mistake. Take the work seriously, not yourselves.

There is more to *Creem* than Bangs's writing. He was, however, the dominant, defining voice. The magazine was somebody else's band, but Lester was the star writer, arranger, and player. He wrote features, record reviews, photo captions, and replies to readers' letters. His attitude pervaded the magazine. That attitude extended to design issues. Many of these things I feel are lessons to the designer, though more subtle than discussing layout approaches.

One idea Bangs had was that every aspect of the magazine could be up for reinterpretation. Like photo captions. Bangs labeled snaps of rockers and amplified whatever buffoonery or falsity (real or imagined) he found there with a choice inscription. Here was text and image playing off, reinforcing, and recontextualizing each other. Many of those pix were nondescript, but Lester found something to focus on and remix. For me, this was instruction on how the radical could lurk in the mundane. A photo caption could cut deeper than a novel.

There was pastiche: the regular Boy Howdy profile that lampooned the Dewar's ads, and the stars who consented to clutch the Boy Howdy can. Back then, I didn't know if Boy Howdy was a real drink. I suspected it was some quirky-smirky Detroit reference to something (what else) sexual (turns out it came from notorious

cartoonist R. Crumb, was a milk bottle, and constituted an "old Southern greeting"). The ads went beyond parody by engaging the musicians in the process of their defaming.

When regarded in standard formal terms, there isn't much—if anything—to value in *Creem*'s pages. The layout was of the slap-it-down/move-it-out school: garish color cover with tubular-phallic logo, B&W newsprint pages, lots of Souvenir type. There were, however, touches that broke down an off-the-shelf design.

Creem had a table of contents and departments, but wasn't very strict about organization. Record reviews seemed to sprout up everywhere. You thought Lester's opinions were crap? Well then, just flip back to "Rock-O-Rama" for those capsule ratings. It could all be rather free-form. Close enough for jazz—or rock 'n' roll. Deliberate deconstruction or deadline pressure? Surely the latter, but it ends up the same. *Creem*'s look was consistent with rock 'n' roll in the 1970s and its place within the system. Professional but loose.

A steady dosing of irreverence was in order for rock. The music was barely into its twenties and already showing early onset of Alzheimer's. Corporate rock was suiting up. Rather than fighting the power, our rebel angels were stroking the gabardine. *Rolling Stone* was still a must-read, though developing a high fawning factor. *Hit Parader?* Please. *Billboard?* If you're into stats. *Creem* was the garage band of music magazines. They practiced but occasionally wandered from the arrangement. They were as tight as they needed to be to get your attention.

Bangs left *Creem* and freelanced for a variety of journals. I found him in *Crawdaddy*, a smarter, mature *Creem* (sounds like an oxymoron), and read it regularly until it folded. *Musician* magazine arose, and there was Bangs—continuing his support for the misunderstood, unappreciated genius—with a definitive profile of Brian Eno. My visits to the newsstands became a Where's Lester? search through everything

music-related. And then, in 1982, the news came of his accidental death. Somewhere along the line, *Creem* died too.

A few years ago, *Creem* reappeared with Marvin Jarrett as editor and Gary Koepke as designer. I got a small thrill at seeing it transformed and on the newsstand again. The short-lived new *Creem* looked much better but was, ultimately, just another 1990s music magazine. It was like a band reforming to capitalize on nostalgia. I realized that brief thrill was my subconscious thinking that Lester had come to life again. But he hadn't. I put the first issue down and never looked again. Jarrett moved on from the former land of Bangs—pushing the envelope of magazine writing—to start *Ray Gun*, land of Carson and . . . you know the rest.

I miss Lester and wish he were writing today. And I wonder how his words would have looked on the pages of *Ray Gun* or *Speak*. We know how those *Ray Gun* texts were never as challenging as their designs. The authors were frequently Lester Bangs wannabes, commanding only a single shot from his devastating arsenal. I fantasize (rationalize?) that Lester would have been hip to those aggressive design approaches and attempted to drive them further. He'd blaze outrageous words for the trailblazing treatments! This unreasonable guide to horrible noise wrote (to quote the *Psychotic Reactions and Carburetor Dung* cover blurb attributed to the *New York Times*) "in gusts and swirls and pratfalls." The variegated typography of Carson or Venezky might well suit Lester's many moods.

And while I'd enjoy seeing some of Bangs's past words reinterpreted this way, I don't think *Creem* would have been improved any by a "better" design. I suppose what I read into *Creem* (and had reinforced from other influences) was the hidden, subversive power of the ordinary. It isn't always the wild, experimental things that inspire. And thinking of this, I stumbled across why I selected *Creem* as the magazine that influenced me the most. It was the high-school magazine I worked on and entirely forgot.

In my senior year, with a couple of friends and a rogue faculty advisor (a math teacher), I helped turn our moribund Haverhill High School newspaper (the *Brown and Gold*) into a magazine. Our serious reporting mixed equally with Monty Python–ish gags. It was, in a word, irreverent. Qualitatively, it wasn't so far from *Creem*—a national magazine. I noticed this. Given the opportunity, anything might be possible. It was my first published writing and design. Looking back, I was in my element and can only wonder why it took so long to get back.

When it came time to choose the after-high-school direction, I was presented with a choice. I could write words *or* arrange them on a page. For me, separating these pursuits was like splitting twins joined at the head. I sought someplace where this condition looked good—or was no odder than anything else you'd see. It was more fun to hang around the art department than the English one. And a "commercial art" career looked, at best, stultifying.

Later, as an undergrad in art school, I voiced the conceit that I would someday publish the *Creem* magazine of the art/culture world. Big talk from a ceramics major. I'd champion the neglected, expose hypocrisy, deflate pretension, and generally wallow in my love/hate relationship with the creative process and its processors. That particular theme got sidetracked, but the desire to do-it-myself obviously hasn't. Most days, my fantasies are modest. I imagine the blurb now: "America's best writer reviews for an obscure design magazine!" You laugh, but stranger things have happened . . . though I can't think of any.

I wouldn't argue that I read a lot into *Creem* magazine. Perhaps the reading-into process is what's most important. I could throw those old copies of *Creem* away because I had internalized the attitude, the understanding. That's the true magazine. I say the same for these rarer, carefully conserved journals in my collection. What is being saved when we preserve these artifacts? Isn't it all personal? Maybe it'd be better

if all this printed matter decomposed quicker. Monthlies evaporate after thirty-one days. Time would be really be history after a fortnight. *Emigre*—gone south with the next turn of season! What would our design be like if printed with secret-agent fading inks? We'd be left with our memories. Maybe we'd then see a real plethora of approaches. Or the wheel constantly reinvented . . . if we're not there already. There's plenty of work I wish would fade away—mine at the top of the list.

What makes us hold onto these things is aura. Aura is an object's ineffable attraction beyond its physical qualities—its history, pedigree, associations, and reputation. You never know where it adheres and why. This is a real concern for designers, who usually labor to generate aura through formal means. The reading into concept drives most of them nuts. You can't specify it. Like Robert Pirsig's Quality (and perhaps they're the same creature), I think there's an aura event apart from the producer and the produced. Some people have the receivers in their heads; when tuned to the right frequency, they pick it up.

It's a mystery what will inspire people. Adventures close to home may be just as exciting as travels at the edge. I really don't know how you deal with it other than acceptance. And keep working.

Today, I see the spirit of Lester Bangs and *Creem* scattered throughout hundreds of zines and small magazines. It's why I'll pick up anything, look at it, and read it. Every so often, something strums that chord—the words, the look, the 'tude—and I add it to the collection.

You can tell—and you never can tell. ✦

My Two and Only

There is a marvelous peace in not publishing . . . I write just for myself and
my own pleasure.
— *J. D. Salinger*

Let's sing in praise of the one-hit wonders. As reprise, the two. This
could be their time.

That interval may be Andy Warhol's famous fifteen-minute
dictum—in its original intent. Warhol was guesstimating the egali-
tarian measure. If everybody gets some fame, how long will the average
lime-lightning be? The quip, however, is regularly employed as a put-
down. Someone's notoriety is being designated cheap, manufactured,
temporary. All three terms are arguable but I'll focus on the third. What's
wrong with having—maybe even seeking—transient renown? Don't
game Warhol's clock; let it ring for thee.

Trouble is, there's an inconstant onus of only, depending on
the discipline. Success can be a cruel trap. Having only one hit can
be worse than having none at all: a repeat is necessary. Do you have a
second act? How about a third? We reserve special scorn for the one
singular sensations. (Where are they now?) Still, you might have that
second act—then call it quits. How much do you have to have been to
rate standing as a has-been? Is there an interzone between upstart and
enterprise? Is three times the charm?

Should our definition of what constitutes creative success involve
a quota? One-hit wonders inherently give us just that. Sustained

notoriety—not simply activity—is what separates an artist from a flash in the pan. Should judgments get made on that recurrent hit scale if the artist doesn't aspire to repeat the triumph—or to have even sought the Big Time? Does every marketplace bid require going all in? You might only pursue celebrity to avoid the pigeonholing if you don't.

But that will turn and bite you in the ass. Tales of fruitless attempts to recapture a single glory are a staple of drama. They alternate with narratives of pathetic strivers perpetually reliving their one triumph. That peak, no matter the conditions of escalation, defines their entire career. That career can be long, with considerable output. What particularly interests me is the short end of scales. I've focused on novelists that in their lifetimes published only one or two books, and musicians that released a sole or pair of studio LPs.

The connection is, I admit, tenuous—probably ridiculous. I'm eliding disparate issues that led to the various artists putting only one work into the marketplace. And, of course, there are the problems of comparing a group situation with that of an individual's motivations. Fortunately, I'm not doing research. It's an aimed diversion—close enough for rock 'n' roll.

This pursuit is part rehabilitation project and part personal rationalization. My chosen career was art but I had ambitions as a writer. To develop ability in either discipline (or to, ideally, fuse them) would take time. Worse still, my writer heroes included Annie Dillard (two novels so far) and James Agee (one: *A Death in the Family*)—not known for their prolific output. To divide my practice might preclude building up standing in either area. Yeah, celebrity in one media frequently offered the opportunity to extend the brand to another.

I hoped for an extended art exhibition record but was content to just get to that one book. But would it—and I—be taken seriously? Fortunately, as an art student in the early 1980s, I was heavily influenced

by the DIY aesthetic of the punk era. At that time, performers flared up out of nowhere, burned brightly, then blew out. So what if they (me!) didn't sustain a career? Did it make the work they (I!) produced any less compelling? Maybe it should count for more.

Between music and fiction, the latter seemed the place to be solitary. Reputations aren't damaged by never producing a follow-up. It's either ranked a shame (could, but didn't care to, or had nothing else to say), a tragedy (died), or a psychosis (paralytic perfectionism). Ask Emily (*Wuthering Heights*) Brontë, Margaret (*Gone With the Wind*) Mitchell, Ralph (*Invisible Man*) Ellison, J. D. (*The Catcher in the Rye*) Salinger, Harper (*To Kill a Mockingbird*) Lee, Richard (*Been Down So Long It Looks Like Up to Me*) Fariña, or John Kennedy (*A Confederacy of Dunces*) Toole.

Just this short roster contains a variety of motivations (or lack thereof) to publish second novels. One labored for years over a successor (Ellison, technically still unfinished after 2,000 pages but published posthumously); two died (Fariña, Toole—accident, suicide); and four were content to stop at the one (Brontë, Mitchell, Lee, Salinger—though he's reportedly written others he doesn't deign to publish). Of course, this listing is arbitrary as some—Ellison and Salinger—produced other books, just not novels.

Finding candidates for my two-book limit means finessing the qualifications more than isolating writers with only one. And the cause is more likely to be fatal. David Foster Wallace's suicide sadly puts him on the inventory. Susan Sontag produced two novels among her distinguished nonfiction oeuvre. Some we might anticipate. Dillard recently published her second novel and has indicated it's likely her last. Marilynne Robinson seemed like she wouldn't get beyond *Housekeeping* and *Gilead*, but has delightfully struck herself off my list with *Home*. The unique nature of *Zen and the Art of Motorcycle Maintenance* (Memoir?

Philosophy? Travelogue? A science fiction book reviewer made a compelling case for it belonging in that last genre.) will fudge it onto my list. *Zen* didn't readily suggest any kind of follow-up by its author. The only possibility was the one Pirsig realized: returning to his life to frame an examination of morality in *Lila*.

While "one-hit wonder" was coined for, and is usually descriptive of, single-song successes, LPs became the dominant popular music delivery system in the late 1960s. As a cultural entity, it's comparable to the novel in that it's a long-form, conceptualized statement. A solo novelist isn't as rare a phenomenon as a music act with one album, due to the unique mechanics of the process. Musicians often come into the studio for the first time sporting a repertoire of songs sufficient for two records. However, there's enough that don't to have given rise to the term "sophomore slump." Also, while labels always reserve the right to drop an act, contracts usually cover multiple releases.

Stiffing on your first release is the sure way to trigger the drop option and is the most common reason for a single album. Often, the labels cause casualties through poor promotion or distribution. Bands also get caught in corporate management turnovers (the A&R guy who signed and championed you is fired) or are assigned an unsympathetic producer. My hometown Boston favorites, the Atlantics, never got over being dumped after the failure of *Big City Rock* (the outstanding demo collection that would have comprised a second release was twenty years too late, and worth the wait).

I may have gotten fixated on single LPs because of the short shelf life of many local bands in that punk/new wave era (some have since reformed): Mission of Burma (one), Nervous Eaters (one), the Zulus (one), Human Sexual Response (two), and Robin Lane and the Chartbusters (two). Beyond my immediate horizon were a host of other bands that fizzed up then flatlined in the ferment: Richard Hell and the Voidoids,

the Dead Boys, the Slits, Fun Boy Three, Fine Young Cannibals, Medium Medium, Romeo Void, Pearl Harbor and the Explosions . . .

Joy Division is chronologically on this register, but dissolved due to the suicide of lead singer Ian Curtis. It's arguable if this counts as deliberately breaking up the band. Prior to Curtis's death, the leading cause of unintentional career-termination was drug-related. RIP Gram (*G.P.*, *Grievous Angel*) Parsons and Janis Joplin (two under her own name). Accidental death is ever-present, with death by drowning claiming former Beach Boy Dennis (*Pacific Ocean Blue*) Wilson, and Jeff (*Grace*) Buckley.

The Sex Pistols are the ultimate of the one-time-only category (as with other groups mentioned here, we ignore the endless vault plundering that followed). What follow-up to *Never Mind the Bollocks Here's the Sex Pistols* was possible—or necessary? Was the band going to hone their craft? Rebooting in a new direction was the only option, as John (Rotten) Lydon did with Public Image Ltd. (Lydon ultimately went literally solo with one LP—*Psycho's Path*—under his own name.)

Together with the archetype of the genius dropped due to poor sales, there's the perfectionist who can't (or won't) deliver the goods. Mania, either real or perceived, can derail sequels.

The La's have yet to produce a sequel to their 1990 eponymous debut. La's leader Lee Stivers repudiated the entire album, assembled by their producer after the band abandoned the recording sessions. Some twenty years later, Stivers insists that first album be rerecorded before coming across with another. (Ironically, the original CD has recently been rereleased in a remastered version, with bonus unsuitable tracks.) My Bloody Valentine, meanwhile, has been stuck in a seventeen-year groove after their critically acclaimed second album, *Loveless*. Its storied history involves reportedly costing £250,000 over two years to record. Mastermind Kevin Shields keeps rumoring, recording, and rejecting a third.

Lastly, "supergroups" form a special category in the single/ double roster: Blind Faith; Crosby, Stills and Nash; Crosby, Stills, Nash and Young; the Stills-Young Band; the Bunch; Power Station; U.K.; the Traveling Wilburys; the Firm, Little Village, Velvet Revolver, the Thorns . . . I'm watching you, Raconteurs! Many are intended as one-off jobs. Otherwise . . . egos and scheduling. And, always, drugs. (We could also describe a novelistic "supergroup" category, featuring such curiosities as the 1969 novel *Naked Came the Stranger* by "Penelope Ashe.")

If I cared to turn this into a music geek-fest, I could pad my numbers by arguing what defines a "real" group. For example, setting aside the rotating roster of bass players, the "original" Roxy Music with Brian Eno lasted only two LPs. The original Pink Floyd dissipated after one (actually, one and three-eighths). I could squeeze in Big Star, who lost Chris Bell after the punningly titled *#1 Record*. Bell also leads me to another, related specialist category: major talents who only released one outstanding, posthumously assembled LP (see also: the Modern Lovers).

This may be the one-hit wonders' time, due to the changed music industry landscape. The old major-label hegemony has been stressed with new avenues of production, distribution, and promotion available to aspirants. Despite cutbacks, major labels will keep throwing product at the public to see what sticks. Whatever fails to adhere and slides down onto the floor—either slowly or on a bounce—will be swept away.

There's also more opportunity for borderliners (or below) with the collapse of the majors' centralized commercial determinism. If you can't deal with an indie label somewhere, release it yourself. The economic risk for subsequent albums is reduced—but never eliminated. Contenders will stick it out longer, while those who would have been rejects under the old regime will give it a shot. The flip side is that bands have regrouped after a lengthy hiatus (often with substitute

personnel, as various original members are deceased or in steadfast retirement). The risk to my eccentric number theory isn't as significant as the reputations at stake. (Please welcome back the New York Dolls! Well, their second LP had its problems too...)

Our supply of one-hit wonders is secure for the foreseeable future. Publishing is also being transformed by on-demand printing, creating new opportunities for writers. This is all good news, as it provides a measure of creative composting. A balance is needed to the artists that have outstayed their welcome, and whose work has devolved into formula. Among the misfortunes, the commercially challenged, the corporately cursed, the feuding band members, and the uncompromising, it's amusing to fantasize that there are good examples—acts that knew when to quit. Just as there are talents that require maturation, some are in need of an expiration date. Now, if we only knew who needed that time stamp and if only they would apply it to themselves...

Transience should be a valid creative option, if just to provide an alternative to begging after history. If my diversion here proves anything, it's a distinguished category. Maybe one-hit wonders are overdue for a cultural upgrade. It may already be in play.

Recently, I was cycling through the TV channels, and paused on an infomercial shilling recycled 1950s tunes (I always stop for pop). To my bemusement, the CD collection was titled... *One-Hit Wonders*. Had the expression been neutralized while I wasn't looking? Or was this an overt attempt at reprogramming it, like gays adopting the pink triangle? Unlikely. It was the marketers who came up with title. They likely found it simply descriptive and catchy. Perhaps it was resignation. Still, I briefly enjoyed imagining comrades in my one- or two-time fifth column. ✿

12² *Sound*

With apologies to the band currently carrying the moniker, the Beatles should have called themselves the Killers. In their short existence, they managed to blow away two major cultural forms. And they offed both in a single felling swoop—one you could dance to!

When the Fatal Fab Four started out, their name was fitting: a punny twist on rhythm generally and an admired American band (Buddy Holly's Crickets). Their music was simple, direct rock and roll—two guitars, a bass, and drums. For sonic color, John would blow some harp. Soon enough, they start to experiment and elaborate on that foundation with exotic instrumentation, studio trickery, literate lyrics. Then their name became a quaint millstone.

But for all the music lovers who revere them for expanding rock and roll's possibilities, there are purists who say they slew the form outright. They led the way for rock and roll to morph into rock, setting the stage for outrages like art rock and disco. (Well, maybe we can't blame them for triggering the second one, but ... you can play anything, just don't play "Goodnight Tonight.")

The infamous scene of the crime was well-lit and crowded with a Who's Who of witnesses (from Hindu guru Sri Yukteswar Giri to Shirley Temple): *Sgt. Pepper's Lonely Hearts Club Band.* Though as a title *Revolver* would be apt, that LP didn't have the same impact or sense of complete departure. After this record, music wasn't going back. Plain four-square-beat rock and roll became archaic, a folk music.

And it turned out that *Sgt. Pepper* was the site of a double homicide. While the disc scratched out true rock and roll, the album cover murdered painting.

Sgt. Pepper was a transformational phenomenon for two major cultural mediums. It's telling that the Beatles turned to artist Peter Blake for their sleeve. They needed an artist to abet putting a hit on art. Poor Peter didn't realize that in elevating the graphics, he would bring down art. The fine art world, plus everyone outside, was unaware of what had happened. It was, ironically, a silent coup. Canvases weren't removed from gallery walls and album covers put in their place—though that would come soon enough. But painting now took a backseat as the source of culturally relevant and influential imagery (it's arguable how dominant painting actually was before then also). No matter how big the reputation, no artist could have enough exhibitions to rival the exposure of even a moderate-selling LP.

It now does more for fine artists to have their work on album covers than it does for the musicians. Cultural cachet was running in the opposite direction. Popular music was far more central to public cultural life. Kids who, like me, never went to an art museum or perused art books, had—and revered—record sleeves.

Album covers were completely contemporary artifacts. To maintain some consequence, painting frantically modified its materials, surfaces, and shapes. It was trying to be something else. Album covers were already alternative and urgent. They were naturally and expressively mutable—different paper and board stocks, single pockets, gatefolds, double pocket gatefolds, wallets, inserts, die cuts, embossing, and so on—all the delights of industrial printing. And we haven't even gotten to the imagery and text printed on the surfaces. And in multiple. And affordable. And delivered to a funky record shop or bland department store near you.

In graphic design history lectures, I use *Revolver* and *Sgt. Pepper* to illustrate the transition from modern to postmodern. Prior to *Sgt. Pepper*, album covers were regarded as simply another package. They were designed according to modern principles, as any container might be. On the front, you place a flattering, identifiable photograph of the product, be it beets or Beatles. That's the "seduction" side. On the back, you put the credits—the stage for pure information design. Plain white background. Check. Black-and-white photos. Check one. 100 percent black basic sans-serif type. Check two. Grid layout. Check check. All the Beatles' LPS prior to *Sgt. Pepper* are virtually indistinguishable from one another unless you read the text. (The iconic Blue Note jazz sleeves by Reid Miles are additional examples of the modern layout format.)

Once again, *Revolver* was the precursor, foreshadowing the upcoming stylistic break. Its front cover is a collage illustration (tiny pictures of John, Paul, George, and Ringo are scattered through the group's hand-rendered hair)—replacing the objective and neutral photo—by Hamburg friend and artist/musician Klaus Voorman. Typographically, the flip side is in keeping with all the previous sleeves. However, text is reversed out (which is, in this context, high drama) of a black-and-white band photo that bleeds to all edges.

After *Sgt. Pepper*, the Beatles turned again to a fine artist—Richard Hamilton—for their next LP release, *The Beatles* a.k.a. "The White Album." Though not meant as such, the sleeve concept was an antipackage, an affirmative statement that the wrapping was ultimately irrelevant with them. It's the Beatles—they could sell a couple million even if the cover . . . was . . . blank—hey!

With the psychedelic era of music and sleeves at full flower power (helped in no small part by the Beatles), Hamilton shrewdly advised them to repudiate it and go for stark, minimal, blank white, with just their name embossed on the cover. After that, they turned

the concept inside out for *Abbey Road*: no title or band name on the front, just a photo of the group.

Sgt. Pepper wasn't the first genre-defying album cover. *The Velvet Underground and Nico* always demands mention, with its peel-off banana cover. However, it functioned, as intended, as another Andy Warhol artwork. And it had nowhere near the sales. But it undeniably contributed to the shift.

Album covers became another playground of one-upbandship (the Rolling Stones countered *Sgt. Pepper* with *Their Satanic Majesties Request* and its lenticular cover image), and a platform for the musicians' creative declarations. Bands seeking to announce their idiosyncratic or innovative musical tendencies could do so through their sleeve art.

Assisting the bands are new specialist practitioners working primarily or exclusively in sleeve design. Many fall into the career as friends of the musicians or through managing them. Some even have some art training. To the wider graphic design world, it's a fringe market, populated by fringe characters (meaning a healthy representation of current and ex-hippies). Like the music itself, it's a youth-oriented business and sustaining a career is tough.

But a group of designers have been able to carve out niches and gain recognition for themselves and their work. Through the indulgence of adventurous record labels and bands both big and small, these sleeve auteurs—such as Roger Dean (Yes), Hipgnosis (Pink Floyd, Led Zeppelin, Paul McCartney, Genesis, et al.), Barney Bubbles (Hawkwind, Stiff, Radar, and F-Beat Records), Malcolm Garrett (Buzzcocks, Magazine, Duran Duran), Peter Saville (Joy Division, New Order, Factory Records), Barbara Wojirsch (ECM), Vaughan Oliver (4AD), the Designers Republic (Warp), Me Company (Björk)—are able to develop oeuvres that designers in other areas can only envy (the recompense, however, leaves much to

be desired—like a living wage). Certain labels become identified as much for their inventive packaging as their musical offerings—to the occasional displeasure of musicians on the roster. Most album cover designers are British (such as those listed above), as that marketplace allows smaller labels to flourish. Daring design distinguishes the product and proves a commercial benefit. Corporate music culture in the United States squelches audacity when- and wherever possible.

For the generation of designers now of age and commanding the field, album cover graphics are the defining, inspirational form. It was what led numerous practitioners to the discipline, where they fanned out across the field. Album covers were a kind of gateway drug to graphic design.

For the previous cohort, the coolest gig around was corporate identity. While the money there was still good, the association wasn't. Corporations fell behind the curve of graphic trendsetting (they hired David Carson after he accumulated enough music biz–related cultural cred). Moneyed culture stepped up big time to fill the void—with LP artists in the lead.

Sadly, what really signaled the role that album art played in graphic designers' lives was the passing of the format. The introduction of the CD ushered out the beloved twelve-inch square canvas, shrinking it to less than half. Lamentations from graphic designers (and album art fans) have lessened in frequency but not intensity over the demise of vinyl. Happily, this has brought focus to masters of the form, revealing them to be overall exemplars of graphic design. The aforementioned Barney Bubbles is a recent example of a formerly obscure but influential practitioner gaining deserved attention. Bubbles (born Colin Fulcher) was the definitive album cover designer, endlessly inventive and astoundingly prolific. He set a standard of creativity that few designers in any area of the field can match.

Signs of the album cover's centrality to cultural representation—beyond influencing graphic designers, not a small thing in itself—can be found in fine art. Multimedia artist Christian Marclay used record album covers to create his *Body Mix* series of collages/constructions. He stitched together sleeves to form Frankenstein creatures of different body parts: Michael Jackson's head and shoulders from the *Thriller* gatefold segues into the torso of an unidentified unclad woman from another sleeve, which terminates in the leg of the model from the first Roxy Music LP. The covers allow Marclay to comment upon advertising and commodification generally in society, and in the music industry specifically. His materials are readily accessible—physically for him as source material and also intellectually for an audience.

The anonymous artist Mingering Mike also invoked the resonant power of the album cover, but from another direction. From 1968 to 1976, Mike—an AWOL GI hiding out and doing odd jobs in Washington, D.C.—fashioned a rich fictional identity as a musician through hand-drawn record covers (and the discs themselves—he cut cardboard in circles and painted in the grooves). He conjured up a meticulously realized, eclectic career through the fantasy sleeves, one that echoed developments in music and design. The Mingering Mike collection, which included more than fifty LP "releases," went deeper than childish dress-up. It comprised a kind of novel in record covers: a thoroughly postmodern fiction. He understood that music was as much—if not more—image as sound. Crafting a convincingly detailed simulacrum of musicality rendered the actual recordings unnecessary.

Such usages aren't affirmation for album cover design, simply more awareness on the part of artists and audiences about where the creative action was. Since the demise of the LP as the primary vehicle of music delivery, album art has turned moribund as a cultural force. It's unlikely that CD packaging will have the same significance for the

generation of designers that will supplant the current establishment. The internet or gaming may assume that role.

Then again, there may be no design artifact or concentration that is a successor to the album cover. Proclaiming "lasts" due to the impact of digital media has become commonplace and facile. And those in the superseding chute often turn apocalyptic in their (dis)regard for the agents of change. However, the motivating factor here may be graphic design's increased recognition as an activity. Students pursue careers in graphic design for its own sake—the specific application will be discovered during their study.

Yet the full splendor and mystery of the vinyl record album was the sound + vision dynamic. Music and sleeve might be complementary, contradict each other, or go off on separate tangents. There were two imaginative worlds to be drawn into, locked in orbit together, not always facing.

Vinyl still has its adherents—even among young musicians— and some artists insist on companion LP versions of their recordings. Attractive as some of these sleeves may be, the medium no longer has immediacy. It's a retro stance. Still, the album covers from those immediate times remain with us, retaining and extending their considerable ingenuity and wonder, no less than the music they enclosed. ✤

Music for Markets

A number of cultural concerns arise when considering independent music labels—small-distribution, low-profile creative forums. The first, and likely most profound, is a question of how value is established. In the music business, high stature is given to artists who possess a major-label contract. It's a given: everyone wants to be in the Big Time. Many of the perks are obviously advantageous and concrete: large budgets to produce your music, promotional capabilities to make listeners aware of its existence, and distribution networks so it can be easily purchased.

There is also a significant intangible benefit: the legitimacy of having Made It. This self-fulfilling status comes only tangentially from the subjective quality of the music. Considering the significant financial investment a major label is making in signing an artist, to do so is understandably seen as a mark of seriousness. The logo of a major label on a release is an imprimatur. So, inevitably, validation resides in terms defined by corporate music. Supporting and advancing this power is only good business for the major labels (as it is for majors in all the arts industries). Having the resources to spread their values, it becomes natural to regard this as given: major labels have the major artists.

When a creative endeavor becomes a product, profound changes occur in the activity and the product. The interests of the activity (what music demands) can be distinct from that of the product (what the market demands). And when a corporation is involved, the distinction is greater. For them, particularly in this era of megamergers, investment

in product demands steep returns. Selling respectably won't satisfy shareholder expectations. The corporate valuation is not the subjective quality of music. Their concern is the marketability of the artist, which engages image almost irrespective of the music.

Challenging music is difficult music—difficult to sell. Packaging a known quantity to an identified audience is better than the odds on trying to "break" a new artist. In an ideal world, music would be subjectively judged on the merits of the individual performances. The public would buy the music it liked. However, everything is not equal. Being heard is complicated and controlled. And what is being purchased is often only incidentally about sound.

As we're stuck with our capitalist system, we need to thread through the tangle of economic versus aesthetic valuations. And we must rejoin a more vital question than "Is bigger (record labels) better?" It is, however, a place to start. Must a willingness to be in the "minors" be regarded as a failing (either as a musician or a label)? When regarding the musician: How big an audience can an artist aspire to and still be legitimate? How narrow can your message be to deserve hearing? And, when regarding the music purveyor: How little can you allow the business to affect the decision of who to present? (How much of a loss can you absorb?) Is it worthwhile to anyone (yourself, the artist, the audience) to operate at such a low level? Is barely heard music any better than music that's unheard?

When we take apart these questions, we find that the corporate valuation of music and major labels are privileged. The ability to make significant profits is valued over the ability to make music. Legitimacy lies in numbers. However, who establishes the cutoff point for legitimacy and how is left unsaid. Why isn't an audience of (for instance) five hundred people worthy of respect? Apart from lesser income potential, there's no answer.

If you have major labels, you must have minors. Big labels are presented as the adults that indies mature into. While this again casts the indies in an unfavorable light, it does point to a common life cycle of labels. Once upon a time, there were nothing but indies in the music biz. A host of local labels competed with the nationals. Some, unfortunately, owed their existence to prejudice: "minority" labels were commercially segregated. (Everything is not equal.) As the music business became big business, corporate music gathered strength. There was too much money to be made for music to be left in the hands of enthusiasts. Indies of varying size continued to exist, but usually with the life support of a licensing/distribution deal with a major label.

In the 1970s, punk rock returned a DIY indie attitude to music and brought a group of smaller, now-legendary (and mostly defunct) labels to the scene: Bomp, Stiff, Factory, Rough Trade. After first dismissing them, the bigger labels utilized them as scouts. However, the small labels' attitudes were just as important to their audiences as the music they provided. Much of that attitude was a disdain for the corrupt practices of the music industry. An artist decamping from an indie to a major label signalled a repudiation of creative ideals. Bigger wasn't better. When the Los Angeles band X left Slash Records for Elektra in 1982, the band was accused of having sold out. Since then, minor-label credibility has been established. It may have been more than a legal necessity that the Sub Pop logo appeared on Nirvana's *Nevermind*, sharing space with David Geffen's DGC. Sub Pop carried credibility with Nirvana's audience that DGC never could.

Sentiments toward big labels have only decreased.* More musicians are now willfully foreclosing the prospect of a major deal. To do so can only mean that both the major label aura and its effectiveness have waned. The reasons musicians are abandoning the major labels are pragmatic and idealistic. Encompassing both is the desire for control.

Accepting and taking hold of commercial concerns may lead to a music business about music, not business. And that musical music will be more satisfying for both musician and audience—and be commercially successful as a result.

The politics associated with creativity—the economics of success—have been highlighted in interesting ways with independent labels. For many artists, the mechanics of distribution and promotion can't be separated from the values espoused in the music. It takes more than singing a protest song to effect change. Fugazi started their own label (Dischord) and priced their CDs at ten dollars (they were also known for their five-dollar shows), much less than the industry-standard (wildly inflated) price. Ani DiFranco has built her career on her own Righteous Babe Records. At first, she distributed her own cassettes from a newcomer's necessity, but then by continued choice. Perhaps no better fusion of musical and business conviction exists than in the name of the label that signed Sleater-Kinney: Kill Rock Stars.

Now a growing number of established artists, from John Prine to Prince, are dropping their major labels in order to have complete control of independent distribution. With new networks of recording and distribution, musicians are increasingly turning their backs on corporate music. With the internet, artists can keep in touch with their fan base relatively cheaply and effectively. Ironically, major labels can now be used as mere springboards to gather an audience. Having established their following, the artist can then go private and make their own decisions along the aesthetic/economic axis.

Disgusted with the exploitive practices of the music industry, many musicians have become savvy businesspeople themselves—producers in entirety. Leaving the business end to others often leads to less freedom in music-making, particularly of the kinds of music the musician wants to make.

However, music has long been about more than the aural sensations. Music is, like everything else in consumer culture, subsumed in the spectacle (to modify the ideas of Guy Debord). Music has moved to being performed at an audience incapable of replicating what they witness. For centuries, music was a small-scale, almost-exclusively intimate event. It was usually private, in that music was performed by and in small groups. When economics allowed for big group performances (symphony orchestras performing before large audiences), the spectacle of music began its ascendancy.

For performer and audience alike, a significant part of performing and consuming music is exploring and assuming identities. It's about image. It's the reason most music packaging has a photo of the artist on the cover. Many people go into music so they can be rock stars. Sure, making creditable music plays some part, but not necessarily the primary one. And buying music also entails an identity assumption: "I want to be like them: not me." To attend the shows of even minor artists is to behold a psychic vampirism. Rock stars whining about the perils of adulation is commonplace. But few like Cat Stevens say it, mean it, and then reject their role in the spectacle.

Not having an easy-to-package image represses more musicians than possessing only humble talent. ("Lack of charisma can be fatal," says Jenny Holzer.) So what if you have no image? Do you then have no music? Can you shun the spectacle and have a career? The technology of contemporary music has allowed musicians to be one-person bands, and many groups are studio-only entities. It's tough to maintain a spectacle with just a disc of music.

Finally, founding a record label is simply the business mechanism to realize a broader, more profound impulse: to create an independent forum for new music. It is another example of creative people fostering others' creativity for its own sake. This impulse is notable across the arts,

both for its generosity of spirit and dubious commercial viability. In the fine arts, we have artists opening galleries and curating; in literature, writers founding journals and editing anthologies; in film, directors forming production companies to make movies. It's an essential aspect of many artists' creative lives to facilitate others' works. The drive to be a cultural participant expands beyond putting one's own efforts out. Bringing other voices and visions to the public completes a circle. Rather than being selfish, art is selfless.

Many record labels began with musicians' desire for control of their music. Their experiences with the music industry often lead them to sign other artists. The Beatles' Apple Records (Badfinger, James Taylor) or Frank Zappa's Bizarre/Straight label (Captain Beefheart, Alice Cooper) are examples of such ventures. David Byrne's and Peter Gabriel's personal music devotions led them to form labels: Luaka Bop and Real World, respectively.

The compulsion to create a forum for music without regard for profits is not limited to performers. German émigré Arthur Lion, who founded Blue Note Records, was one such enthusiast. His commitment to the music can't be denied. And, of course, the label also stands as a design icon with the work of Reid Miles. Is it coincidence that singular music visions often engender exceptional design (e.g., Manfred Eicher's ECM with Barbara Wojirsch, or Ivo Watts-Russell's 4AD and Vaughan Oliver)?

Such a motivation could, of course, be seen as self-serving. Indie labels, particularly those created by musicians solely to distribute their own music, dare the designation of "vanity press." This derogatory term exists solely to legitimize someone else's opinion—frequently that of established interests. Self-publication, self-determination is suppressed intellectually and physically. You'll take what we give you, say the mainstream producers. As a label grows in profitability, what they increasingly deliver is safety. Decision-making is driven by the business demand

for the maintenance and growth of profits. This drives the life cycle of success: risk-taking devolves into defense of a status quo. Whether it be individuals or groups, once a success is achieved, everyone begins working to not lose the status. The eternal irony is how the methods that bring success—daring, invention, liberty—are abandoned when recognition is gained.

To encourage artists and labels to be venturesome, we must reconsider our expectations. For creative people, is the desire to reach millions of people—moving millions of units—a creative impulse or a commercial one? It is sad to consider that we may have lost the ability to appreciate something done well if it doesn't include the desire to make big money off of it. For some artists, simply having the opportunity to make a record is enough. Others are content with whatever coterie permits them to keep making music. An obsession over how many other people are in agreement about an artist's value is a personal insecurity. When placed upon the artist, this anxiety can marginalize an activity worthy of respect.

With labels, we can question if they must aspire to major status—or even just stay in business long term. It's unfortunate that Stiff Records no longer exists. However, I don't consider their enterprise a failure because they went belly-up. Indie labels can be temporary phenomena, creating and defining a cultural time, then passing on. (It's better to burn out than to fade away, Neil Young says.) While this may not be a viable business model, it may be a vital cultural one. This is not to say that the only good label is a dead label. ECM and 4AD venture on, remaining true to their visions and fertile as ever. The ability to combine business acumen and a singular vision is something to cherish.

Questioning should extend into ideas of profit and promotion. If you're into the marketing of creativity for its own sake, breaking even is a success story. A small financial loss is a victory if you can keep

going. And must a label strive to place their product everywhere? That effort alone can sap all of a company's resources. In a society saturated with product, it is refreshing to encounter temperance. In addition, the delights of self-discovery are undervalued. There's added pleasure in finding something on your own—not due to a PR push.

The value of an indie label for musicians and audience alike is independence. It is the opportunity to make new meanings. The continued existence of small labels provides ongoing diversity protection for the culture as a whole. The consolidation of major labels into a few multinational media empires is the definition of inbreeding. Labels with a strong commitment to music are usually formed by and suffused with the spirit of a single person, or a few, who started the label because of their devotion to the music. There is an ability to forge new connections among artists, their supporters, and audiences. The terms of these relationships cannot be free of commercial considerations or the crafting of a professional image. However, music will be the purpose and cause of the affiliation.

Independent music is, for me, the ultimate example of an impulse shared by many music lovers—those with big LP/cassette/CD collections. The enthusiasm for the music makes sharing it imperative. So you make cassettes for friends. Sometimes, it's a proactive gesture. I've made tens of these tapes: samplers with a variety of artists and anthologies of a favorite musician. To know I've turned a friend onto something new, something I love, is its own reward. It's communication, not product. That's what trumps aura: a personal recommendation. "You've got to hear this." ✿

[*] The latest fracture in the business of music is downloadable music from the web, eliminating the need to manufacture and ship products. The artistic downside to MP3s has been prominently played in the media's coverage of Napster. Having been digitized and made web-accessible, music underwent another conceptual transformation. It became the equivalent of any other program—freeware. Ignored was the reality that money must be placed somewhere in the system or musicians are unable to make any further music. What was lost was the musician's ability to receive recompense for their labor. Simply, it wasn't free to create the music.

The argument has been put forth (usually by advocates of free online music) that free music actually encourages more people to buy the authorized products. Proof for their contention is the corporate profits that ensued even after widespread home taping of albums. Ultimately though, the musicians' subservient role in the industry remains unchanged. An audience unwilling to pay a fair price for it erases whatever gains musicians have made with the ability to market their music independent of major labels.

The real impact of free downloadable music is still speculative. It's likely that some portion of those people downloading the music would have paid for it if there were no Napsters. Many may have gone on to purchase the product legally after getting a free taste. For whatever reason, millions of people ignored the reality that musicians make their livelihood from audiences paying for their efforts. Perhaps the rationale is no more complicated than when offered something free and easy, people will grab for it, regardless of the long-term consequences. Whatever the reason, a social contract was broken between artist and audience.

That music is primarily image and largely spectacle may have contributed to or caused the break. Music is incidental to the overall spectacle: the arena tour, the video—perhaps even the LP/cassette/CD. Having paid big bucks for the concert, you might feel that you've already made your contribution to the cause. They're rock stars, you say, they can afford it. Since you've bought into an abstraction—an image, not a person like you—you're disconnected from having affected them.

The Graphic Equalizer

Graphic design isn't graphic design, not quite yet. Often, it sounds like something else. The field continues the process of establishing its own distinct identity. A major aspect in this effort, especially at the academic level, is crafting a model to describe design activity and evaluate its products. Students, practitioners, and audiences have some basic questions. What circumstances bring a design artifact into being? How should we critique it, once it's made?

In the course of fashioning a critical method, design has, understandably, looked to other creative disciplines. Art and architecture were adopted early as potential sources and continue to be popular references. "Auteur" theory from film criticism was briefly floated as a model, then discarded quicker than it had been in its own domain. And from literary theory came the concept of "designer as author," despite the author's presumptive death.

A positive aspect of looking to other disciplines is that it expands the view of what design is and could be. It also connects design to wider cultural activity. Frequently, design isolates itself from scrutiny, insisting its processes require specialist knowledge. Like other disciplines, design has unique aspects that must be taken into account for a thorough and accurate study. But it has significant commonality with other cultural activities. Design will benefit critically from linking itself with the right ones.

In all of the aforementioned disciplines, the intent of the artist/director/author/designer is privileged in critiques. Creative activity is

portrayed as existing in a vacuum insulated from practical concerns or outside influence. Even inside influence is absent, as the creator is rendered as an egoless, idealistic agent answering only to a muse and/ or a set of abstract principles.

Graphic design's current evaluation methods continue to emphasize aesthetic achievement. Analysis is conducted primarily on a formal level. Quality is determined by an artifact's (or designer's) adherence to a specific formal agenda. This is the influence of the modern movement, which channels all considerations through a predetermined formal structure. Good design conforms to a specific formal agenda, bad design doesn't. The common claim of a design solution demonstrating "inevitability" implies only a single possible resolution of the design process. This diagrammatic structure isn't adhered to as dogmatically as it once was, but is still dominant. The method remains static and inflexible. The range of possible formal approaches is proscribed, despite changes in culture and technology. The designer's intent remains the predominant aspect of the process. Only occasional—and often unwelcome—influence may come from a client.

good = conforming
bad = nonconforming

Even if we argue the specific formal approach a designer should take (Swiss International style or an eclectic historicism), we must acknowledge that the design field values notable aesthetic achievement above all. Good design is defined as high formal accomplishment,

such as can only be realized through the patronage of elite cultural or commercial clients. The critical method that can be extracted from, for instance, winners of the National Design Award, or the Cooper-Hewitt Triennial, is one that excludes the overwhelming majority of design and designers from a fair estimation. Great design, as currently defined, must be inconsistent with and unrepresentative of common practice. What design actually requires is a sliding scale that contains a variety of balancing pans.

For a true reading of the diverse aspects that determine what brings a particular design artifact about, we need an egalitarian and expansive model. This critical method should cut across the broad field of design. Is it possible to have a model that includes the supermarket flier, the annual report, the self-promotion, the upscale fashionista exhibition, and the everyday yard sale sign?

My first step toward attempting such a model was inspired by the essay "Axis Thinking" by musician and artist Brian Eno, from his 1996 book, *A Year with Swollen Appendices*. Eno offers a view of culture as a series of intersecting axes. Rather than being a strict binary—an either/or situation—each axis represents a continuum of choices.

Eno demonstrates his system by describing haircuts. You can have, for instance, two axes with the endpoints "neat/shaggy" and "masculine/feminine."

neat ⟷ shaggy

masculine ⟷ feminine

The intersection of these two axes he calls a "cultural or stylistic address." The result is a diagram showing "a possible haircut."

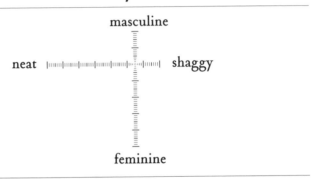

"cultural or stylistic address"

"a possible haircut"

Of course, Eno admits that there are many more variables that go into a possible haircut: more axes. To properly diagram them, you would need a three-dimensional model. Citing this functional difficulty, Eno goes no further in attempting a representation of his system.

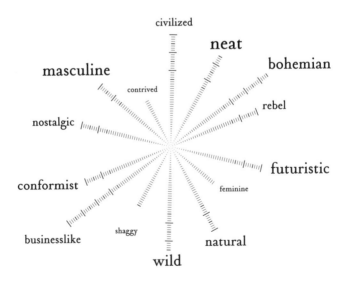

After reading the essay, I set about identifying design axes: their titles and the endpoints. Starting from the top left, the axes move from objective to subjective concerns:

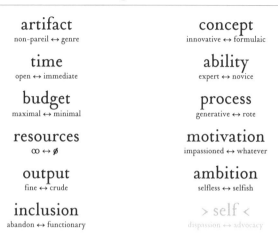

design axes

artifact
non-pareil ↔ genre

time
open ↔ immediate

budget
maximal ↔ minimal

resources
∞ ↔ ∅

output
fine ↔ crude

inclusion
abandon ↔ functionary

concept
innovative ↔ formulaic

ability
expert ↔ novice

process
generative ↔ rote

motivation
impassioned ↔ whatever

ambition
selfless ↔ selfish

> self <
dispassion ↔ advocacy

Artifact roughly describes the type of design object under consideration. Genre would be a well-established, well-worn form: an annual report or brochure. The client usually sets time and budget, while resources combine both what the budget provides for and the existing assets of the designer. Output expresses the quality of production: a fine offset press as opposed to silkscreen. And within these options are further levels of quality. Inclusion addresses the level of involvement in the overall process that's allowed the designer. Concept considers the designer's ideation. Ability attempts a measure of technical skill. Process asks if the procedure to realize the concept feeds back into the idea or is wholly mechanistic.

The final two axes are speculative, yet influential, aspects of any activity. Motivation sets a level of immediate personal engagement with

the project. It's distinct from the following axis as an ambitious designer might still "phone in" a project they know is unlikely to advance their aspirations. Ambition brings the designer's ego into play. It's possible— and arguably best—when the ambitions of a client and designer match. Is the work to the designer's greater glory—their aesthetic or professional aspirations—or the client's? What about the user? Personal ambition can be a positive energy, and need not be a detriment to the success of the work. The important point is to assert that designers—like any creative people—answer to themselves as much (if not more) than to an abstracted muse.

The self axis is set off from the rest, as it addresses the viewpoint of the critic. How deeply will a critic examine a work? Will she or he question the verities of the field? Design's critical figures are almost exclusively practitioners. They have a stake in maintaining certain assumptions about how and why design is done.

Initially, I diagrammed a three-dimensional model, such as shown with the second "possible haircut." However, considering Eno's particular expertise as a musician, and the processes involved in generating music product, I was led to a more effectual model. Music is a metaphor I regularly employ to articulate design ideas to students. Admittedly, it's due more to my own love of music than any contrived attempt to relate to "the kids." However, my choice here does seek to be relational after attending to the practical and philosophical concerns I've previously stated.

Graphic design is a form of popular entertainment, something the field has mixed feeling about and frequently downplays. Design's out in the world, offering accessible visual gratification. That's no small task and nothing to be ashamed of. Also, the majority of design applications are for things that are frivolous, ephemeral, and disposable. There's ample reason for design to embrace its entertainment status. It's no obstacle to also being relevant, profound, desirable, and useful. All of these traits

also describe popular music. By popular music, I mean the forms that were popularized due to economic and technical advances such as sheet music and phonograph records. In the search for a model to establish and critique graphic design's role in society, pop is top.

What's significant about popular music when scrutinizing design is how it is made and heard. Recorded and live music isn't only performed—it's constructed. The recording studio is a technological forum where disparate elements are assembled across a multiplicity of tracks. Mixing—and remixing—those tracks results in the final "song" and variations thereon. Similarly, individual listeners may customize the sound through use of a graphic equalizer.

This is a useful metaphor for graphic design. Every design artifact is the result of the interplay of various inputs. Unlike in the recording studio, all aren't under the designer's control (though stories of producers trying to manage drunk, drugged, or otherwise unruly and uncooperative musicians during recording sessions are legendary). Still, we can identify these influences and speculate on how they interact. The diagram displayed here attempts to illustrate this interplay, using the mixing board as metaphor.

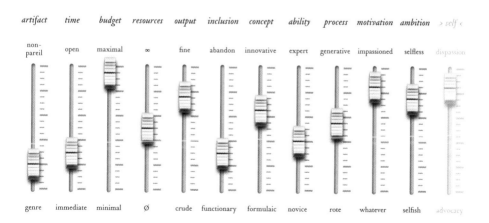

In the graphic equalizer, axes become channels or tracks. Though unintended, this configuration may suggest a good:top / bad:bottom designation. However, a horizontal alignment is also possible. Of course, a reduced ability is not necessarily a negative. A lessened circumstance may constitute a deliberate and effective strategy. And then there is always making virtue out of limited means. Some channels overlap in their concerns or are closely related. Others directly affect others. For instance, an expert practitioner is likely to do more with less time or money than a novice.

A design work is then the array of settings across the board. Alter a setting—create a new design. Any design artifact can be described on an equal playing field with any other. As an example, I've taken what might be regarded as two extremes of design artifacts to "demix."

First is Irma Boom's *Thinkbook*, her five-years-in-the-making, 2,136-page megatome for SHV Holdings. Here, most of the sliders are cranked to the top. However, as it's ultimately still a book, though an inflated one, it's a genre form under Artifact. And, as described by the few critics to actually have seen a copy of it, the volume's layout is more restrained than revolutionary. I've also placed the Ambition slider at the midpoint, as there's no record of Boom either attempting or desiring to scale down the effort. And the client certainly desired the most grandiose graphic statement.

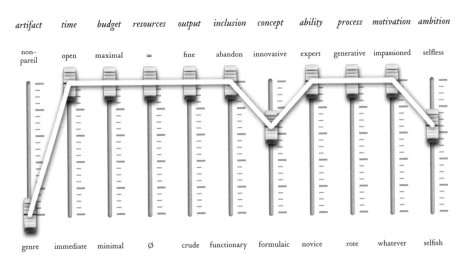

artifact	time	budget	resources	output	inclusion	concept	ability	process	motivation	ambition
non-pareil	open	maximal	∞	fine	abandon	innovative	expert	generative	impassioned	selfless
genre	immediate	minimal	∅	crude	functionary	formulaic	novice	rote	whatever	selfish

At the other extreme is your typical lost pet flier. The only channels set on high here are those of Inclusion—as it's a self-commissioned and directed work—plus Motivation. You've lost your cat, and will utilize all your graphic skills to regain it. Unfortunately, they're limited—but who cares about design niceties? I just want Blackie back!

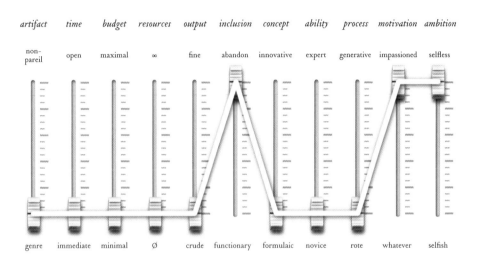

artifact	time	budget	resources	output	inclusion	concept	ability	process	motivation	ambition
non-pareil	open	maximal	∞	fine	abandon	innovative	expert	generative	impassioned	selfless
genre	immediate	minimal	Ø	crude	functionary	formulaic	novice	rote	whatever	selfish

The graphic equalizer is a work in progress. Old Dominion University graphic design student Paul Gonzalez suggested the need for a separate Motivation channel after a lecture. It remains highly subjective and speculative in some channels. But its primary function is to stimulate an expansive and inclusive discussion of design activity and artifacts. Unfortunately, this model doesn't provide a way to reliably predict the impact or effectiveness of a design proposal. However, it does provide a concrete metaphor for a broad, yet practical, critical process.

What lies ahead for design is a future in noise: pushing the endpoints of what's considered music and design. In his essay, Eno maintains that an essential aspect of culture is extending axes into new

territories—people doing things that no one thought of doing before. Eno described the punk-style haircut as "hacked about by a brainless cretin." This was an option never before regarded a viable haircut option. Other axes may be forever off the charts, such "clean/dirty."

In music, an example of an axis extension was guitar feedback. Classically, this would be considered "bad sound." Now, as with Jimi Hendrix playing "The Star-Spangled Banner" at Woodstock, it's not an instance of improving the ratio of "signal to noise." The noise *is* signal. In graphic design, David Carson is the popular face of an axis extension beyond the modern, commercial standard. Or the extention is a debate point where, depending upon the viewpoint of the self, the Ability channel is pushed to either extreme. Whatever may come about, we will need a critical model that can encompass all possibilities. It needs to be as adaptable as design itself. ✪

Teleidoscopin'

Aerosol

The story of the twentieth century is fission, whether it is in culture, science, or the arts.

Unities have dissipated into a fog of ideas and particles. The firmament is now an ambience. And this circumstance is of our own doing. Our favored method of gaining knowledge and mastery of our world is smashing things together and reading the debris like tea leaves. Physicists construct increasingly powerful and sophisticated devices to collide enigmatica into the metagnostic—all undetectable to the human senses.

It's not odd to question whether any of this matter exists. But it makes a fascinating story, reality or not. In the first decades of the twentieth century, while physical scientists were fashioning the first cloud chambers, the arts were engaged in their own early collision experiments. These explorations were, and continue to be, conducted with the most rudimentary yet volatile of technologies: words. Ideas were split with bigger ideas, to result in more refined, precise concepts . . . or so it seemed.

Bigger and bigger minds were built by the emerging disciplines of art history and criticism to manage the task. Over the previous century, culturalists theorized an Art particle. This Art had the magical property of being the essential component of aesthetic experience. Most fabulously, it was possible to create objects containing this particle, using, primarily, mineral pigments within an oil base applied to taut fabric. The Art component increased an object's value tremendously. However, a disturbing

realization arose, one that generations of researchers and practitioners have glossed over. It was impossible to determine the exact location of these Art particles at any given time. Were they present in the Art object or the observer? Or both? Were they universally detectible?

At the turn of the century, a now-prominent culturalist announced that the Art particle was ubiquitous. As proof, he successfully (it appeared at the time) demonstrated a plumbing fixture wholly composed of the Art particle. Theory said that ordinary objects could similarly be Art-irradiated. Subsequent testing with more sophisticated equipment, however, has failed to detect said particles in any other fixtures. This pronouncement—a theory of relativity—shook the culturalist structure. Was the particle ubiquitous or nonexistent? Fact or fancy, delusion or devotion, we may still celebrate the story of the wondrous particle, and all directed applications of the "mist-ical" arts. ✪

The End of Design

We open on an august museum of contemporary art in a world-class city. Bright morning sunshine glints off the resplendent, angular structure, a recent exponent of the reigning starchitect du monde, whose reputation can be measured in inverse relation to his physically realized plans. To merely term the institution "progressive" in its doings is to wrap it in virtual cobwebs.

This museum happens to be the venue for the last stop on the tour of a pioneering exhibition. The show presents the oeuvre of the Original Rock Star of graphic design. It is a landmark solely due to the fact the exhibition was held at all. Simply put—it's graphic design. Still, the show drew respectable turnouts and positive reviews at sites around the world. Response was gratifying enough that the ors even showed up—often sober—at most of the openings and attendant lectures.

As we join the action, it's the day after the show's closing. In an almost-postcoital bliss, the Original Rock Star stops by the museum to observe deinstallation and, if luck holds, get ego-stroked by a stray design groupie (a creature slightly less rare and more fantastical than the unicorn). His mellowness is such that he decides to no longer be peevish toward the museum for selecting the Upstart Rock Star to design their identity. At every public opportunity, the ors refers to the Upstart as "Rockette"—all New York glitz and not at all manly. Skipping up the museum's front steps, the Original contemplates the Upstart's professional motto, one that clearly denigrates output of ors's kind

as being insubstantial as wind. "Blow me," thinks the ORS as he enters the building.

Satisfied but melancholy, the ORS stands in the main gallery as a staff member approaches a work ("This is my favorite!" he hears her say). Stunned, then livid, he watches as it is hauled to a waiting trash bin and dropped inside. After the first toss, the rest of the preparators quickly follow suit. Within minutes, the entire exhibition lies crushed and torn in the museum's dumpster.

As staff members congratulate each other on a job well done ("I wish all the shows were graphic design!" someone proclaims), the ORS storms to the museum director's office. Flinging open an oddly cantilevered door, the ORS bellows, "They've trashed my work!" Familiar with the designer's substantial yet brittle ego, the director assumes an expression of administrative disapproval. "The staff's insulting your work?" she inquires gravely, lifting her telephone. "They threw it all in the fucking garbage!" the ORS roars.

At this, the director pauses, angles her head slightly, then gently rests the handset in its cradle. With an expression of sincere (almost childlike) bewilderment, she says, "But—it's graphic design." ✹

The Importance of White Space

In our time there is a grayed, eminent, internationally recognized graphic designer, who heads an eponymous consultancy in (where else?) New York; a European émigré still possessed of a charming accent—and the most authoritative opinions of all matters cultural. This titan of the industry is renowned for his deft handling of clients, masterfully getting the most obstinate and querulous corporate board to say *sí*. His projects are rationally conceived, meticulously composed, and comprehensively executed. He lives and breathes the X- and Y-axes, the whole 1,944 picas. He's always nattily dressed in the big K (for blacK: think high priest). We'll call him the Maestro.

One day, the Maestro received a lecture invitation. These requests were familiar occurrences and the Maestro always magnanimously accepted each and every offer. It was simple courtesy first—he might be blunt, but never bad-mannered. Secondly, the engagements provided him the opportunity to further proselytize on the cause of modernism, for which he had a missionary zeal. To speak of the Maestro, or to ask him to speak to you, was to summon forth an encyclical on modernism's virtues. Expecting him not to engage the topic was like asking the pope to go easy with all the Jesus Christ references.

The group that extended the invitation, however, was not related in any obvious way to graphic design, either from within the industry or its natural clientele. It was a social interest group located in the state of Montana. This was a part of the country in which the Maestro was

unstudied. He regarded it as being part of the geography buttressing the East Coast against the Atlantic. It also admirably served to keep the West at a permissible distance.

The group calling for the Maestro went by initials that, while unenlightening as to the organization's purpose, had the good form to not be one of those vulgar acronyms—and would kern smoothly in any of the five typefaces they might be set in.

The Maestro believed in thoroughly researching a client's business, so he instructed a junior designer to investigate his future hosts. The underling reported back—with a curious look of puzzled apprehension that baffled the Maestro—that the group was an adherent of early-twentieth-century Russian avant-garde art. At least, that's what the Maestro thought the junior designer meant, as he heard they were "Suprematists." Though curious throwbacks, he could comprehend people with such interest welcoming him. What else could they be? Some aspects of American culture and society eluded him, as did some regional accents, but this seemed rather straightforward.

Men who shared a regrettable predilection for camouflage patterning on their attire met the Maestro at the airport. Taking in their apparel, he sensed he'd arrived just in time. The Maestro's many interests included clothing, and he'd designed some rational dress for himself and discerning clients. At least these people recognized their need (if not, he'd soon bring them to the realization). As he was a disciplined man, the attendants' crisp, almost military demeanor impressed the Maestro—while also evoking some unsettling historic precedents. These he set aside—this was the United States.

The subsequent drive to the lecture site stretched over hours and miles of desolate prairie. Eventually, they arrived at a sprawling, gated compound, replete with cinder-block structures encompassed by stockade fencing topped with copious coils of razor wire.

The Maestro was ushered to a spacious hall filled to capacity with men so similar in deportment that they almost defined an archetype. Each audience member nodded curtly but deferentially at the Maestro as he passed, as if acknowledging not just a fellow traveler but also a trailblazer.

The speech that the Maestro delivered had been tailored for a general audience. It was a ringing declaration of principles that eschewed specifics for soaring rhetoric. At graphic design conferences, it reliably killed. With this crowd, however, he noticed a distinct restiveness, a palpable sense of unfulfilled expectation. The Maestro, as was his wont, confronted the situation directly. He asked the assembly what the nature of the problem was. What hadn't he provided?

After a brief exchange of deferring glances among the homogeneous audience, one member finally stood in response. What the man said made the Maestro acknowledge that interpretation could be more of a variable than he previously vouchsafed. It was simply a question: "Could you please speak about the importance of white space?" ✪

Pejoration

Tina was having a tough time at her thesis defense. About two-dozen people—reviewers, graduate students, other faculty—milled about as she was questioned about her presentation in the college's main gallery. Tina was in the painting graduate program, I in the design. I was on hand, as we'd become friends through sharing George as our thesis advisor. He led the graduate seminar class we both attended, and was neither a painter nor a designer. I'd wanted an advisor unfamiliar with the design discipline and conversant with contemporary critical theory. Tina, meanwhile, was simply frustrated with the faculty in her department. She wasn't receiving meaningful feedback as she worked, representational in a department whose professors were entirely into abstract expressionism. The situation hadn't improved when her subject matter swerved into nonrepresentation.

Which brings us to the awkward, contentious ritual now underway. For her thesis show, Tina set out a grid of eighteen separate paintings, each two-feet-square and abstract, with simple, mostly geometric, patterns. Instead of individually labeling the works, she provided a "legend," as if the arrangement were a map.

It wasn't going over well. Each of the faculty examiners stepped forward to proclaim their inability to connect with Tina's work. They knew that her work could be placed in context with recognized methodologies of painting. They just couldn't relate. One reviewer latched onto a work where the paint roiled uncharacteristically.

Here, it seemed, was Tina's personality coming through, a sign of emotion.

Next up was a guest reviewer, an older, established local artist. I recognized his name, as we both had work selected for a major drawing exhibition a couple years back. He had shown these dramatically rendered, monochromatic, gnarly trees. Tina's work was giving him trouble too. "They all seem . . . designed," he pronounced, after a brief search for words. At this declaration, George quickly looked around to find me in the crowd, as though establishing whether the artist was in my line of fire. He knew I wasn't going to let that go without a (likely heated) response.

However, at this point, I was content to play out more line. The gallery ceiling was high. In any case, another graduate student, a printmaker, immediately interjected, "What does that mean?" The response was obligingly blunt: "It means artificial, shallow, about the surface." "So, it's a pejorative?" I asked. "Yes," came the flat reply.

The conversation returned to the work, and I dropped the noose I'd tied mentally (complete with an Eva Hesse-ian knot). I didn't want to take attention from Tina by starting a fight with yet another artist putting down design. When it came to design's specific output, I agreed with the reviewer. Design was usually all those things. But, unlike him, I didn't assign art any automatic relevance.

In the end, any argument with artists about graphic design was futile. Art's import and design's lack of it were articles of faith, not critical positions arrived at intellectually. For now, I'd hold my fire. But someday, I planned to paint him—and all other artists like him—a picture. ✷

Form vs. Function

For the final term of our graduate seminar course, all MFA candidates were required to draft an artist's statement. This wasn't an onerous task for me, as we graphic design grads already had to produce a substantial research document as a component of our thesis. Studio artists only had to come up with a statement, and a single-page one at that. I wasn't rankled by the inequity, just bemused, in the context of design's supposed superficiality. But let's move on.

The paper I submitted was the requisite one page, but in keeping with my graduate research, it was designed. I'd spent considerable time and effort in the seminars arguing the expansive possibilities and imperatives of graphic design. To generate the typical twelve-point-Helvetica document would contradict my contentions—or so I thought.

My statement consisted of three brief texts: my own writing and two quotations. I wove the three passages together in alternating lines, using separate typefaces for each—all eminently readable. As punctuation, I placed a small image of an abandoned, decaying billboard (a recurring symbol during my studies) in the lower right-hand corner. In context of the graphic design explorations of the time (1996), it was tame and straightforward. However, I wasn't in that context.

The seminar leader was a decidedly tolerant theorist who had expressed support for my investigations into the rhetoric of design. When she returned the statement, her penciled comments were short and succinct: my text was good but, of course, it wasn't in the proper

form—in other words, double-spaced, twelve-point Helvetica. With a few concise words, she had negated my entire graduate study … without even realizing it. Before theory could go somewhere, it had to realize there was a "where" to go to. But for the moment, I was content in the knowledge I was writing wrong. ✿

Light Turning

One day, I was driving south down Mass. Ave. in Cambridge, heading to my home near Fresh Pond. Usually, I'd go through Harvard Square. It was the simplest route—one turn—though not the easiest—lots of traffic. I'd traveled this path hundreds of times: walking, riding buses, driving. But when I hit Porter Square, I contemplated the Harvard Square bottleneck and impulsively decided to improvise. Imagining the map, I knew where I was and where I wanted to go. If I just turned right here and kept moving in a rightward direction, I'd reach my destination.

Of course, it wasn't that simple. Flying over the area in my mind's eye, I could easily connect points A and B. But the city of Cambridge had a more complex agenda than making it straightforward to get from here to there. Turning off the main drag into the neighborhoods ensnared me in a tangle of one-way and obliquely connected streets. I tried to keep to that rightward track, looking for something recognizable. That emerged when I saw a street sign for Huron Avenue, on which I traveled by bus nearly every day. I turned onto it and was brought immediately to an intersection. As Huron wasn't that long, I knew I had to be close to home now.

But as I waited for the green light, I gazed in bewilderment. Nothing looked familiar. Had I misread the sign that said Huron Street? The Boston area was like that. Not knowing which way I should turn, I grew quietly frantic. There was another car behind me, and local drivers weren't known for patience. When that light turned, I'd have to move in some direction.

Suddenly, my awareness reoriented itself. It was as if my mind's-eye map instantly spun around 360 degrees and I knew just where I was. I'd simply come to the intersection from a new direction. My trepidation had made the familiar strange.

I realized that as we go through life, we edit out a lot of experience. Once we think we know something, we go on autopilot mentally. Rather than constantly seeking new experiences, we need to trigger a re-sight, or insight into the known. At least, this was another demonstration on the limitations of labeling and signage. They can identify where you are. But they can't help you know where you are. �khǎ

The Last Wave

This exhibition is the result of the conjunction of a flat file and a computer monitor's reflection. The flat file, the tallest and widest model made, dominates our museum's storage room. It bulges with hundreds of graphic design works: cards, posters, booklets, brochures, and journals. A handwritten label made from a torn strip of masking tape indicates the file is the Traveling Collection.

The reflection in the monitor was of our dismayed faces as we searched in vain for information on the materials. Among them we found a bound journal that we initially took for an artist's book. Its pages were densely layered with notes, images, clippings, and scraps of all kinds of print materials. We eventually discovered that the journal outlined what may have been a potential exhibition plan of the file's works. Left to ourselves to make sense of the materials, we eventually came to the exhibition before you. Whether it is the intended exhibition, we can't say. And what we can say seems ludicrous.

As identification of the source of its contents, the file only contained an internal shipping manifest from a Sacramento business to the museum. From the tag, we expected that the file contained pieces from a touring show that had originated from then returned to our museum. This wasn't the case's case. A secretary at our museum informed us that the impromptu label was actually an approximation of the donor's name, now lost. The contributor was an organization that went by a term that was "something like 'Occupant,' only it meant

you had moved," or so a departed staff member had explained to the secretary. Whoever had accepted the materials was long gone or not making admissions.

Such circumstances are quite common in museums. It's a dirty secret of the venerable halls of timelessness. Various individuals donate curiosities either to acquire tax write-offs, rid themselves of clutter, or endow an institution with artifacts that may once have been precious but are now junk. The museum becomes a cultural landfill. Most suspicious collections find their way into repositories because of friendships between collectors and board members. Sometimes questionable offerings are accepted during times of administrative flux. (Let the next guy or gal throw it out.) Though it seems haphazard and hardly studied, these nonprocesses of acquisition led to many of today's museum collections.

As new curators under a new director, our first charge was to sort through storage and select the quick from the dead. Bursting with ambition, we decided to tackle the big file first. In trying to establish a provenance, we were able to locate a facilities staffer who remembered picking up the collection. He said that whatever business had occupied the space had cleared out, leaving just one room stacked to the ceiling with the works. A laser-printed sign with "funny letters" directed them to haul everything in the room away. For insurance purposes, they took a photograph of the room before packing it up. They also took the sign. The photograph stayed in our files, while a docent attending art school pilfered the sign—allegedly.

At a cursory glance, the works seemed ordinary in their ultimate form. In their finer surface elements—typographic style, layout, and imagery—we saw deviations from mainstream norms. Formal approaches ranged across a spectrum from inspired articulation of accepted structure to willful flaunting of conventional display. The question of their value

as aesthetic objects we would leave to tastemakers and connoisseurs. Our interest was their exhibition potential—were they significant in some way?

We began sorting through the Traveling Collection on the assumption that it was randomly accumulated. The little information we had gained on its origin supported that conclusion. Having found no information on the collection as a whole, we sought to gather data on its components. We fared no better there. Roughly 80 percent of the works were nonstandard, noncommercial products with enigmatic or no attribution. Calls to organizations for which the remaining 20 percent were produced gained us little. Depending upon who we spoke to, the design was inevitably handled by "our ad agency"—the name of which couldn't be divulged—or was the work of "some friend of the director."

Such frustration became the norm. Even when pieces included a credit line for the producer, the individuals or firms turned out to be bogus or extinct. Inquiries to printers (in the rare instances where they were named) proved fruitless due to their suspect record keeping and frequent unlogged, "piggyback" runs for favored practitioners.

Considering their formal attributes, the designs in the collection proved to adhere to or deviate from recognized styles in enigmatic ways. Various formal elements defied even labyrinthine rationales for their use in relation to their ostensible content. In addition, the "authorship" of the works was similarly ambiguous, rendering a plausible identification of commissioner and executor impossible. Finally, many of the works seemed to have no discernible function—or seemed directed toward obscure, improbable audiences. In many ways, these designs shouldn't exist. Yet they did.

We then turned to some professionals in the design field to offer their insights. They immediately began to obsess over surface

treatments as if scrutinizing heraldry. Pieces were ordered in terms of "camps," which were deployed as if we were studying not the design field but a battlefield. We found it odd that while the professionals could confidently "align" works, they were unable to name their specific designers. They declared a vague familiarity in many of the pieces. It was insinuated that the Traveling Collection might be a selection of class projects from design schools.

Our immediate problem with classifying the designs as classroom copies was that the pieces couldn't definitively be linked with an "original." Though many pieces likely were variants on real, attributable designs, the heatedly derivative nature of the graphics industry made this aspect almost irrelevant. Determining the degree and egregiousness of derivation quickly devolved into value judgments founded on personal biases and ethics. The situation was further complicated by the conflicting opinions of our consultant design critics. Some proclaimed the "derivatives" as superior, while others derided all pieces not usable in recognized commercial capacities.

We felt we were at a dead end. While there was individual merit in all the designs, the same could be said for any other randomly gathered mass of print works. We began to select personal favorites in advance of consigning the rest to the recycling bin. It was then that we stumbled across what was to become our Rosetta Stone—and Pandora's Box: the bound journal that we had first thought was another work of the collection. Instead, it contained the notes of an unknown figure we'd dubbed the Descientist. This journal claimed that the Traveling Collection was a unified assembly of works. Their formal curiosity provided a mere hint of their true strangeness.

We had taken the journal to be another work in the collection due to its ornate pages. Like many of the pieces, it was densely layered with images, unique hand-drawn and machine-generated typographies,

meretricious chartlike graphics, and an unconventional reading structure. Whether this was done in response to the works or was the Descientist's personal style is unknown.

No one at the museum could affirm that the journal was written by anyone at the institution. If it had been the project of a former curator, it was done "off the books," on his or her own time. It was also possible that the book accompanied the collection when it was brought to the museum. The original owners may have intended their own analysis and presentation. The journal was the record of a failed attempt to organize the materials. When the Descientist's effort was abandoned, the collection was disposed with. The timing of the company's departure only raised more questions.

We saw that the journal had started out normally, as handwritten notes. As time went on, the Descientist overwrote and designed on top of the original entries. We've been able to decipher only a small portion of the journal. Its dense, cryptic language makes us doubt we will ever fully understand the Descientist's theories. And seeing the effect those theories had on their creator suggests it may be better not to know.

The journal begins with a simple taxonomy of the collection. Works are assigned to categories based upon their formal attributes in prelude to an analysis, an approach to organizing graphic design works that is standard in the field—almost pro forma. Despite having an obvious design background, the Descientist seemed to have had as much difficulty understanding the works as us. Numerous taxonomies appear in the journal, with some pieces appearing under every possible category. Eventually, a terminal taxonomy was compiled, either in completion of or escape from the project. (It is this structure that we have used to organize our exhibition and this catalog.)

Late in the journal, the Descientist suddenly begins to make startling proposals for the origin and meaning of the designs. It is as

if prolonged exposure to the collection produced an epiphany—or a derangement. Speculation begins with the Descientist taking a number of common critical circumstances and disputed intellectual claims literally. For instance, when you disagree with someone's critical opinion and say, "You must not have seen the same thing I did," you may be describing an actual truth. Differing perceptions could physically create different objects.

Certain dichotomies are accepted by the Descientist (surface and content are distinct entities) while others are rejected in favor of believing both—or multiple—sides of a story to be true. The modern is deemed impotent to understanding itself, and methodologies from the past century are embraced. Design is regarded as a method of investigation in its own right: a research science. The words *descience* and *designce* are illuminated across the center spread of the journal.

The other claims the Descientist examines pertain to authorship. The attribution of meaning to individual "authorial" intent is long established and regarded as de facto by society. Countering this is the proposition that culture speaks through the (non)individual and brings work to life. However, this phenomenon has proved impossible to demonstrate. We cannot name a single artist or designer who claims this as their process. In addition, the ego naturally rebels at being relegated as a mere conduit. However, both theories involve the direct forming action of a person.

The Descientist's theory declares that culture is the author of specific types of works in particular periods in history. The Traveling Collection is made up of culture-created graphic design. The Descientist's model is unique for the additional claim that works emerge from nothing, unmade by human hands. Design artifacts can be spontaneously generated by the expectations and undirected imaginations of everyday individuals. The Traveling Collection was thought (dreamed!) up.

Science insists we can't create or destroy matter. To propose the manufacture or annihilation of even a single atom is to enter the realm of metaphysics. Yet the Descientist's research indicates the works in the Traveling Collection actualized themselves through the unconscious fears and desires of people. No other explanation satisfies. The Descientist came to this conclusion through a mixture of scientific and cultural speculation. The journal includes a newspaper article followed by tens of pages of numbers in series. We discovered these figures were hundreds of telephone numbers followed by a count. After these pages are tens more of complex calculations.

A newspaper article included in the journal reports on investigations into the universe's "missing mass." By scientists' estimations, all the visible matter in the universe can't account for the total mass the universe must possess to make other estimations come out right. They concluded that there must be vast quantities of unseen stuff—dark matter—that form the remaining amount.

When confronted by the Traveling Collection, the Descientist computed how much design existed and was being produced. Extrapolating from figures provided by a cross section of ad agencies, design firms, printers, publishers, and paper mills, the Descientist found that more print material exists than can be accounted for through normal production processes. The extra quantity equaled the amount in the Traveling Collection.

How did these works come to life? Their origin is oblique. Culture seemed to be realizing works individuals imagined or failed to carry out. In some instances, they are perceived ideals of a kind of design, born in a dream scenario. Other times, they are waking dreams or reveries, speculations of a designer or visual consumer, made while fully conscious. (We suspect that a significant portion of these works sprout from the fevered imaginations of current or recently minted design graduate students.)

It is also feasible that certain pieces are someone's nightmare visions made paper. Antipathy involves a potent visualization aspect.

Where the designs chose to originally surface remains unclear. Works do not materialize next to the originator like reverse-action Cheshire cats. (No one has ever witnessed one of these works come into being.) Pieces are dislocated in space from the originator. They are, however, always found in mundane public venues, though slightly away from mainstream distribution. It is an essential aspect of these artifacts that they be discovered. Culture insists on being heard.

The effect the Descientist's discovery had on us was profound. To consider that each and every one of us may unwittingly cause a material object to spontaneously—magically—materialize was staggering. Even as readers, we might all be authors. The Descientist was no less disturbed by the findings. The journal concludes with the relating of a dream had by the Descientist in the wake of the proof.

The dream is a common one of yearning: encountering something that is a personal holy grail. The desire to have the thing is so strong that you recognize within the dream that you are dreaming. If you are a creative person, dreaming of your magnum opus, you urge yourself to remember the image, to carry it into the real world. Tragically, it usually evaporates upon waking. Or perhaps worse still, one does retain the vision, only to discover it's hackneyed.

In this particular instance, the Descientist comes into possession of a book that contains every work in the Traveling Collection—and more. This anthology, titled *The Last Wave*, claims the pieces as the output of a coterie of designers. The introduction to the imaginary volume explains that the creators deliberately crafted their works to scorn tradition and disturb convention.

Suddenly, as awareness instantaneously surfaces in dreams, the Descientist knows all about these designers. An unstated, pernicious

intent is immediately understood. Apprehensive dread washes over the dream as the book's pages are turned. The designs' true purpose is to act like viruses within visual culture. The Last Wavers seek to institute a new, alien visual language at odds with all existing formality. The Last Wave project proves wildly successful—beyond the conspirators' hope and to their horror. Their visual viruses run amok, accidentally (?) instituting a cultural apocalypse. Meaning becomes arbitrary and form permanently disassociates itself from subject. Representation decays into malignant obscurity. For their efforts, the designers are persecuted, and all traces of their work destroyed. The book likely contains the sole remaining samples of their designs. By reading it, the Descientist threatens to rerelease the visual pathogen. The Descientist then turns to the book's title page for the name of the author—and it's the Descientist's own.

However real or imagined the Descientist's speculations are, we've found lessons in considering them. Before deliberating over these special, uncommon design works, we've come to regard everyday artifacts more seriously. We are all museums, all curators—constructing meaning and identity through acquisitions. We receive printed matter on a daily basis. Considered individually, on form alone, they are absurd. It's only when they are curated, placed into the context of our lives, that they make sense. The sheet of random numbers becomes an electrical bill, linking us to a wider network of use and desire.

And in various somewheres out in the world, people unknown to us are donating endlessly to our museums, attempting to create new networks, new meanings. If their donations fit in our exhibition, we accept them. We also trust there are people out there making these things. Some works seem totally lifeless and mechanical, while rare objects are suffused with an undeniable personality. We have only faith that these people exist. All we can prove to exist is the made thing, and

whatever meaning we make for it. We can't prove the Descientist's claims for the Traveling Collection. Nor can "real" designers prove their own claims for their work.

What is culture saying? Perhaps that it is people. To speak in terms of an abstract force or an individual cut off from society are equally absurd. Culture is us, saying: This is what it's like to be aware.

In the years that the Descientist amassed (or was visited by) these works, debates raged and conjectures flew on what design ideas should be allowed and what may be created. Could creation be halted? Should it? Eternally haunting the discussion was the creative corollary to the conservation of matter: that everything had been created, nothing new could be made. The best that could be accomplished was to reshape what already existed.

The Traveling Collection is testament to the limitations of these concerns. Whether made by individual, culture, or some other process beyond our comprehension, they're here, they exist. If they shouldn't exist, they wouldn't.

At some time, we may, to eventual great reward, speculate on origins and reasons for being. For now, we might just accept these graphic works into our world, saying, "What a world this is, to have such things in it." ❈

Inference and Resonance

Eponymity

The promise of working in the arts is self-determination. Just pick up, produce, and lay claim to the applicable title: writer, designer, artist, musician. Each of the disciplines encompasses a profession that offers a regimented path to acceptance. But that route can be and is regularly short-circuited, or circumvented. Success, though qualified, is still attainable.

That qualification depends on the type of recognition that's sought. If you want certification by "the academy," you'll need to play by their instruments. Popular success is open and result-driven. Endorsement by an arts establishment arguably derives more from adherence to standardized methods than objective excellence. Objectivity may simply have no role here. It's all ultimately cultural activity, where rules—and boundaries—are fluid . . . or nonexistent.

Not long into my undergraduate art education, I became interested in the figures that lay outside training. Of the hundreds I was introduced to, the first artist I identified with was Joseph Cornell. He was the archetypal self-taught artist. After viewing a gallery exhibition of surrealist collages, Cornell set about crafting his own work, becoming one of the most influential artists of the twentieth century. I was receiving the training he never had, but easily romanticized the alternative. Struggling to find a voice within the system, I sometimes feared I could only sound it outside.

When I began insinuating myself into graphic design, I encountered a raging debate about the untrained. Part of the appeal in studying design

was that a window seemed to have reopened for enthusiastic amateurs. I first contemplated the meaning of the outsider as a graduate student. The motivation admittedly included a healthy measure of self-justification. And I can't claim that my strategy to learn about something by studying its opposite was a novel one.

Like modernism—its antithesis—outsiderism manifests differently depending on the discipline. Some designations are easier to self-declare. "Musician" possibly is the toughest to claim, as a specialty skill is involved. But even the need to learn to play an instrument in order to create music has been popularly sampled away.

Only art has self-declaration built into its fundamental identity. Contemporary art is built upon the notion of an avant-garde, a self-appointed, extra-sensitive "elite" at the vanguard of society. At its inception, this elite was made up of fringe characters, contrarians of the dominant culture. They rejected the accepted art of the time, and demanded a perpetual critique. Eventually (and ironically), this status has systematized into what critic Dave Hickey dubs the "therapeutic institution"—a legitimizing and self-propagating structure of academics, curators, and critics proclaiming art's goodness for society. Continual novelty becomes the order, along with continual obsolescence—theoretically.

Early in my own art studies, the concept of being professionally creative seemed bizarre. To do so had to lead to formulaic production and self-referential, insular art. If you're always making art, how could you be experiencing life *outside* art so you could comment upon it? And if you gain any acceptance and longevity, you become part of the establishment that required ousting.

If institutionalized art has a talent, it's incorporating insurgents into its mainstream. Art history presents itself as a succession of eventually subsumed movements, giving the appearance of perpetual

novelty. However, the institution undergirding everything continues on, the therapeutic institution perpetuating itself. Art as commodity never changes. This isn't so bad, except for the rhetoric that insists you ignore that galleries and museums are blatant trading floors.

The sleight of hand that converted even conceptual art into commodity would seem to be art's crowning achievement. But the construction of outsider art trumps even that. By definition, to have an art, there must be *nonart* to contrast against. (This is separate from bad art, which aspires to but falls short of institutionalized art standards.) These works of nonart have to come from the untrained, the folk artists, the outsiders. Shrewdly, institutional art, which had always drawn on this production, set up a parallel marketplace. Rather than fearing or loathing it, the institution created a separate but unequal category for outsider art. It gave recognition of a sort to the outsiders while firmly cordoning them off. A parallel marketplace was established where buyers could cross over without shame. But the fabrication of the categories "folk" and "outsider" art has managed—as intended—to suggest but ultimately deny those works their full status.

If the label remains lucrative, the partition will stay in place, even as the reality erodes. Reviewing the 2009 Outsider Art Fair, then in its seventeenth year, *New York Times* art critic Roberta Smith wrote, "By now the term outsider has become close to meaningless in its elasticity. It implies self-taught, which many insider artists are; it also means isolated, although these days younger outsiders are being influenced by previous generations." But there exists an actual outsider production that art firmly holds to be nonart and bans from its marketplace: graphic design. And design itself, when it's not railing at the injustice, affirms the *cordon sanitaire*.

What eventually attracted me to graphic design was what professionals in the field lamented: it was culturally marginalized, difficult

to define, and wide open to intruders. I picked up the essentials on my own by looking intently at work I enjoyed. Other stuff I made up just because it pleased me. Graduate study taught me some niceties and the terminology for what I was doing right. And about the theoretical rationales of why the stuff I invented was considered "wrong." At that time, the mid-1990s, being untrained in design was all the rage, in that the work of the unschooled ignited both fury and fascination. The vernacular was being championed and David Carson was the designer of the moment. Both developments brought the disdain of professionalists and modernists. Sporadic calls came for certification, to put graphic designers on par with architects and cosmetologists.

Nothing was resolved in the disputes, nor did they ever go very deep. Nature—pragmatism—took its course. Vernacular influences were too formally intriguing and functionally useful to be purged, and so were absorbed. They didn't constitute a threat to the profession, as they would always be ameliorated and wielded by the adroit. And it was never part of Carson's agenda to challenge the professional hierarchy—just to place him atop it. The certification drive? It floundered as supporters failed to devise a process.

Through it all, I naturally gravitated toward discussions where credentials weren't emphasized. Unfortunately, these were rare. Even Carson could, without any sense of irony, dismiss criticism because the commentator wasn't a working graphic designer. My autodidactical status had me by turns empowered, then insecure. Both impulses have kept me interested in the issues surrounding the untrained, even as attention has waned in the field.

In its wrangling over the vernacular and untrained, graphic design was, within itself, playing out a larger anxiety about its status in culture overall. Here it was, a pervasive and influential aspect of culture and society, and its practitioners were invisible. There was no

regard for their authority as masters of a distinct discipline. To be a graphic designer was, by definition, to be unsophisticated. To fine artists, graphic design, no matter how accomplished, was *all* a vernacular that they might plunder.

"I never associated advertisements with having an author," wrote artist Richard Prince in 2007. He was referring to the Marlboro ads he had copied, when informed of the existence of the original photographer of the uncredited, unrecompensed "appropriation." While Prince may now legally recognize that authorship—perhaps to forestall a potential lawsuit—it's unlikely he intellectually conveys the status of artist upon "commercial artists."

So art doesn't set a good example for graphic design in how to relate with the amateur producer. Then again, the comparison only goes so far. Folk art is actively sought out by sophisticated collectors, who are willing to pay premium prices for it when they can purchase it indirectly from a gallery. It's unlikely that a viable subfield of graphic design will emerge that has naïve formality as its selling point.

When the progressive wing of graphic design advocated the vernacular, it essentially encircled the mainstream and put it under siege. The established method of how to make graphic design was under challenge, as was the means to evaluate it. Previously, modernist principles defined both. Now, that routine was at a loss. How did you distinguish a good Carson from a bad one? (You don't. Just throw it *all* out.)

For my part, I didn't deliberate much over my own design critical method. Establishing a model for criticism continues to be a signal effort within graphic design. The critical literatures of art and architecture have frequently been cited as cautionary and exemplary tales. Reflexively, I channeled rock album reviews when evaluating print matter. My entrée into graphic design was the album cover, an artifact that, within design, went from fringe activity to defining form. But after

some measured reflection, the comparison of graphic design to forms of popular music was apt.

Graphic design is an instrumental creative form. So is music, as it's just as much an industry. Music is "pay to play," with the marketplace exerting various client pressures, whether directly from recording execs and management or diffused through the audience. More than this, if we inventoried all the music we heard in a typical day, the majority would accompany or be part of other media: commercials, segues, videos, games, film, and more. It's designed music, creditable and enjoyable in its context and sometimes—especially with film scores—standing alone.

Graphic design could be regarded as "scored" two-dimensional art, a contemporary application of a longstanding creative form. Graphic designers frequently cite music as an analogue for their activity. However, their comparison is usually abstracted and generalized. They stop short of making a practical, enlightening comparison.

Drawing these specific comparisons also illustrates the source of much dissatisfaction within the design field. Graphic designers may be akin to musicians, but regularly work the design version of the average wedding reception. It's a paying gig, albeit highly constrained. They'd love to rock out, but it's time to play the "Hokey Pokey" again. Not much chance to wail—except in frustration.

At this level of service, credentials are practical and performance-based. The more "popular" music gets, the greater the instance of the self-taught in its making, even at the highest level of public acclaim. Rock/pop music, the defining cultural expression for the decades at the end of the twentieth century, is famously only three chords (four if you're showing off).

As a cultural force, rock has been supplanted by rap/hip-hop, which largely samples from preexisting sources. Minimalist layering is

the process. It's not a *performed* music, so much as an *assembled* one. With this, music has caught up to graphic design, a practice that conducts an assortment of adapted, prefabricated, and commissioned elements.

Academic music study is the province of technically demanding forms like classical or jazz. Scorning another musician's mechanical ability outside these realms sounds stuffy, irrelevant. Training seems the antithesis of popular music, which trades in immediacy. With styles such as punk, technical ineptitude was an indicator of authenticity. Participation itself was key.

Once, when performing his own songs at CBGB, famed rock critic Lester Bangs was heckled from the crowd with "You suck!" "Who cares?" retorted Bangs from the stage, "I ain't doin' nothing you can't do! Get up here and do it yourself if you don't like it!" It wasn't Bangs's first time on a stage. Years earlier, he'd "accompanied" the J. Geils Band, brought on with his electric typewriter for one of their encores. As the band tore into "Give It to Me," Lester bashed away at his keyboard, producing fervent (VDKHEOQSNCHSHNELXIEN (+&H—SXN+ (E@JN?.) gibberish.

That incoherent streak could be a transliteration of what emerges from the axe of an untrained musician. But working a Smith Corona *musically* doesn't require the same manual skill as operating a guitar. With just one finger you can get poetry—or a novel. Fluency requires only literacy. And our society provides multiple systems so everyone can achieve that. We're trying to make everyone a writer. This can't be said of art, music, or design.

It's a truism that what's necessary to be a great writer is to be a great reader. And you're likely to hear it from distinguished writers, from Samuel Johnson ("the greatest part of a writer's time is spent in reading, in order to write") to Stephen King ("if you don't have the time to read, you don't have the time or the tools to write"). These are not precisely endorsements of amateurism or dismissals of creative

writing programs. Then again, there's Charles Bukowski: "just drink more beer / more and more beer / and attend the racetrack at least once a / week." ("and win / if possible.")

Success in writing is famously experience-based—write what you know. Of course, this refers to subject matter. That the styling goes unmentioned suggests it grows out of reading and writing the known. Word craft will come on its own, evidently. Just keep reading, living, and writing.

The category of the outsider as a relevant designation has collapsed after a decades-long decay. Like an unstable, artificial element, the dissolution began the instant it was synthesized. Its goal of generating authority for professions was accelerated by technology-driven social changes. Journalism has been destabilized by bloggers, encyclopedias by wikis. While we gain democratization, we lose vetting—and some confidence of quality. But that assurance is assumed. Shouldn't we be making determinations on our own? Are we responding to the work or the reputation?

With graphic design, loathing the vernacular seems quaint in the face of profession-based threats like online logo mills. The field still has methods of exclusion, based in its own version of class. While I sometimes rankle at falling outside this regard, I also find it presumptive when renowned professionals place their selective, adjunct teaching on a par with my own full-time standing. Either way, I'm flushed.

"Outsider" and "self-taught" are situations within disciplines, not indicators of a state beyond labeling. They are roles on the axis of creative activity. To have any title is to create a presumption that prejudices perception. Even "anonymous" is a statement. And, functionally, if you're crossing disciplines, it's awkward to pile up multiple titles. Many, none: it's all the same. Whatever helps you be you. ✤

Be Yourself, Be Someone Else

"Forcible dislocation of personality" was what he called the general technique, which is not exactly the same as "seeing the other fellow's point of view"; for it involved, say, wearing clothes that Stencil wouldn't be caught dead in, eating foods that would have made Stencil gag, living in unfamiliar digs, frequenting bars and cafes of a most non-Stencilian character; all this for weeks on end; and why? To keep Stencil in his place: that is, in the third person."

—*Thomas Pynchon*

Every creative career faces two major problems of self. The first is *finding* a distinct artistic identity and the second is *having* a distinct identity. Almost as soon as you manage to "find yourself," you need to get lost.

The way to a distinct creative sensibility (colloquially: originality) is often contradictory this way, and counterintuitive. Maintaining that sensibility, or simply keeping the creative process from growing tiresome and formulaic, introduces more paradoxes. However, there's a common—fictional—strategy to address both circumstances.

My province as an arts educator in graphic design is the front end of the artistic identity chase. To aid students in becoming more than complete regurgitators (we must stipulate that an amount of restatement is frequently necessary and desirable), educators need to understand the nature of their beginning status. Our intent is greater than inciting students to try different formal expressions. We should aspire to help students make discoveries of their own in their academic career.

For novices, outside of some practical inability to realize a work—a shortfall either in material or technical means—the barrier to realizing that discovery (which is usually expressed formally) is conceptual. It's what's commonly described as a "lack of imagination." However, the real problem isn't so much a deficiency in producing ideas. Many possibilities are envisioned, often too many. The sticking point is the *origin* of the ideas. They're usually decontextualized replications of a specific work, or an amorphous aggregate (colloquially: copies).

Students don't come to us as blank slates. The *tabula* is actually dimensional and extensively marked up, in haphazard layers, over a period of years. We all receive a broad but shallow education in graphic design—from the cumulative artifacts of design that we encounter. From them, we derive elementary rules of what graphic design should look like. As the bulk of these materials are components of a great mean, variation is slight. This untutored indoctrination affects how everyone anticipates and perceives graphic design. As an educator, I must confront this "natural" design education. I try to make students self-conscious of the training they've already received, not necessarily to eradicate it. Instinct at this stage might not be completely resisted, but must always be questioned.

Proponents of Roland Barthes might regard this condition as culture expressing itself through the student, a reality that's unavoidable and unalterable. Perhaps any effort to restructure students' awareness merely results in moving to other, more subtle instances of culture speaking—not the individual. Whatever the case, subtlety is better. The task is then to circumvent or short-circuit students' reflexes. The direct path is forcing them to do what they don't want to do. (A cynic would interject here that just going to classes accomplishes that.) The more resistant students are to some track, the more rewarding it should be.

The paradox of establishing a distinct identity is that becoming *you* requires doing things you normally *wouldn't* do. Education—progress—is change. The known is comfortable and not conducive to change. The more unnerving a particular direction or choice is, the more likely it should be adopted.

Through entertaining the atypical (for them), students' own proclivities might emerge. Essentially, it adds up to playing at being someone else. Adopting a different persona reveals the true character. If the methods they were comfortable with were working, there'd be no need for instruction.

Practically, I urge students to adopt awkward methods, and embrace the unfamiliar. Often, these are no more exotic than working at a dramatically different speed. This is different from the standard academic tactic of introducing them to "new ideas."

"New ideas" are often works by established designers. Emulating an admired artist is the standard method of directing students toward a sophisticated model of creativity. While this approach will expand a student's palette of possibilities, it's overly specific and retrograde— looking back on what *was* successful. Most importantly, it puts student in a bind. They're called upon to simultaneously regard *and* ignore the work, as we don't want them copying it. They couldn't be blamed for considering education (and their teachers) a big tease.

In a role-playing situation, students must fully engage *their* imagination to realize a work. The teacher's role is to perhaps provide an initial script, and always to coach and encourage improvisation. Along with providing the means into a creative identity, role-playing also offers an exit strategy should it become confining. Success frequently brings pressure to deliver more of the same. A winning formula is still a formula.

A prominent example of an escape role came out of desperation to break free from one of the most lucrative but eventually suffocating

identities of our time. "We were fed up with being Beatles," Paul McCartney said to biographer Barry Miles in *Many Years From Now*. "We were not boys, we were men . . . artists rather than just performers." In late 1966, McCartney imagined an album by the Beatles masquerading as another group, one eventually called Sgt. Pepper's Lonely Hearts Club Band. "We'd pretend to be someone else," McCartney explained, "It liberated you—you could do anything when you got to the mike or on your guitar, because it wasn't you."

It's arguable that the masquerade was unnecessary for the band. John Lennon stated that the album wasn't drastically different from and only continued the innovations of the one prior, *Revolver*. But it's certain that the Beatles' music subsequently underwent a pronounced transformation, or maturation, on *The Beatles* and *Abbey Road*. In a sense, they went from role to real, with each turn bringing them closer to themselves.

McCartney continues to dip into role-playing to depart from his known musical persona. As Percy "Thrills" Thrillington, he released *Thrillington*, an instrumental version of his *Ram* album. He's additionally recorded three albums as the Fireman in collaboration with bassist/ producer Youth. (John Lennon enjoyed toying with his credit lines— Rev. Thumbs Ghurkin, Dr. Winston and Booker Table and the Maître d's—but those were more opportunities for wordplay.)

Role "playing" was utilized by Brian Eno when acting as coproducer and conceptual provocateur for David Bowie's 1995 album *Outside*. Eno is a longtime (and long-winded) creative strategist who once expressed the wish that he could release each of his LPs under a different name, so both he and the public might come to it without preconceptions. For *Outside*, he scripted fictional characters for all the musicians and instructed them to play as that character might. For instance, the bass player may have received this script: "You are a musician at Asteroid,

a space-based club (currently in orbit 180 miles above the surface of the moon) catering mainly to the shaven, tattooed, and androgynous craft-maintenance staff who gather there at weekends. They are a tough crowd who likes it weird and heavy, jerky, and skeletal, and who dance in new, sexy, violent styles. These people have musical tastes formed during their early teens in the mid-nineties. Your big influence as a kid was The Funkadelics [*sic*]."

As with *Sgt. Pepper*, the goal was to inspire performances beyond standard licks and riffs, as good as those might be. From a critical standpoint, the results of the experiment were mixed. The album contains interesting textures and some standout tracks. However, it's not the high point of either Bowie's or Eno's separate or collaborative careers. But from descriptions, it must have been fun to make.

Espousing a public alter ego is now a recognized career move for megastars. What was a method of launching creative adventures has become an exercise of brand invigoration. (Prince's transformation into "unpronounceable symbol" and back was another creature entirely.) Garth Brooks donned the garb of "Chris Gaines" in 1999 for a "pre-soundtrack" to accompany a never-completed movie. Brooks's output as a faux rocker proved even less satisfying than his work as a "real" country musician. Some points to him though, for actually attempting a shift. Not as much can be said for Beyoncé's *I Am . . . Sasha Fierce*. Though superficially a separate character from the singer, "Sasha" was represented by tracks not far stylistically removed from Beyoncé's usual highly polished, carefully calibrated music industry product.

The necessity for media figures to reinvent themselves is now a platitude. And role-playing and image manipulation are already major components of popular music, especially at its highest levels of celebrity. Graphic design is heavily invested in the latter of these two endeavors, but as its technicians. For their professional identities, stability is best.

And fine artists are the most carefully and tightly branded figures in the creative arts. Their reinventions are either profoundly disparate (e.g., Philip Guston) or so subtle as to require the explication of a squad of theory-nimble art critics.

Everyone's personal identity, though, should allow for some flexibility. To say we all need to be open to change and new ideas is just mouthing more truisms. Easy to say, tough to implement. You don't want to let the fans down, however large or small a crowd they may be. And the mind has many defense mechanisms to keep the ego intact. It requires some deft misdirection to give us the license to go outside our proscribed boundaries of self. Creativity might be one continuous process of constructive self-delusion.

Do you think that it's hard—or too easy—being you? Then just try being someone else. ✿

Chaos Theories and Uncertainty Principles

"*Order out of chaos* is not the order of the day." This understated, finely calibrated put-down is the sound of Paul Rand putting his foot down in "From Cassandre to Chaos," the final essay in his 1993 book, *Design, Form, and Chaos*. As Rand saw it, some graphic designers had gone off the rails and needed to be called out. So he crafted the most devastating critique imaginable. Turns out, it was, unintentionally, the highest praise.

Graphic design bills itself—literally—as the order-maker. Its highest aspiration is instituting structure and sanity in a disorganized world through an aesthetics founded in functionality. This claim, incarnated over half a century ago ("Typography, perhaps even more than graphic design," wrote Emil Ruder in 1959, "is an expression of our own age of technical order and precision."), has since lost some poignancy. Normalcy via streamlined, scientifically derived, rational products fit that time's zeitgeist. However, every era believes its society is the fastest-paced and most pressured by rapid technological innovation. Therefore, we're perpetually in dire need of a primo instruction manual. So graphic design's claim on order still resonates today.

Designers make a fetish of instilling order. Practitioners don't consider it peculiar to contrast the different methods they've devised to organize their studio libraries. (Some delight in arranging books by the color of the spine. Once, the staff of bored and disdainful rock star wannabes tried that at a used CD store I frequented. I kept away till they rediscovered the alphabet.)

To hear designers tell it, society would be near autistic without their intervention. Could we be that helpless? Overall, skepticism has grown about perfectibility—and respectability. The rebel meme rides higher. "Orderly" comes with a tinge of repression. And how accurate was this "bringing of order" ever? The relationship of graphic design to order and chaos is more complicated than usually expressed. Maybe it's time to put the order function to rest. It never was design's true purpose anyway, despite what designers thought. Now as then, graphic design, in all its forms, is a cultural saboteur—a chaos-maker we want and need.

Challenging the status of order in the arts goes back to the mid-1960s, with theorist Morse Peckham's 1965 book *Man's Rage for Chaos: Biology, Behavior, and the Arts.* He asks, "Is there any real basis for these splendid claims for art in the name of order, and for order in the name of art?" He dismisses the assertion that "experience comes to us in a chaotic blizzard of phenomena," stating, "all behavior is patterned and all behavior is styled, including perceptual behavior; and by 'perception'... I mean all data reaching the brain through various senses." Citing studies of human perception, Peckham determines that "any perceptual experience is organized by a pre-existent pattern in the mind. Art, then, does not organize the chaos of experience. As far as human beings are concerned, experience is not chaotic and cannot be, at least for long; and while it remains chaotic the individual cannot act."

The inability to act that Peckham speaks of is intellectually paralytic—more profound than the confusion design commonly claims to work against. With design, chaos still has you functional enough to know you need to hire a good designer. Without one, you won't know which direction to turn, from what end to grab the tool, how to escape the airplane in case of a water landing, and so on.

Even when design allows that it's just proposing an ideal or preferable order to what would arise vernacularly—and here resides Edward Tufte's entire oeuvre—there's an existing order that's being supplanted. Something's already there. We're talking about *destroying* order—causing chaos. However "bad" that original order was, it was familiar and known. Graphic design is tearing around the landscape, ripping up as much order as it can get its hands on.

To the designer, this may not make much of a difference. But it does to the audience. That graphic design is replacing order for order makes no difference. To the audience, it's a violent act against *their* order. The new order requires adaptation.

In Peckham's estimation, this chaos-making is a good thing—it's life practice: "Art is the reinforcement of the capacity to endure disorientation so that a real and significant problem may emerge." This turns another doctrine of the discipline on its head. At its best, graphic design isn't trading in solutions; it's making problems. Graphic design is a representation of reality, an interpretation. It can't set reality to right, but it can provide practice in dealing with its stresses.

To this end, in its product and process, graphic design should actively counter complacency. To do so doesn't require any specific formal approach (the historic power of beauty has been its disruptiveness). An important measure of the value of any new design development should be whether it is disorderly, so as to challenge designers and audience alike.

Encouraging disruption anywhere in the design process seems counterintuitive, more so if you're developing a new technology. Efficiency, reliability, and ease have been essential objectives of any software development. This makes it doubly peculiar to intentionally write a program to sow unruliness. Any design-related program's ultimate purpose is to foster creativity. And the best way to accomplish this may not be the easy way.

During my graduate studies, I was introduced to a computerized editorial design program in development at MIT's Visible Language Workshop (VLW). The layouts of diverse publications were being quantified to develop templates that "content" could then be flowed into. Designers would only be needed to create the initial layouts.

The VLW members were taken aback when I declared the design program an ill-advised effort that should be junked. My objection wasn't that the software would put editorial designers out of business. I found the whole concept mundane and out of step with the times in magazine design, where *Ray Gun* was in its ascendancy. (In the VLW's defense, mainstream magazines then were all grid, all the time.) Rote formal expression of any kind—adopted by, not imposed upon, designers—seemed a bigger problem. Many graphic designers already were robots. Could we turn that around?

Their project neglected the computer's potential as something generative, not just facilitative, of design. Rather than shuffling blocks of data into preset frameworks, the computer might spur fresh thinking about design—through (controlled) chaos.

I proposed a computer program called Set/Reset that would run constantly in the background while a designer worked, tracking usages and habits. Rather than automating (and reinforcing) a designer's proclivities, this software would defy them—limiting or denying aspects of graphic design that had become habitual: from typeface choice to the amount of work time. The program would also be activist—making changes to individual elements or doing a wholesale reworking of documents. Set/Reset would actually operate much like the VLW program—you just didn't know what you'd get after you clicked "start."

The response to Set/Reset was bewilderment: "How will this help quantify magazine layouts?" They regarded it as a sincere but misguided proposal for real software. Any critique of modernist-inspired aesthetics

was a nonstarter. And the intrusive business was just impractical. So much for introducing uncertainty. If they were unsure of anything, it was just my rationality.

Promoting confusion and ambiguity as both process and goal will do that. In academia, where teachers are urged to fashion detailed assignments with clearly articulated terms of evaluation, it's a career risk. "I don't know what you want!" is a frequent, plaintive complaint of students. An injection of chaos seems contrary to their needs—cruelly so. But they seek a certainty that many working designers will testify is rare coming from clients.

Making chaos a deliberate element of graphic design education may be a responsible choice. If we really want to bring graphic design education closer to professional practice, we need to mix things up. A practicing designer should be adept at compromise and flexibility. Except at elite levels (and perhaps not even there), designers cannot dogmatically insist upon a unilateral, unwavering direction for a project. The client will want to have a say, as will other unpredictable forces: schedule, budget, acts of God upon hardware and software, and so on. Contingency plans are always necessary.

Preparing students to be creative under these circumstances means subjecting them to uncertainty—while jobs aren't on the line. For that, education is probably overqualified as is. Mission accomplished! I've been tempted to arbitrarily shorten deadlines, or alter the specs on a project in midstream—slashing or adding pages, inserting thousands of words of text, declaring that everything must be green. The only certainty will be that my student evaluations will suffer. However, in asking students to take risks, I might take some myself.

Under "normal" circumstances, aspiring designers provide a possible affirmation of Peckham's idea of an innate urge toward chaos. Beginning students regularly demonstrate a penchant for muddled,

unstructured layouts. The simplest assignment provides occasion for grandiose statements dismissing hierarchy and reason. It's almost as if students had never been exposed to examples of the artifacts they've been asked to craft. Since that's hardly the case, what's the cause?

Order is boring. Students have been there. Transmitting a received order is tiresome for them and, they intuit, an audience. Their choices aren't made out of naïveté or emulation of some alternate aesthetic. Having ordered the work mentally, students seek a visual disturbance. Though the expression may be tentative, we can give greater credit to the impulse—and help students pursue it.

Chaos is spreading. Chaos theory began in science and moved to a variety of disciplines, including politics and philosophy. The commonality between them is the presence of a subtle structure unrecognized under a preexisting set of assumptions. Will there be a graphic design chaos theory? Professional design might not be averse to such a theory, as it will doubtless claim the ability to manage this "new" chaos. The order meme is too valuable to design consultancies, peddling "strategic design" solutions for nervous companies.

I don't know what's to be found under graphic design's presumptions of chaos, but it's worth a look. Fortunately, we're not without guides. Here is the sound of Salvador Dalí, putting his foot down to take a step: "What is important is to spread confusion, not to eliminate it." ✪

Indiscipline

Proposing an interdisciplinary curriculum for design education infers that such programs are currently rare and absolutely desirable. To eliminate any suspense, I'll stipulate agreement with both points. Design curricula that aren't essentially vocational are scarce, perhaps nonexistent.

Even among the elite design programs where theory and experimentation are prominent—such as Yale, Cranbrook, and CalArts—professional practice is the determinant. As proof, it's notable that the educators regularly featured by the nation's largest professional design organization, the AIGA, come from these institutions. It's a love/hate relationship, to be sure, but selectively adversarial. Meanwhile, in academic forums outside the design profession (such as the College Art Association), they are rarely seen. Other disciplines may inform design, but it largely keeps to itself.

As to the desirability of the proposed interdisciplinary format, I believe that the move to a broader and deeper conception of design activity and study would benefit students, society, and the design field. That's a big claim to make. I admit I can't provide any solid evidence; I may be lucky to offer some proof that's fluid. I'll also confess, my prime rationale is: "Why not? What's really to lose?" I will try and show that an interdisciplinary study is in line with design's rhetoric about itself. And that it is a responsible, possibly *the* responsible, structure for design students to study within. However, before outlining my conception of an interdisciplinary design education, I have questions about some of

the assumptions I see around the topic. I don't know if any of these are "deal-breakers," but I want to raise them.

First, to have interdisciplinarity, you need two or more disciplines, according to my dictionary. But is design a discipline at all? This seems like a nasty, almost sneering question to ask. Unfortunately, design educators know proclamations like this are made often, with intended sarcasm. Actually, it's more a rhetorical question—posed within art departments by nondesign faculty.

Much as I dislike giving credence to such puerile behavior, the question has merit. Design has an unstable, amorphous identity. Its discourse and history borrow heavily from art and architecture. The overwhelming majority of its practitioners are most comfortable describing it as a service. To hear design professionals describe their field, design education seems on par with classes at McDonald's Hamburger U.

My point is that a discussion of interdisciplinary design education has much higher stakes than we may think. While design programs are widespread—perhaps distressingly so—their legitimacy and efficacy are dubious. The design field itself pays only lip service to the importance of education. Practitioners regularly assert that effective design can only be learned through on-the-job experience. Design itself doubts its identity. The late Dan Friedman, who questioned if design was ubiquitous or nonexistent, famously stated this.

So we shouldn't immediately assume we have a place at the disciplinary table. In debating interdisciplinarity, we may really be establishing ourselves as a true and vital area of study. I am aiming for something greater and more substantial here than acquiring academic legitimacy. Rather than conforming to established boundaries and methods in academia, I see design as having a potential to challenge them.

Design resides at the intersection of culture and commerce, giving its study relevance unmatched by other areas of cultural produc-

tion. The tension between individual action and societal need is also significantly played out in design production. The potential for a substantive discipline is there, though largely unrealized. Ironically, by moving toward interdisciplinary study, design may establish its discrete identity.

Interdisciplinarity has been a popular concept in education, but the term is vague. The confusion on my part may be due solely to my unfamiliarity with the academic playing field. But what is the difference between interdisciplinary and cross-disciplinary? And what of multi-disciplinary? Perhaps it is best to speak of a hybrid curriculum?

Debating nomenclature is an essay word-killer, and I pledge to now move on to articulating the content rather than the label. The interdisciplinarity frequently proposed is limited to one between art and design. My call is for a broader engagement. In my view, there is a distinction with no difference between these terms. Both activities conceptualize form and are firmly rooted and determined by capitalist forces. A call for an interdisciplinary curriculum between art and design describes what currently exists.

Since many design programs exist within liberal arts colleges, they could claim they already provide an interdisciplinary education. Students are required to take courses in various disciplines to obtain a well-rounded education. The questions then become: Why would we need to duplicate the effort? Is the call for an interdisciplinary curriculum a de facto critique of the liberal arts model?

A criticism of the standard liberal arts model that isn't unique to design is that shaping one's education becomes a "one from column A, one from column B" menu exercise. Only an illusion of a broad-based education is achieved. The structure is static, suppressing investigation. Designers—including design students—frequently question the relevance of these outside courses. Time spent in lib. ed. classes is time

taken away from the studio, where the real work is done. Any further intrusions into studio time would be strenuously resisted.

While I am a firm believer in the opportunities of a liberal arts education for any student, I must confess difficulty in justifying it. When questioned by students on the relevance of math or science to their studies, I find I mouth the party line without any substantiation. It's wishful thinking. A liberal arts education might provide the advertised advantages. Motivation is always the sticking point.

I am also unsure if I am not generating an intellectual disconnect between what I say about my personal experience and my advice. Having gained both of my degrees from art school, my liberal arts education is largely autodidactic. What kind of example am I? Do what I say, not what I did? And I complicate this further by being a self-taught designer. Maybe I shouldn't be opining at all.

Overall, the term "interdisciplinary design education" might be regarded as redundant. Design by definition—but not often in practice—is distinguishable by activity inspired, informed by, and at the service of other intellectual pursuits. Though this continues to be the field's rhetoric, form-making for its own ends has been the real determinant. How far can form-making be de-emphasized and still be design?

Do any students go into design because they've been inspired by the nutrition label on their soda can? Or been so frustrated by the instruction manual to set up their Xbox that they vow to make a better one? So-called information design plays an increasing role in our society but draws few disciples. It would seem a natural area within design where an interdisciplinary education would be advantageous.

Meanwhile, other design programs are within colleges of art. These institutions offer "singular" curricula emphasizing form-making. Here, interdisciplinary studies means getting down and dirty in ceramics or other studio areas. There may be liberal arts courses at these schools,

but as adjunct to the primary studio activity. I'm unaware of any other studio arts program—the area within which design is usually located—that is considering anything like we're discussing here. Is the call for an interdisciplinary design curriculum a veiled reproach of art schools? Because of their nature, liberal arts colleges will be better positioned to put some kind of interdisciplinary study in place. Instituting it in art schools may require a wholesale reconsideration of the art curriculum.

We must also consider the disparate nature of the students for which design curricula are intended. Is there a single goal of design education? Should success be measured solely by how many designers we put in art department cubicles? Is the goal the same for programs in art schools as for within universities, or is there a similar divide between the two, as described above?

The major divide between design students is that some will go on to employment as professional designers, while the majority will not. Most educators can get a good read on the surefire future designers and the total washouts. The largest group lies between: those who could go either way. There are more computer chairs available when the music stops than can be filled by the elite students. But there's never enough for everyone. Determining who will fill those extra seats can be a matter of chance and other forces we can't foresee. So we're unable to state for certain whom the majority of working designers will be.

But the principal group in our classes remains students who will never see work as practicing graphic designers. What is our responsibility to them? Shouldn't our curricula focus on their needs? Is our goal only to try and make everyone into graphic designers, even when we know it's impossible?

We might say that there is more likelihood that the students from art school programs will work as designers. The standards of

acceptance, hence commitment, are more stringent. The students are more motivated and learn under a more intensive formal program—one preferred in the field. What about everyone else? Are we educators or impersonal trainers? Rather than regarding itself as a visual art, design might move to recreating itself as a liberal art. Here, the study of design is a means of interpreting and gaining knowledge irrespective of the intent to practice.

Gunnar Swanson furthered this idea in his 1998 essay "Graphic Design Education as a Liberal Art: Design and Knowledge in the University and the 'Real World,'" published in *The Education of a Graphic Designer.* He suggests the possibility of studying graphic design without the intention of actually practicing it: "We must begin to believe our own rhetoric and see design as an integrated field that bridges many subjects that deal with communication, expression, interaction, and cognition," Swanson wrote. "Design should be about meaning and how meaning can be created. Design should be about the relationship of form and communication. It is one of the fields where science and literature meet. It can shine a light on hidden corners of sociology and history. Design's position as conduit for and shaper of popular values can be a path between anthropology and political science."

The most prominent critique of Swanson's essay was by Andrew Blauvelt, in accompanying notes to an *Eye* magazine article ominously titled "Dumb": "Design as a field of study without practical application is unlikely and undesirable . . . it is the practice of graphic design . . . that provides the basis of a theory of graphic design." To Blauvelt, Swanson's idea was merely a "quest for academic legitimacy." "Critical making" is the model Blauvelt proposes: an intensive examination on how and why to make design.

Though a distinguished scholar, Blauvelt's counterpoint is in the voice of the professional maker, demonstrating what appears to

be a surprising insecurity about his field's potential in comparison to "true" liberal arts. He shortchanges design's capacity as a subject for study, discounting the possibility of a substantive external critique from nonprofessionals. Blauvelt's move from academia to design direction at the Walker Art Center is notable in this regard. Blauvelt is likely correct that, at present, design study without practical application is unlikely. Academia doesn't promote the idea for design the same way as it does for, say, philosophy or creative writing. The attitude isn't part of some conspiracy, just a mirroring of societal attitudes. And the graphic design field explicitly advocates design for designers.

It is naïveté on my part, but I'll claim that my interest in design as a liberal art isn't a stuffy quest for legitimacy. Rather, it might challenge traditional academic boundaries. What is the danger to design in throwing open the doors? What makes it "undesirable"? Are the current models for design education so effective?

Swanson allows that it's not clear what form a liberal arts graphic design study would take. He has personally critiqued his essay and identifies a serious flaw. Who will teach in such a program? Considering that most design professors come from programs that privilege formal concerns and/or are drawn from the profession, instituting an interdisciplinary curriculum is problematic. An awareness of, and belief in, alternate inspirations and routes for design is necessary.

Is it more likely that design educators will develop a breadth of interest or that nondesigners will acquire a graphic sensibility? Swanson is pessimistic about designers (and a scan of the field offers little to counteract this response) and realistic about the latter: "While parallel disciplines are the basis for understanding the context of design, we can hardly expect a real examination of design issues by non-designers." Unfortunately, we may be stuck in a Catch-22. To establish the interdisciplinary liberal arts design program, we must

have design educators who have studied in interdisciplinary liberal arts design programs.

The future of a true interdisciplinary design may lie with nondesigners not only working with designers, but also becoming designers. The infusion of educators with backgrounds in other fields—e.g., literature, sociology, the sciences, and psychology—promises a break with the dominance of form exploration at the expense of meaning generation. Another potential is to move away from the professional-practice orientation of design theory.

The stakes are high with an interdisciplinary design program. The ramifications for design and the art programs they usually reside within are greater than we may expect. The odds against it happening are also high. What it may take is students abandoning the other liberal arts for the discipline of design. If they do, we must be ready to welcome them in. ✿

Seen and Not Seen

These, like the over-largely lettered signs and placards of the street, escape observation by dint of being excessively obvious; and here the physical oversight is precisely analogous with the moral inapprehension by which the intellect suffers to pass unnoticed those considerations which are too obtrusively and too palpably self-evident.

—Edgar Allan Poe

Business wants him [the designer] to help create an attitude about the facts, not to communicate them. And only about some of the facts.

—William Golden

Graphic design as a *project of legibility of the world* little by little extends to all aspects of the environment.

—Abraham A. Moles

Let's agree for a time that all histories are conspiracy theories. Today, that's not much to ask for—it isn't even necessary to be paranoid. It's a logical conclusion since histories are commonly presented as narratives. All historical developments are provoked by various individuals acting in concert to achieve desired ends. Events are set into motion that culminate in the present. When we're in the midst of developments, it's rarely—if ever—clear how matters will turn out. But once we've reached a result, we can cherry-pick the past for signs of the eventuality. Argued in reverse, there's a sense of inevitability, though events could have played out in multiple ways.

Design history works the same way—as visual scheming on a vast scale. Our particular history is a series of successful graphic intrigues performed upon culture. These schemes are considered benign by most—from Bauhaus to Basel to Yale to Cranbrook and beyond. All are members of a Cabal of Clarity.*

Going against type, design's conspiracies supposedly seek to reveal. Like a free-market CIA, design deciphers the world and sells its encoding and decoding talents to the highest bidder.

Of course, design has debates about the efficacy of some fellow conspirators' plots. Certain practitioners and theorists will occasionally be accused of counterinsurgency. However, it is generally accepted that clarity is the core mission. To obscure (or be obscure) is merely a sign of poor contrivance. But the larger conspiracies in our visual culture are silent and undirected. They evolve from inertia. They're the unintended consequences of innumerable actions in the Clarity Conspiracy. This essay's epigraph from Poe illustrates one of these outcomes. Individually, each sign is clarion. As a group, they're cacophony.

One hundred and fifty years after Poe's description, matters obviously haven't improved. Along with articulating the world on its own terms, design is also locked in a struggle against itself. It's now a truism that the contemporary designer's challenge is cutting through the media noise. Always ignored is the fact that any counteraction generates yet *more* furious sound. The strategy of choice is pumping up the volume—same tools, same outcome. Is it possible to overcome the conspiracy with its own weapons?

Before cranking the amp to twelve, we might examine the operation of (in)visibility more closely. Is graphic visibility solely a product of novelty, and invisibility inevitable when that novelty wears off? Is invisibility hastened by ubiquity? Are there strategies of low visibility (small-scale, limited distribution) that may prove more effective for

longevity? Is longevity desirable if possible? Are many claimed strategies of graphic efficiency actually camouflage?

Poe's "palpable" self-evidence could more simply be stated as "Familiarity breeds invisibility" or, to restate another cliché, "In sight, out of mind." Since attaining high visibility, then maintaining it, is design's traditional goal, these are disturbing realities. However, a need has arisen for designs that selectively obscure and reveal. This method of design responds to a multiplicity of new texts created for the overabundance of products churned out by consumer society. It may be that design adopts a modernism-derived simplicity, not so much to have ultimate clarity, but to be able to squeeze more new languages onto artifacts.

These new texts are specialized and arcane: inventory numbers, indicia, ingredients, catalog numbers, legal notices, copyrights, et al. The more artifacts that are brought into being, the more texts we need to situate and describe them. A location within the language must be established. These languages are specialized, a kind of ambient code: ever present but ignorable.

Chief among the new texts is the universal product code (UPC) symbol—the bar code. Bar codes are the most prominent and omnipresent example of an essential language that is meant to be invisible. While created by humans, the UPC is text for machines to read. However, as the bar code has multiplied and been disseminated in our culture, it has acquired meanings for humans as well. And for designers, the bar code is possibly the most visible—and maddening—language they must deal with.

Karrie Jacobs's 1989 *Metropolis* article, "The Code," presents a thorough and entertaining history of the UPC symbol. In her essay, Jacobs immediately notes the UPC's ubiquity and invisibility, and how these two aspects intertwine. She recognizes that bar codes are now "read" by people. Simply, the presence of a bar code signifies

that something is for sale. It's a stamp of authority. The UPC is the elementary signifier of commerce. Many designers utilize the bar code rhetorically to trade on this.

To claim the bar code as also having invisibility, Jacobs suggests the public wills it out of existence. But is this really the case? To drive something from your consciousness, you must first acknowledge its presence. Perhaps Jacobs is only partially right. The bar code likely exists in a kind of public quasi-existence where it is more *sensed* than seen. For the public, the UPC is of a kind with the rest of the designed environment: natural. It's just there—no more or less than the type and imagery seen elsewhere on the box. The UPC's designers (or, more appropriately, engineers) never considered human response to their artifact and its final impact. And this, of course, is the precise reason designers object to it.

As visual sophisticates, Jacobs and designers overall understandably obsess over the formal import of bar codes. If anyone is determinedly trying to will UPCs out of existence, it's designers. After providing background on the code, the majority of Jacobs's article is given over to various designers' statements of loathing for the symbol and their attempts to circumvent or conceal it. For designers, the lesson of the UPC is an old one: nondesigners always impose restrictions that prevent us from doing good design.

In this way, the bar code is the designer's ultimate nightmare. It's created by a committee of nondesigners, requires prominent placement at an oppressive scale on everything, and—most of all—is impervious to aesthetic manipulation. Imagine musicians being forced to include a grating, monotone voice bellowing a string of numbers in all their tunes. Unless you're Philip Glass, it would be an intolerable requirement.

We might, though, measure a designer's true acceptance of their material role by their level of comfort with bar codes. Designers

frequently cite their willing embrace of commerce as what distinguishes their practical activity from art. The quality of a designer is regularly determined by their facility in ameliorating aesthetic and commercial demands. Welcoming the UPC may be the greatest demand commerce has placed upon designers. Following this rationale, the British graphic design group the Designers Republic emerge as exemplars. Their designs make a fetish of all of the unseen languages of our commercial culture. It becomes ironic that the Designers Republic are regarded as avant-garde and artistic.

Graphic design's desire to have unbroken vistas of formal space likens it to fine art. Artworks are popularly regarded as artifacts born out of and generative of emotion. Bar codes are frequently accused of being soulless and mechanical. Their precise, rigid vertical lines are devoid of any feeling. It may be, though, that such criticism looks in the wrong way for feeling in formalism.

In the abstract art following the Second World War, profound emotion was invested in straight lines. Barnett Newman invested deep meaning within works such as his *Stations of the Cross* series—all vertical stripes of white within a black background. In the shadow of extermination camps and potential nuclear holocaust, figure drawing seemed precious and incapable of expressing disturbing new realities. Artists could only turn to the stark abstractions and contrasts of light and dark and elemental form. Their works emphasized the collapse of old methods of expression and artists' struggle for a language to communicate the enormity of contemporary fears.

Finding a way to formally portray profound moral concerns will always be problematic. But it is worth noting that minimal linearity was used by artists seeking to engage society's ills after both world wars. The early modernists also turned to elemental, abstract forms in the early decades of the twentieth century. While we continue to

debate the validity of these creative programs, we must also credit the impulse to transcend art's insularity from immediate social concerns. Rather than being regarded as soulless, straight lines were the formal weapons of choice to assert responsibility.

The legacy of these formal movements is highly questionable. The repetitive grids of artists such as Sol LeWitt derive all their significance within the boundaries of art theory. In design, the bar code might be the elemental symbol of modernism's failure and colonization by commerce. Societal good has been defined as transmitting the broadest, most persuasive commercial message—and ignoring the source and impact of that message.

In the clarity conspiracy, the central tenet has been obtaining the greatest visibility for the greatest numbers. The audience for design was regarded as a singularity. Increasingly, the public has become a true plurality, an array of target audiences. The directive to know your audience implies a multiplicity. Design has more than allowed directed visibility; it has demanded and trumpeted strategies of directed *invisibility* as a virtue.

The strategy of creating visibility for a product has long been recognized in design. Passed over is a corollary, generated *invisibility*. A novel aspect claimed for some design works, like the David Carson–designed *Ray Gun*, was that they attracted one audience by repelling another. Youths identified with and desired artifacts adults refused to or couldn't see. This supposedly turned the clarity conspiracy on its head: a willing *unseeability* was sought.

The designers of such artifacts, of course, claim this repulsion/attraction as a fortuitous consequence of their primary strategy: self-expressive, rebellious design. Theirs is an accidental genius of branding. Since then, strategic repulsion has been invoked many times and judged a viable tactic. The truth is that this strategy has always been with us,

occurring more often at the "conservative" end of the spectrum. Once again, the rule of unintended consequences is more properly credited as a generator of invisibility. But if we indulge in our conspiracy theories, a different agenda may be outlined. In this formulation, certain audiences keep "classic" or "outdated" design in place to deter investigation.

Take the *Wall Street Journal*. An argument can be made that it is the central informational artifact of our capitalist society. Detailed in this newspaper are the operations and movements of capital, from which all power derives. To know who controls wealth and the uses to which it is put is to have key information on how the world works and who's in charge.

The *Journal*'s design is hardly inviting, particularly to the average newspaper reader. USA *Today* it's not (this is not to suggest that USA *Today* is any ideal of design or information delivery). While arguably polished and refined, the *Journal* is also debatably dense and user-unfriendly. As much as any "cutting-edge" design, it requires a strong motivation to plumb its depths. What is probably considered "sober" may also be called unappealing.

The *Journal*'s rationale is that it is inviting to its audience and provides the information they desire in the most efficient and appropriate manner. In a letter posted on the *Journal*'s website to introduce a 2002 redesign, publisher Peter Kann declared that the introduction of color was merely to help readers "navigate" the paper. "We won't use color for color's sake, or merely to entertain you," said Kann, "That isn't the *Journal*, and it never will be." (Rupert Murdoch's 2008 purchase of the paper, and subsequent re-redesign, may have fudged that promise.) Further, Kann unapologetically declared the *Journal*'s elitist agenda: "This publication isn't for everybody, and we don't intend for it to be."

For all the import claimed by and attributed to the *Journal*, only brutal economic pressure forced it to resort to strategies to make it

more accessible to a wider audience. They argued that they were already widely popular, with over a million subscribers. However, that audience was—and continues to be—hardly mainstream or populist. To nonsubscribers, the paper's stolid grid of gray type acts like camouflage colors or a force field. *I'm boring and of no significance to you*, its pages say, *go on about your business elsewhere. Ideally, the mall.*

If one believes the activity of capital to be innocuous, a conspiracy of invisibility seems dubious. And as we venture further into a world of niche markets and target audiences, such theories will seem even more suspect. The conspiracy of clarity is still ascendant, and designers are just talking to their audiences in the languages they understand.

In Thomas Pynchon's 1966 short novel *The Crying of Lot 49*, heroine Oedipa Maas stumbles upon the vast Tristero conspiracy. Or, she may have been driven to delusion by a crazed culture and concocted a paranoia fantasy out of graffiti, misprinted postage stamps, and updated anthologies of Shakespearean-era plays. Once she becomes sensitive to particular markings that previously blended into a background of signs, symbols, images, and texts, her view of the world shifts like a double-image postcard. Turned slightly askew, a new, sinister world is revealed where an alternative message-delivery system parallels our familiar one. Only this alternate system is reliable—conveying both the artifacts *and* their true meanings.

Pynchon's vision has been replicated *en mass media* over the past three decades since his book's publication. With conspiracy theories a prevalent mainstream theme of television, movies, and books, suspicion has been downgraded. The more fiction turns to it as subject, the more all conspiracy theories are likely to be regarded as more (mere) entertainment. Meanwhile, the true conspiracies are far more subtle and closer to the surface. In design, they *are* the surface. And the conspirators are unaware (or uncaring) of their involvement and sustenance of the plot.

Frequently seeing themselves as victims, designers are more rightly perpetrators. Cursing the minor inconveniences of clients' stylistic demands—such as fouling their layouts with a bar code—they ignore the major machinations of capital. Having historically not seen beyond the surface, they distance themselves from their role as conspirators *against* clarity.

A wonderful conspiracy would be participating in a true, populist program of visibility. Designers might make themselves discernible as a group dedicated to social and cultural change. The machinations of power would be made apparent and designers would refuse to be complicit. Such a program is, admittedly, utopian—though no more so than the modernist program. Designers also do not possess the capital to create and disseminate mass messages. However, it is undeniable that they are actively engaged in creating those mass messages. A mental reassessment from active to activist may make a world of difference.

We also know that small messages over time and multiplied a thousand-fold may also have impact. These might be ideal for the best visibility. Making a living need not equal papering over corporate interest or barring the questioning of institutional prerogative. Designers with foresight and critical hindsight might make a life of res(v)olution. We might then see all there is to see. ✜

*In this context, I am using "clarity" to indicate a stated intent to reveal a complexity of ideas, as opposed to a deliberate obscuring of information. We may, as this essay does, debate the effectiveness of a particular strategy and whether the actuality matches the intent. However, here I am taking designers' claims at face value. In my interpretation, all design theories in this spectrum ultimately desire to provide rather than withhold or direct attention away from significant ideas.

Skilling Saws and Absorbent Catalogs

> The teacher tries to make the aspects of graphic design interesting but he
> really can't because they are boring.
>
> *—Art student's evaluation of a foundation graphic design course, spring 1997,*
> *taught by Kenneth FitzGerald*

The Matter with Two Minds

Designers have an art conflict. When attempting to establish design quality, discussions customarily enter—some say intrude into—the region of art. Is design an art overall? Is great design art? For the latter question, the answer is usually yes, no matter the designer you ask. For the former question, the answer invariably seems to be no.

Paul Rand himself couldn't arrive at a consistent, coherent answer to these questions. Depending upon where his theorizing wandered, design was or was not art. Neither author nor editor cared (or dared) to resolve the internal inconsistency created by contradictory claims. To Rand's legacy we may add the initiation of this art schizophrenia. Design desires to be art and not-art simultaneously—and fears it's neither.

While it is futile to argue what is and isn't art or design, we will gain from studying the origin and operation of the terms. By revealing our need for such terms, we may move to a healthy method of evaluation. The goal is not to "elevate" design to art's level but to relocate both. It's a given that art has higher cultural station, however nebulous and undeserved. Establishing this hierarchy is a valuating function

based entirely upon self-image rather than objective criteria. People want the prestige that derives either from producing art or knowing it when they see it. This despite the fact that there is not, never has been, and never will be a consensus on what art is. Art is all aura—wondrous but unable to sustain itself under the spotlight.

Challenging stock convictions may move us toward what Edward O. Wilson calls a "consilience." This obscure 1840 word derives from William Whewell's book *The Philosophy of the Inductive Sciences*. Wilson describes the word as meaning "Literally a 'jumping together' of knowledge as a result of the linking of facts and fact-based theory across disciplines to create a common groundwork of explanation." As art and design are intellectual constructs, we can never prove any assertions. We may, however, establish a more realistic foundation for discussion of our visual culture.

More than conceiving new theories, we need to identify and disassemble the many ill-constructed conceptions between and within art and design. Ultimately, consilience is a radical action for both fields. For art, consilience challenges a position at the top of the cultural food chain. A major threat for design is to the stature of designers whose regard within the field depends upon peer ignorance of art. The paradox of design is that the more it tries to distance itself from art and assert independence, the more artlike it becomes. Conversely, prominent efforts to (re)connect design to art have only served to devalue design and produce a legion of irascible practitioners.

Articulating a substantive difference between art and design is impracticable. In terms of forms, process, intent, causality, or response, the activities are identical. Difference is located in the sector of consumer culture a person wishes to operate in, and in the cultural role one feels most comfortable playing. Artists are people who choose art, designers elect design.

The Cap A, Dropped

It is clear that art is useless, that perceiver and artist are arrogant and indifferent . . . Art tells us nothing about the world that we cannot find elsewhere and more reliably. Art does not make us better citizens, or more moral, or more honest. It may conceivably make us worse.

—*Morse Peckham*

The presumption of art's essential "goodness" is a conventional trope. It describes nothing. Art education is not redeeming for the vast majority of students, nor is art practice redeeming for the vast majority of artists. The "good" works of art that reside in our museums reside there not because they are "good," but because we love them . . . [This] is the argument: art is good, sort of, in a vague, general way. Seducing oneself into believing in art's intrinsic "goodness," however, is simply bad religion, no matter what the rewards.

—*Dave Hickey*

The immediate obstacle in talking about art is locating which type you're talking about. Is it the personal, the pop cultural, or the academic? The calling or the art culture industry? As described by art historian Donald Preziosi, the academic meaning is constantly in flux: "The broad amalgam of complementary fields in which the modern discipline of art history is positioned never achieved fixed or uniform institutional integration. Nevertheless, in the long run its looseness . . . proved particularly effective in naturalizing and validating the very *idea* of art as a 'universal' human phenomenon."

Transition is the requisite state. The only possible answer is a conditional one. (Want design to be art? Wait a few minutes.) With the expansion of what art history considers its field of study, excluding anything—not simply design—is problematic. Selecting out design becomes a matter of personal taste or prejudice. These motivations continue to be the most powerful influences on discourse.

A more fundamental complication to debating art is the origin of the term. The structure of our language precludes arriving at a functional definition. When Aristotle and Plato carved up reality, art was the Other. Art is what's left when you can't categorize something as useful. To paraphrase Jacques Lacan, *l'art il n'existe pas.* Rather than being elevating and resplendent, the term is a linguistic black hole. Calling something art effectively removes it from our universe altogether. The activity collapses into a realm we can only speculate upon.

Art speculations are essentially mystical. Art is venerated for its ability to produce transcendent experiences. Attributed to art are virtues and verities that are as profound as they are ineffable. While these art apotheoses are likely very real for their recipients, we may still question their cause. All attempts to locate "artness" within objects or their producers have proved to be failures. Describing the art experience is more rightly the province of perception theory and cultural study.

Morse Peckham describes art in terms of role-playing. The purpose of studying art is to instruct us in how to play the role of art appreciator. When presented with what we recognize as an art appreciation situation (almost exclusively in a gallery or museum), we know to adopt the art viewer role and anticipate the art experience. A great work of art is one that best meets our anticipation of what an artwork *should* be. The rigidity or flexibility of our expectations determines what we will consider art. The inherent nature of the work is, at best, secondary.

Our reaction to art is hardly spontaneous—culture instills it. That art exists is a teaching of culture. We respond as a result of training. The profundity of our reaction depends upon how seriously we take our role. Everything we today regard as art—whether it be a Renoir or a Koons—was once nonart and was rationalized into the definition.

Art is also purported to be our vanguard of culture and a vital experience. As prevalent as the belief that art anticipates culture is,

little evidence can be found as proof. If art isn't *following* the concerns of society, it is blissfully uninterested. Art objects may be catalysts for and products of social change. However, all artifacts of our material culture possess these qualities.

The means by which art enlivens existence are a matter of faith. Billions of people have lived and continue to live without exposure to anything considered art, and are no worse for it. A better argument may be made that the experience of art is detrimental. It either proposes an unobtainable fantasy or twists the mundane into distressing phantasmagoria. Assuming, that is, you are able to comprehend the work. And of course, there's always a bottom line. If you get addicted and want to possess some art, the costs are exorbitant. Is it expensive because it's art or art because it's expensive?

Then there's the disturbance of interacting with artists. Certainly, no one can claim art-makers are de facto a saintly breed. The popular conception insists just the opposite. One of the most bizarre and insupportable contentions of our culture is that only reprehensible persons have the ability to generate the art experience. Though possessed of a self-image as exemplary humans, artists are no better than most, likely worse on average. And in their emulation of artists, designers adopt their most offensive traits. They regularly fuse aesthetic superciliousness with an arrogance born of considering themselves masters of practical action. In art as in design, this conceited attitude likely compensates for a bitter realization. Society considers their activity a marginal, self-indulgent pursuit. Artists receive adoration from the greater public only in the abstract.

The Designers' Art

Be regular and orderly in your life . . . so that you may be violent and original in your work.
—*Gustave Flaubert*

Designers consider themselves creatively aware and often study within art programs. However, they are no more in touch with art than your average Joan. When designers talk about art they rarely deal with the reality of contemporary art practice or theory. The art of the past seems a more commodious area to opine in. However, comfort doesn't bring clarity. Misinterpretation and misrepresentation are common when designers engage past activity. Art is rarely looked at rationally. The people, process, and product all become romanticized.

When referring to art, designers usually settle in one of two historical eras. For those of a more traditional bent, nothing seems to have happened in art—at least, nothing worthy of attention—since about 1940. The more progressive-minded designers will, however, accept art up to 1955. What often distinguishes a conservative from a progressive designer is which outmoded conception of art they prefer. Art after 1960 is largely ignored, even though conceptually, it's more interesting for designers.

The former, larger group of designers sees art as high aesthetic activity. The lineage that Rand created in his books is a classic demonstration of this model. Art is an artifact of transcendent genius that stirs profound emotion in the human soul. A masterly manipulation of formal elements moves these artifacts to a rarefied plane. Only the finest of design may claim this level of achievement, though all should aspire to it. The requirement is awareness of and strict adherence to aesthetic rules consistent throughout history.

This model is no more arguable than any that have evolved since. However, it is historically backward and archaic. Rather than responding to the critiques of their models—in other words, recognizing any of the art made in the latter half of this century—Rand and his followers dismiss them. Where design makes the cut is significant: it occurred when graphic design comes into being. Was design the end of art?

"To poke fun at form or formalism is to poke fun at . . . the philosophy called aesthetics," Rand wrote in his 1993 essay "From Cassandre to Chaos." The problem is, art had been debunking aesthetics throughout Rand's entire adult life. In his books, Rand referenced outdated doctrines, peppered his text with a multitude of often-contradictory quotes yanked out of context, and constructed a philosophy ultimately dependent upon his status in his field. Only within design could you find regard for these declarations.

Of course, Rand's books were self-promotions. His theory's ultimate end was to create a noble lineage into which he could insert his work. Like David Carson's *The End of Print*, these books theorize to self-aggrandize. An objective, critical analysis is nowhere on the agenda. The art interpretations made by design-star hagiographer Lewis Blackwell in Carson's name supervene Rand's in shallowness and distortion. Both theorize from surface readings. Carson considers his work as having "similarity" with "Outsider artists/Art Brut" in *2ndsight*. This statement sounds learned, but is more empty romanticism. Ignored, as always, are the quite separate historic, intellectual, and cultural circumstances that brought these artistic conceits into fashion. The former construction, outsider art, is a self-negating term (if it's outside art, it's not art) that denigrates, not celebrates, the activity. Carson's "outsider" stance is similar to a career politician claiming to be a Washington outsider.

Rand was entitled to formulate his own version of art history. For the majority of people, Rand's claims sound succinct, sensible, and lyrical. This is because they are concise bursts of received knowledge. *Everyone knows these things.* It is, however, comforting to hear them intoned by the Oracle. If someone with his stature lives by these beliefs, there must be something to them. Designers forget that design conferred his stature, creating a self-reinforcing system. It also doesn't hurt to write your own monograph.

Rand's theories require review because of how they continue to shape the sensibilities of designers. In "Paul Rand: The Movie," (*AIGA Journal of Graphic Design* 16, no. 2 [1998]), Elizabeth Resnick describes the response of design students to a new film on Rand. All show enthusiasm and admiration for his insistence that design is art. However, those students will become even more marginalized and disenchanted with their work and status if they attempt to define themselves by Rand's fallacies. Elided in his process were the wholly subjective and situational-specific circumstances surrounding the acceptance of his work. (Rand regarded the turn by corporate America toward designers who were formally antithetical to him as evidence of a CEO dumb-down. What it actually demonstrates is that CEOs are shrewd enough to recognize how to utilize design styles to signal contemporaneity. No matter how aesthetically "correct," business will junk design that doesn't signify what consumers respond to.) Rather than investing in the ideas of their times, the students accept inculcation into an illusory legacy.

Today, it is a common opinion of designers that everything went to hell with art in this century. For many people, art of the last half-century has been progressively more and more appalling. Art stopped being about the visual and became ideas—masturbatory and ridiculous ones at that. Once the province of genius practitioners and unquestioned aesthetics, academics hijacked art and stifled it under incomprehensible jargon. Artist-manqués were only too happy to join the game.

There is merit in some of these arguments. Unfortunately, designers lack the critical substance to properly expose any conceit due to their fundamental misinterpretations of past art activity. Art has *always* been about ideas. It is designers who focus on the visual nature of the works and assume the surface is what art's about. As Dave Hickey says, "Junior professors (!) began explaining to me that non-portable, non-object art had arisen during the nineteen sixties as a means of

'conceptualizing' the practice of art in response to 'commodification' and the 'commercialization' of the art object during the postwar era. This would have been a wonderful argument if a painting by Edward Ruscha or Jacques-Louis David were any less 'conceptual' than a pile of dirt on the museum floor." The complex iconography that makes up so many great paintings was the incomprehensible art-speak of yesterday. If you hold that art of earlier times was "about" the visual aspect, *all* painting is ruined.

Fabricating this lofty art can only make design suffer. The ideal is unattainable not because of a designer's cupidity, indifference, or hack status. It's because the artist ideal is wholly fictional. The closer you examine art activity, the more diverse a behavior it becomes. If it resembles any contemporary activity, it's design.

The Archetype-Cast

> He had never realized that he had produced quite this many things. Why, some people might consider him an actual artist, by profession. Was that possible? He pictured all those hours spent alone in his room, patiently fitting together tiny scraps, feverishly hunting up the proper textures, pounding in a row of thumbtacks until the back of his neck ached—all that drudgery. It wasn't the way he pictured the life of an artist.
> —*Anne Tyler*

The artist's beau ideal is that of a loner pursuing a personal agenda. Design is said to be different because of its collaborative nature. Often, a team accomplishes design projects. Credit usually goes to the principal designer, of course, obscuring the process. The determination to produce under one person's name (e.g., Kenneth FitzGerald Design) intends to appropriate the artist's cultural authority. When a designer stresses that they are a "one-person shop," the intimation is one of greater creative distinction—working like, being, an artist.

The fact is that most artists past and present operated as a firm. For hundreds of years, artists apprenticed in shops, working under masters. Whether it was painting portraits, creating frescoes, or blacksmithing, you weren't working alone. The goal was to set up your own shop, then make *your* underlings do things your way. Rather than temples of individual attainment, museums are show houses of art direction. The Rembrandt Research Project—an ongoing research effort devoted to identifying "authentic" paintings by the master—displays the normative situation, not an aberration. The "Great Masters" were a collection of schools: art firms directed by principals. The devaluation of works only partially executed by Rembrandt speaks more to our culture's skewed values than to the paintings' intrinsic worth.

Social and cultural changes did occasion a more specialized art commodity provider. These individuals desired a higher social status, as did the purchasers of their wares. From here, the art idea as we know it began to form. However, the lone genius remains the exception. It's almost a truism that to find an artist working alone in a garret was (and is) to find a failure. Today's major-selling fine artist is still regularly a company in every way. Assistants fabricate the bulk, if not the entirety, of pieces. They stretch the canvas, paint the content, and then wash the Range Rover. It's a plum job for aspiring artists, and has been for centuries.

In process, art is like design is like fashion is like scientific research is like most human activity: the labor of many to the glori-fication of one. The solitary creator myth, however, still dominates inside and out of the art world. I remember my disdain when, as an art school undergraduate, I first read of an artist's assistants. This pseudorevelation is regularly rototilled up by the popular media as an exposé of contemporary art's avarice and hypocrisy. My naïveté resulted from the reinforcing art school indoctrination and a wholly

visual definition of art activity. The dissimulation lies with our culture. We demand mass commodities with the aura of exclusivity.

Alternating, and often mixed, with the Great Master model is one inspired by the heroic artists of abstract expressionism: Pollock, de Kooning. These American (native or adopted) painters wrested the art world from European dominance in the 1950s. Combined with the lust-for-life archetype of the late nineteenth century (van Gogh, Gaugin, et al.), the artist became a tormented soul. Art now was an intensely personal self-investigation of the psyche. Artists make art to purge their demons. It is a representation shared widely within our culture, though the movement was brief and problematic.

Designers, for all their claims of practicality, buy into the romance. They either play against it to assert their creative sobriety, or conjure its spirit to siphon off artistic aura. At the Fuse'98 design conference, Erik Spiekermann received a round of applause for stating he designed to solve his clients' problems, not his own. He offered the comment while reviewing presentations by other designers whose speculative nature he saw as bordering on the artistic. ("Artistic" meaning, in this context, impractical and useless.) Conversely, Blackwell again imparts Carson with the legacy of the rebel Americans. In *2ndsight*, Blackwell explains of Carson, "He doesn't go to a psychoanalyst to express himself—he designs." Blackwell fancies a double play as he links Carson with Big Art while disparaging critics who have read something other than *The End of Print*. Of course, Pollock painted *and* went to the psychoanalyst.

Jackson Pollock's work is as totemic for designers as painters. Frequently, designers express a desire to "paint with type." The implication is of scattering letterforms as expressively and directly as Pollock splattered enamel on canvas. However, a quick scan of art history, particularly within this century, reveals that *everybody* paints with type. If you can't find a painting approach that matches your

design process, you haven't looked hard enough. The aspiration to type-paint is less a desired working method than another longing for artistic legitimacy.

Coincident with this self-expressive longing is a fixation with becoming "abstract" with type. Neville Brody and Jon Wozencroft's Fuse project is the vocal proponent of this fashion. Once again, the impulse seems aimed more at linking arms with artists than opening minds of readers. When we consider the language theory that has emerged in the past twenty years, it seems difficult to construct a *more* abstract system of representation than the one we currently endure.

The Big Express

The ultimate artistic license is personal expression. Designers will be forever distinct from artists because they must present someone else's message. To free themselves from corporate/modernist shackles, designers strive to inject their own personality into their work. This idea of self-expressiveness permeates the design conception of art. Within art, dispute of this rhetoric came soon after its inception. Once more, design seems bent on rearguing constructs art moved beyond decades ago.

In his 1983 *Art in America* essay "The Expressive Fallacy," Hal Foster demonstrates expressionism to be another fabrication: "First and foremost, expressionism is a paradox: a type of representation that asserts presence—of the artist, of the real. This presence is by proxy only (the expressive marks of the artist, the indexical traces of the hand), and yet it is easy to fall into the fallacy: for example, we commonly say an expressionist like Kandinsky 'broke through' representation, when in fact he replaced (or superimposed) one form with another—a representation oriented not to reality (the coded, realist outer world) but to expression (the coded, symbolist inner world). After all, formlessness

does not dissolve convention or suspend mediation; as the expressionist trope for feeling, it is a rhetorical form too."

As examples of the artistic reaction against expressionism, Foster details a succession of painters, beginning with Jasper Johns (*Target with Plaster Casts*) in 1955, to Roy Lichtenstein (and his brushstroke paintings), to, more recently, Gerhard Richter. In other art media, self-expression acts primarily as a conceit to work against. As we draw closer to contemporary times, artwork in form and concerns moves closer to design. Foster quotes appropriationist Richard Prince (who rephotographs and manipulates mass-market advertising): "Essentially, my own desires have very little to do with what comes out of myself, because what I put out (at least in part) has already been out ... My way to make it mine is to make it again and making it again is enough for me and certainly, personally speaking, *almost* me."

Designers regularly travel extended rhetorical distances in form to arrive at art. Usually designers aspire to painting—the traditional art medium. In contemporary times, though, art must coexist with design to have import. Foster cites Jenny Holzer and Peter Nadin's artist book *Eating Friends*, which "debunks" expression with a literal obsession with "inner life": texts and images focused on internal organs.

In a fascination with self-expression, design falls into a house of mirrors where irony reflects upon irony. Design, as the source of a public language through which culture defines itself, likely usurped the expressionist idea. Expressionism long ago became a language—one appropriated by consumer culture. As Foster says, "We must open up the term to include the expressionist rhetoric of psychology and consumerist society in general. Express yourself, we are exhorted—but only via the type, only via the commodity." Desiring to elude commodification through self-expression, designers charge headfirst into commodification's maw. The point being made here is not that

one must be absolutely contemporary in their art metaphors. The past should be neither venerated nor rejected. The issue is that designers continue to work from a romantic ideal of art. Rather than construct a relevant model for their activity, designers orbit a hoary salon.

Unfortunately, when art isn't romanticized, design treats it as visual supermarket. Designers unashamedly urge peers to investigate art because it offers many graphic ideas to purloin. Design becomes a process of raising movie-set facades behind which business is conducted. For a time, it appeared that Paula Scher would be the Michael Bolton of graphic design. Direct quotations of artists like Mondrian seemed to make up the majority of her output. Could she, however, be design's Sherrie Levine? In avoiding self-expression by appropriating form, Scher matches art's decades-long critique of self-expression. Art has always cannibalized itself, formally and intellectually. On the basis of the repetition of subject matter (crucifixions, portraits, still lifes, paint, etc.), high art seems to *demand* cribbing.

The cycling of imagery through art and design are merely returned favors. To inject new imagery into its market, art raided popular culture (art being unpopular culture) big time in the 1960s. Somehow, Warhol's painted Brillo boxes became high art, while the original item remained banal. The Museum of Modern Art's infamous High and Low: Modern Art and Popular Culture exhibition attempted a rationalization that only served to direct attention to high art's intellectual bankruptcy.

Filthy Lucrative

What are the essential, irrefutable particulars separating design from art? People go into design to make money. Designers prostitute art for business. Designers work for clients, artists work for themselves.

These clichés hold up as well as the other aspects of the art myth. It is a delusion that the activity of fine artists is divorced from commercial

considerations. It isn't even a matter of degree. All that separates art and design is the kind of marketplace one chooses to operate in. The direct evidence of this is the art world's obsession with sales. No matter how "conceptual" or "non-object" oriented, art can and must be sold. Economic viability is the preeminent determinant.

The traditional estimation holds that designers are dependent upon having clients and are subservient to their will. Artists, however, are self-starters who answer only to their muse. To believe this, you must disregard admissions committees, art faculty, review boards, competition jurors, selection committees, gallery owners, curators, critics, grant committees, opening attendees, et al. Each of these groups has a profound and often direct influence on how and what art is made. For artists, these encounters are client meetings. Artists frequently modify how they make and present their work in the wake of feedback from these groups. The input of knowledgeable art insiders is craved, not scorned.

The notion that art is an "anything-goes" zone is misinformed. Straying too far from well-delineated boundaries is hazardous for artists. The field is broad, but often shallow. To gain recognition as an artist, it is incumbent to exhibit regularly in approved forums. Critical recognition requires first being seen. This means you must please people, particularly gallery owners. If they are to be at all successful, gallery owners must make a basic economic decision about art. *Will it sell?*

Sales are evidently not a requirement to be an artist. If they were, we must remove the majority of practitioners present and future from the canon. The large number of artists successful in their time but ignored in contemporary estimation complicates the situation. Unless we are ready to accept that unseen creations are artworks (just as anything done in type and image can be design), we must acknowledge that art is mediated by forces exterior to the artist. Artists must face the reality

that the surest way for their labor to be considered art is to attach a high price tag to it.

Historically, artworks have always functioned as commodities. Finding clients has concerned artists throughout history. Jacques-Louis David resented having to accept portrait commissions. The historic epics he preferred to paint couldn't find a clientele. Art was born of the marketplace, as was design. Design was merely a new product line.

Brian O'Doherty takes a scathing look at the art industry in *Inside the White Cube: The Ideology of the Gallery Space.* The gallery is a showroom floor, displaying manufacturers' latest models:

> For many of us, the gallery space still gives off negative vibrations when we wander in. Esthetics is turned into a kind of social elitism—the gallery space is *exclusive.* Isolated in plots of space, what is on display looks a bit like valuable scarce goods, jewelry, or silver: aesthetics are turned into commerce—the gallery space is *expensive.* What it contains is, without mediation, well nigh incomprehensible—art is ***difficult.*** Exclusive audience, rare objects difficult to comprehend—here we have a social, financial, and intellectual snobbery which models (and at its worst parodies) our system of limited production, our modes of assigning values, our social habits at large. Never was a space, designed to accommodate the prejudices and enhance the self-image of the upper middle classes, so efficiently codified.
>
> The classic modernist gallery is the limbo between studio and living room, where the conventions of both meet on a carefully neutralized ground. There the artist's respect for what he has invented is perfectly superimposed on the bourgeois desire for possession. For a gallery is, in the end, a place to sell things—which is O.K.

The modernist gallery didn't transform art into commodity. It was always in that state. Like the illusory neutral grid, the gallery is an ideological space—and receptive to commerce. Willingly complicit is the artist. O'Doherty writes:

The economic model in place for a hundred years in Europe and the Americas is *product*, filtered through galleries, offered to collectors and public institutions, written about in magazines partially supported by the galleries, and drifting toward the academic apparatus that stabilizes "history"—certifying, much as banks do, the holding of its major repository, the museum. History in art is, ultimately, worth money. Thus do we get not the art we deserve but the art we pay for. This comfortable system went virtually unquestioned by the key figure it is based upon: the artist.

All art is in the marketplace. It must be to be considered art; its validating establishment resides there.

The fiction of the artist as victim of these forces—and not devoted accessory—is a component of the modernist construction of the avant-garde. To command authority, artists must claim a privileged status in society. They must be above crass commercialism and defend culture. Art must be kept pure. But someone must take the fall. That would be designers.

Nevertheless, a look at the most prominent art stars shows individuals responding to markets and making no (or little) pretense to making commodities. To afford his epic *Cremaster* videos, Matthew Barney has to up-front please people with money. Damien Hirst conceived floating a shark in a tank of formaldehyde, but it took the financing of a Saatchi to do it. *The Physical Impossibility of Death in the Mind of Someone Living* is as much a brochure for its patron as was the *Mona Lisa* for whoever commissioned that vanity item. Commissioning a work of art has historically been a public declaration of virtue and wealth. Why is it different if your claimed virtue is the making of a beverage?

An Artist's Design

It isn't necessary to detail the scorn most artists have for designers. In an interview in *Emigre* 46, the designers of Orangeflux relate a typical story

of artists dismissing their work: "When we show *Rust Belt* within the art community they tell us it's not art, it's design. They can't see beyond the type." The ongoing marginalization of fine artists in our culture drives their determination to keep designers in a lower status.

These are attitudes within the arts deserving mention. They relate to the way design dispels certain works as not being design but art. In keeping with its art schizophrenia, design can't decide if having your work called art is condemnation or acclaim. It depends, of course, on whether you respect the designer or not.

As Orangeflux learned, the art world is not a commodious place for daring designers. The work condemned as art by designers is a nonstarter for artists. Art industrialists who champion the most diffi-cult, challenging art become obstinate conventionalists in their design concerns. For every Walker Art Center, there are one hundred museums that can't get enough twelve point Helvetica. The preferred exhibition announcement is a template design: color photo of the art piece on the front (always white-bordered, like a frame, so you know it isn't just a design) and easy to read centered type (Helvetica, Gill, Garamond) on the back. To violate this design space is like stepping outside the gallery, which the card emulates. You risk not being taken seriously.

At a presentation to fine art graduate students, I garnered the expected response to contemporary "cutting-edge" design. The reaction to the art school publications I brought for the students' appraisal—P. Scott Makela's Minneapolis College of Art and Design catalogs, ReVerb's Otis College of Art and Design and CalArts works—was almost uniform. They regarded the publications as incomprehensible indulgences that failed to meet their fundamental purpose. Students expressed their opinions with a startling passion. They recoiled from a representational disturbance they assiduously cultivated in their own work.

It's only slightly ironic that artists are the most vehement defenders of conservative design. *Design is different,* they'll say, *it's about relaying facts, information. It's about communication.* Though this would seem to be a harsh judgment on art—that it is uncommunicative—it certainly proves true. Arguably, art isn't about communication—at least, no more than design is.

Artists thrive on the avant-garde notion that it is their role to critique and experiment with cultural forms. A designer investigating these ideas is an offense against sensibility, against the cultural order. Artists don't like this view contested, as it leads to prying apart desperately held illusions of relevance.

Factographic Design

Design has directed attention to contemporary artists thought to have links with its practice. Barbara Kruger is cited as a kind of designer-made-good. She's often looked to for insight on design's potential as a medium of cultural commentary. While Kruger's work is significant, its relevance for design is limited. Her works were readily acknowledged as art, unlike the magazine layouts she briefly worked on. Acceptance of her work hasn't increased regard for design activity. Also, Kruger hardly utilizes the potential of the rhetoric of design. Though she explored different typefaces in early works (and nothing controversial in design), she has stuck to an extra bold Futura italic since. In this, she proves more discriminatory than Massimo Vignelli. Considering the conservatism about design described previously, it may be that Kruger recognized what was unacceptable in art. Being typographically challenging might prove professionally dangerous.

The artist Hans Haacke provides a crucial insight into the construction of art and design. Critical study of his work highlights the artificiality of the art/design division. In their content and reception,

Haacke's installations disclose the overriding commercial concerns of the art industry. By denying what he terms the "trademark appearance of art," Haacke constructs a relevant art by constituting it as design.

Haacke—a German-born artist who has resided in the United States since 1965—has been one of the most significantly controversial artists of the past two decades. ("Significantly" means that the controversies have not centered on political distractions such as obscenity and flag burning.) Originally allied with conceptual art movements in the 1960s, he turned to political art at the start of the 1970s. His works blandly document "the institutional, discursive and economic apparatuses of international high art." Manipulating the advertisements and collateral of multinational corporations, he exposes their connections to repression and exploitation. Support for the arts serves as whitewash, not altruism. Art is implicated as another method of control.

Censorship and cancellations mark Haacke's exhibition career, motivated by institutional discomfort with the works' content. Elaborate circumlocutions attempted to draw attention away from accusations of suppression. Haacke's work was criticized for its lack of aesthetic pleasure and for being mere journalism. Curiously, he employs strict modernist design tools to attack modernist ideals of "esthetic autonomy and esthetic pleasure."

Art historian and critic Benjamin Buchloh's "Hans Haacke: Memory and Instrumental Reason," is an important analysis of the artist's work and its ramifications not only for art, but our entire visual culture. Buchloh believes Haacke's work "has in fact been marginalized because it represents a turning point—one of those historical moments in which a set of traditional assumptions about the structures and functions of art are being effectively challenged (in a way that Heartfield's work constituted such an instant in the 1930s)." Like John Heartfield's, Haacke's work utilizes the forms of "commercial art," using its language to critique society.

To categorize Haacke's (and other like-minded artists') work, Buchloh coined the term "factography." Factography is an art form that is motivated by a desire to expose economic and political powers manipulating our society. Factography also attempts to escape from and disrupt the corrupted art practices of the past. It takes as its subject matter a neutral accounting of facts, such as statistics. The public regards this form as both participatory and immediate—no art education is required to comprehend its message. Factography thus denies the typical aesthetic concerns of art and invites challenge as an art practice.

Haacke's works frequently simulate corporate PR materials. Billboards and advertisements are restructured with elite design precision. Through these simulations, the photographic and textual inversions have great impact. The bland straightforwardness becomes highly charged in ways a more adventurous design could not. An infamous, censored work, *Manet-PROJEKT '74*, is chilling in its simplicity. The rejected installation would have displayed a Manet painting with ten panels tracing the artwork's provenance. These panels, with text set in Times, resemble the ubiquitous head-shot/text bios of countless annual reports. (The work was rejected, as its ninth panel revealed that "A prominent figure in the economic establishment of the Nazi government . . . now functions as a major cultural benefactor in the liberal democracy of postwar Germany.")

Along with demonstrating the complexity of meanings attendant to design forms, Haacke's work leads to a profound insight on the relationship of art and design. In his article, Buchloh scrutinizes different artistic strategies to "reject the idea of esthetic autonomy." To accomplish this, artists have also needed to "abandon traditional procedures of artistic production (and, by implication, of course, the cognitive concepts embedded in them)." To describe this process,

Buchloh expands upon a term used by artist Ian Burn: deskilling. Deskilling rejects "manual dexterity" as a principal component of art so it may relate to a public lacking that ability. To pursue traditional art practices is to be caught up in their ideological adulteration. New practices with new skills must replace what has been abandoned. This new practice is identical in form with design. The initial new skill must be the ability to recognize factographic forms as culturally significant and intellectually substantive.

Here, Buchloh echoes the rhetoric of design and its impact upon audiences. The conception that there is an unmediated, objective visual language is still questioned. However, we can recognize that particular forms popularly signify factuality. This indicates a greater potential for using "style" as signifier. Design work, however, is not universally factographic because of its form. Design is popularly regarded as more ideologically corrupt than art. Most designers unabashedly adopt the rhetoric and politics of their patrons. Negotiating the problems and potential of design requires novel skills indeed.

The Guerrilla Girls are also factographers design should make note of. This anonymous group of women artists and art professionals has arguably made the only truly dangerous art of the past decade. Through a remarkable series of mostly text-only handbills, the Guerrilla Girls have pointed out the gender and race biases of the art world. (Like Kruger, their font of choice is Futura.) Once again, the most cutting and substantive art uses design as its principal constituent.

Through these works, design demonstrates what Preziosi calls a "carrying capacity"—the ability of a study object to have art-historical significance as a cultural artifact. It also confirms that design artifacts require a much deeper reading.

Haacke's influence has already paid significant dividends for graphic design. Ellen Lupton and J. Abbott Miller studied with Haacke

at Cooper Union. Their use of design as a fundamental element in their factography refers to Haacke's investigations.

The Pleasures of the Vortexture

Aesthetics is for artists as ornithology is for the birds.
—*Barnett Newman*

A cynical opinion about art theory is that its complexity and self-referentiality can justify anything. But rather than shunning it, designers should investigate and elaborate. Of course, the basis of art-world regard is doctrinal adherence, not theoretical alignment. The goal shouldn't be gaining acceptance from the art world. Designers must add art's material culture speculations to their database—if only to chart wrong directions.

Art is a recent construct historically. The notion of timeless objects being preserved through the centuries because of their inherent quality is misguided. Art is all "presentism." Much of what we value was a previous generation's excess. And who knows what was lost?

That there is an "art" phenomenon is still pure speculation. As stated before by Preziosi, art history has not only described art, it has shaped it. Artists' awareness of art history and their subsequent desire to be part of the canon have been the fundamental motivation for art-making this century. All other rationales are secondary at best.

Art history indoctrinates students into the art industry primarily through books and magazines. Firsthand experience of art is still rare, and overshadowed by the preponderance of art publications. Artists become artists because of what they see in print, not in a museum. Ruscha's determination to be an artist came from seeing a reproduction of a Johns painting in *Print*. For scores of artists, art is a small repro (frequently in black and white) with an accompanying caption. Art

became its representation almost immediately upon birth. Concrete artifacts were but illustrations of concepts. This, of course, is the truth of all art, inadvertently revealed.

With print as the direct vehicle defining art, design becomes the framework for its perception. Rather than being handmaiden, design is art's validation. As with the gallery show announcements, it is the design that tells you it's real art. Art publications (direct descendants of auction catalogs) don't support and frame art, they consume it whole. At best, there is symbiosis.

The design filter provided by publications has been modernist. However, this structure is breaking down, as is the gallery framework. Postmodern art within modern frameworks are causing public dissonance. Art needs to reconfigure its perceptual vehicle, which will also change its nature. This direction leads through design.

A prototype of this eventuality is Jonathan Barnbrook's design of the Hirst monograph, *I Want to Spend the Rest of My Life Everywhere, with Everyone, One to One, Always, Forever, Now.* Barnbrook and Hirst realize that the modernist paradigm for representing artwork cannot adequately serve a postmodern artist. (The artist's "original" works, of course, regularly appear in the modernist white cube gallery.) Hirst's problematic pieces are far more engaging as graphic devices than as objects of contemplation. Barnbrook's inventive and seductive design comes closest to accounting for the appeal of the morally questionable practice of segmenting farm animals.

Meanwhile, designers like Rand deserve inclusion in the art canon. This recognition, however, will not come in the way he would have wanted. As art history gravitates toward visual culture studies, attention will move to design. Rand's logos were the emblematic artifacts of their time. They were of a kind with concurrent abstract painting and sculpture. Corporations hung and placed those artworks

in their offices for the same reason they placed Rand's symbols on their letterheads. Each signified modernity and efficiency, and was resolutely neutral. Rand's aesthetic rationale is dissertation material but not germane to the impact of logos.

Eventually, art comes down to aura. Walter Benjamin predicted that works of art would lose their aura due to mass reproduction. However, it hasn't quite turned out that way. During his presentation at Fuse'98, Bruce Mau noted that mass reproduction has caused art to become even more valuable. The *Mona Lisa*, for instance, now transcends valuation as a commodity.

What has also happened is that auras have formed for mass-produced works with no original. Designed artifacts may generate an aura due to the various associations people append to them. A personal example is record albums. It was aura I was experiencing when I picked up certain desired albums. I knew there were millions in circulation, but it didn't matter. Purchasing one was enough. I still experience the aura when I'm shopping for CDs and run across a favorite work I already possess. I want to buy it *again*, to refresh the aura.

Art for Our Sake

Art is the orientation that makes innovation possible.
—*Morse Peckham*

The one important thing I have learned over the years is the difference between taking one's work seriously and taking one's self seriously. The first is imperative and the second is disastrous.
—*Margot Fonteyn*

What role does art and design play? For Hickey, art should be a function of democracy. The first step is for art to admit it is a "bad, silly, frivolous thing to do." Hickey continues, "We can stop regarding the art world

as a 'world' or a 'community' or a 'market' and begin thinking of it as a semi-public, semi-mercantile, semi-institutional agora—an intermediate institution of civil society, like that of professional sports, within which issues of private desire and public virtue are negotiated and occasionally resolved." This is also design's state. All the aesthetic rationalizations and informational architecture conceits can't change the fact that design is usually self-indulgent in toying with form—which is OK.

Peckham finds a biological necessity in art. Rather than an expression of order, art strives to create disorder, in order for us to learn to handle the stress of reality. "Art is exposure to the tensions and problems of a false world so that man may endure exposing himself to the tensions and problems of the real world." Peckham and Hickey come from different directions to agree on art's frivolity and necessity. Peckham states, "The only moral justification for the study of the highest level of art . . . is to take what it can give so seriously, so passionately, with such conviction that one can learn to do without it."

Art offers many theories that suggest it's in crisis intellectually, but the industry keeps rolling along. (Haacke is regarded as a major international artist and sells work.) Socially, the art world grows increasingly marginalized. Art industrialists show little inclination to reverse the trend. Art is a pleasant bourgeois playground.

Helping to drive this marginalization is design assuming its former status as art. The ephemera of today will become tomorrow's timeless art. Design is the contemporary popular art that mediates for people. Therein lies its power. Designers hankering after art legitimacy are like rock stars writing operas, symphonies, and musicals. They crave high-culture affirmation, effectively renouncing what came before as frivolity.

The challenge for designers is not to become fluent in art-speak so they have comebacks the next time some artist disses them. Their task is far more difficult than regurgitating theory. It requires unequivocal

honesty about what you do and why you do it. It's about looking for that honesty in work, not arbitrary surface features. It requires putting aside the desire to be seen as doing something "higher" than other people. It's wanting to do something meaningful today, not begging history.

And the best part is that you can do it with any materials, in any style, any theory, any job, any time. Then art isn't and doesn't matter.

So much for Art. What of Thought?

—*Thomas Pynchon*

References

· Blackwell, Lewis, and David Carson. 1997. *2ndsight: Grafik Design after the End of Print.* New York: St. Martin's Press.

· Buchloh, Benjamin. February 1988. "Hans Haacke: Memory and Instrumental Reason." *Art in America.*

· Dooley, Michael. September/October 1994. "Ed Words: Ruscha in Print." *Print* 48: vol. 5.

· Foster, Hal. 1985. *Recodings: Art, Spectacle, Cultural Politics.* Seattle: Bay Press.

· Hickey, Dave. 1997. *Air Guitar: Essays on Art & Democracy.* Los Angeles: Art Issues Press.

· Hirst, Damien. 1998. *I Want to Spend the Rest of My Life Everywhere, with Everyone, One to One, Always, Forever, Now.* London: Booth-Clibborn Editions.

· Holzer, Jenny, and Peter Nadin. 1986. *Eating Friends.* (Hallwalls. For an extended look at this exhibition, and background on the idea of a "high and low" dialogue, see Dooley, Michael. September/October 1991.) "High Way Robbery." *Print* 45: vol. 5.

· O'Doherty, Brian. 1999. *Inside the White Cube: The Ideology of the Gallery Space.* Berkeley: University of California Press.

· Orangeflux. Spring 1998. "Rust Belt," *Emigre* 46.

· Peckham, Morse. 1965. *Man's Rage for Chaos: Biology, Behavior and the Arts.* New York: Schocken Books.

· Preziosi, Donald, ed. 1998. *The Art of Art History: A Critical Anthology.* Oxford: Oxford University Press.

· Rand, Paul. 1993. *Design, Form, and Chaos.* New Haven, CT: Yale University Press.

· Resnick, Elizabeth. 1998. "Paul Rand: The Movie." AIGA *Journal of Graphic Design* 16, no. 2.

· Wilson, Edward O. 1998. *Consilience: The Unity of Knowledge.* New York: Knopf.

Professional Suicide

I come to bury graphic design, not to praise it.

To consider how to teach or theorize about graphic design, a basic question must be answered: what is its ultimate goal? Ideally, that answer will be less abstract than the platitude, "to make the world a better place." However, for the purpose of this discussion, I'll agree that improving life is one of design's ambitions. It's just not design's primary objective. An impulse precedes it that is truly primal.

Already I, like many other commentators, have described design as having intent, as a species might. If design behaves with such self-awareness, its essential impulse is to perpetuate itself. In other words, with apologies for the pun, its first concern is reproduction. This motivation is often to the exclusion of better-place-making the world. Most theory—whether it is "academic" or "practical"—also comes down to procreation: assuring the creation of more professional design.

To ensure its existence, design strives to create a class of expert professional practitioners with high social standing. The archetype that designers emulate is the architect. Unfortunately, there hasn't yet been an Ayn Rand with a thousand-page novel about a heroic information architect who plays by his own rules.

While ostensibly desiring awareness of and recognition for its activity, design deliberately makes little real substantive effort to reach out to nondesigners to explain what it's doing and why. Instead, it incessantly argues that design professionals should be given more work.

And the arguments are aimed inward. For instance, there's the AIGA's recent twelve-step booklet with the poignant question "Why?" on its cover. It's another demonstration of simultaneous affirmation ("We're influential!") and denial (preaching to the converted).

While an elevated status would benefit practitioners, a cadre of design specialists may not be the best condition. Do we desire a society permanently estranged from its visual expression? Is mediation perfection? Do we seek to extinguish the vernacular?

We should be resigned to never achieving full regard for expert design production. The reason is that as the nondesigner public becomes converts to design's message, the conversion is total. The design connoisseur will become a designer—and by all measure, a good one too. The situation is analogous to why it's impossible to surpass the speed of light. The additional energy that is input to increase acceleration is progressively converted to mass. The faster you go, the closer you get—and the more weighed down you become. Likewise, a broader and deeper appreciation of design can—and should—only lead to its demise as a specialist profession.

A thorough appreciation of design should elicit the DIY desire. Isn't this where little designers come from? It's also the ultimate purpose of all the arts. We seek a society where everyone is making art, being creative. Increasing access to the means of production + desire = an explosive mix. But if everyone's an artist, then no one is. So too would designers be everywhere and nowhere.

A high-profile example of conversion is Rem Koolhaas. The controversial architect was evidently so taken by Bruce Mau's productions that he got into the game and formed his own graphic design studio. Koolhaas now self-directs slabs of cool architectural theory like *The Harvard Design School Guide to Shopping*. He also devised a flag for the European Union, which, in its design, deliberately refers to bar codes. Of course,

trained graphic designers are doing the heavy lifting, with Koolhaas as art director. The works are contemporary, capable, and forgettable. Koolhaas's engagement in design might be considered another triumph for the field. It is, in fact, a sign of the coming apocalypse.

Another recent nondesigner celebrity is former Mac temp Dave Eggers. Though he only designs for his limited edition *McSweeney's* literary journal and associated products (such as David Byrne's pseudo-Bible *The New Sins*), Eggers was selected for the second Cooper-Hewitt National Design Museum Triennial. Apart from attempting to siphon off some of his media velocity, the choice is puzzling.

Eggers's approach is an antidesign style, flouting professional treatment. Issues of *McSweeney's* are dense with classically readable text, set solely in Garamond. Monotony is relieved by goofing about with cover typography and altering the issues' forms. Never has a strategy so outwardly minimal been so showy and indulgent. The design is clever but no more so than numerous zines—except for the producer's notoriety. Honoring Eggers seems less a pronunciation of design's significance than an expression of self-loathing.

Interest in "undesigned" design has increased recently. This approach isn't antidesign, as it doesn't mock the field's concerns. It is puritan, invoking what is thought to be an essential form purged of visual rhetoric and subjectivity.

Rob Giampietro recently critiqued the prevalent undesigned design, "default systems design," in *Emigre* 65. Here, an automatized design format has been widely adopted as a standard. Determined more by production software than intention, it establishes a vernacular by Adobe or Quark fiat. Giampietro rightly points out that investigating the origin and meaning of these systems is a vital concern for design.

A surprising instance of attention to the undesigned is in the second edition of Richard Hollis's *Graphic Design: A Concise History.*

Hollis concludes his book by highlighting a design without designers. It isn't a forum where you'd expect the unprofessional to be championed. And it's not. He cites examples of information design: "Paradoxically, the 1999 book *Open Here: The Art of Instructional Design . . .* drew attention to diagrams and instructions prepared without the intervention of 'designers.'" Hollis then muses acidly on designerlessness: "The world may yet dispense with the profession while designers are arguing about whether they are artists or not." His interest in undesigner activity is confined to its effect on work he loathes. Perhaps he dares to hope that modernist design principles have been fully assimilated into culture. However, the risk encompasses even designs that Hollis endorses.

Though from a different perspective, I agree that untrained design can make inroads into information design. This might be considered the branch of design impervious to unprofessional interloping. But we should consider the example of Edward Tufte, as practitioner and in practice. His route into design shows design training isn't necessary to be considered a genius of information design. But in practice, his methods show flaws, as in the discussion of the Challenger shuttle disaster in *Visual Explanations.* Tufte shows the poor diagramming of O-ring temperature performance data and suggests professional design might have averted the tragedy.

However, Tufte fails to account for the subjective realities of culture—culture as broad social forces and as smaller group dynamics. Recently, for instance, it was shown how the culture within NASA—what would seem a wholly objective, rational institution—made the efficacy of diagrams irrelevant. As the Columbia accident investigation once again demonstrated, the relations within NASA made for curious and fatal reinterpretations of data. Managers could interpret a professionally perfect diagram of excessive risk as normative—just as they redefined the ongoing threat of falling ice as a benign nuisance.

Design culture is similarly blind to its motivations. If we imagine graphic design as an individual, we must explain why it doesn't affirm its desired identity, then breed wildly. My explanation is Freudian: design has a death wish. It constantly seeks to eradicate itself.

Designers will instinctively reject this notion. We're fighting for our lives! Indulgent clients are at a premium. Remedies are hard-sought, sometimes extreme. In a 1995 column for *I.D.* magazine, "Three Little Words" (republished, appropriately, in his book *79 Short Essays on Design* as "In Search of the Perfect Client"), Michael Bierut suggested we might have to psychologically condition future employers from childhood. "Why not," he asked, "find an artistically inclined ten-year-old who might otherwise choose a design career . . . establish them on the corporate fast track, and wait for this "mole" to become CEO of a major corporation?" Elsewhere, Bierut seems to insinuate that genetic engineering is the answer.

Bierut's proposal is facetious, but the situation is serious. Graphic designers still bemoan their impotence despite having decades of protean communicators in their ranks. I offer this without sarcasm. Design continues to contain prodigious talents and intellects. What's wrong with this picture? The answer's not in *I.D.*, it's the id.

The foremost sign of design's Thanatos compulsion is its bipolar relationship with the vernacular. Here is design's ultimate poison pill. It's popped regularly—but in prophylactic, subcritical doses. For some designers, it's an elixir, to vitalize. For others, it's an inoculation, providing immunity.

Self-identified modernists and fellow travelers habitually scorn the vernacular and any designer having truck with it. In a 2002 letter to *Eye*, designer Robin Fior wrote: "A keen vernacular relativist like Mr. FitzGerald could surely paste the 'just visiting jail' icon from the Monopoly board alongside the bars, and Bob's your uncle." While the

meaning of the statement continues to elude me, I'm 100 percent certain it has a *mueca* of distaste for all-inclusive design.

To detractors, vernacular design is crude, subjective, and … well, often I'm not quite sure what their problem is with the colloquial. It's puzzling how individuals proclaiming devotion to the dissemination of text could so loathe its spontaneous expressions. Or find value in them. The inevitable result of their disdain is public suspicion of design. Designers are widely seen as possessing an elitist aesthetic agenda insensitive to people's needs. (To be fair, antimodernists, while not present at the creation, haven't substantially countered the perception.)

Isn't there a disconnect between advocating the free flow of information and allowing only a clique of specialists to direct it? The modern rejection of the vernacular may come from recognizing the true risk to designers. It's not that commerce—the public exchange of ideas, goods, and services—will be stultified but that it will go on quite well, thank you. And that very little of the design everyday people respond to looks like work they champion.

Meanwhile, design also has a fascination with and frequently embraces the vernacular. It's a bracing reality check for over-theorized design. Someone needs to make a sign, and they just make it. Appreciating vernacular speech is an inspirational experience of humility.

However, in its passion, design stalks contemporary art and "outsider art." We have no verdict if these romances represent appreciation or abuse. The uncritical use of vernacular sources has received extensive critique. Cultural exploitation and aesthetic sloth are regular appraisals.

In his 1994 pamphlet *Fellow Readers*, Robin Kinross rightly discerns another motive: "In another move … against the threat of redundancy, the fad for vernacular bad taste may be an attempt by designers to survive by blending into the landscape, chameleon-like." Here are designers abandoning their identity, acting on the death wish.

Yet after delivering this insight, Kinross immediately follows with a questionable conclusion: "These strategies must be doomed—by their own bad faith, if not by public indifference to them." The public popularity of work like Charles Anderson's contests the latter part of the statement (unless we dismiss him as "primarily a North American phenomenon"). And to the former, it's an unfortunate cynicism that decries when it must descry.

Of course, the boundaries of what constitutes "colloquial speech" are variable. As in the work of Anderson, it can be an anachronistic commercial art that meets all the tests of professional product. The distinctions are irrelevant. What is significant is that designers look outside their professional standard to a source considered pure and immediate. And, often—from hand-drawn and painted signage to zines to desktop horrors no designer would uphold—distressingly effective.

Design education is where "little designers" come from. Despite its total allegiance to the profession—even in the renowned/reviled "progressive" and "experimental" programs—the importance of education is still given only lip service in the field. The notion that design is an on-the-job learning experience continues to dominate. Students enter with a vague interest in text and image—often, not even that—and are channeled wholesale into professional design-making. A successful design program is defined as one that (re)produces more professional design and designers. What other measure is there?

There is the accumulation of knowledge for its own sake: the goal of the liberal arts. Gordon Salchow wrote "Graphic Design is not a Profession" ten years ago for the AIGA *Journal.* He pointed out design's semblance to literature and music, calling design a "fundamental humanist communications discipline … its peers are the Liberal Arts." Gunnar Swanson furthered his argument in his 1994 *Design Issues* essay "Graphic Design Education as a Liberal Art: Design and Knowledge

in the University and the 'Real World.'" He speculated on studying graphic design without the intention of actually practicing it. "Can studying design be of general, not just professional, interest?" Swanson asked, "Do we really have anything to offer outside of the sometimes questionable promise of a job?"

Andrew Blauvelt critiqued this proposition in notes to Will Novosedlik's 1996 *Eye* article, "Dumb." "Design as a field of study without practical application is unlikely and undesirable . . . it is the practice of graphic design . . . that provides the basis of a theory of graphic design." Swanson's idea was, to him, merely a "quest for academic legitimacy." He promotes a "'critical making,' teaching when, how and why to question things." Blauvelt's counterpoint is so terse (likely from space considerations) that it's difficult to speculate overmuch on it. However, it is completely in line with the prevalent professional viewpoint. It's also surprisingly self-deprecating when comparing design to "true" liberal arts. Blauvelt's move from academia to making is notable in this regard.

He's right that design educators are on a quest for legitimacy, though not in the surreptitious sense he means. Design education should strive for the idealism of education. Actually, matters are much better than I am presenting them. Every time I encounter a designer complaining of the "theoretical" and "impractical" projects they were assigned in college, I know they likely studied under a teacher who recognizes an educator's responsibility.

Blauvelt is also correct that, at present, design study without application is unlikely. Academia promotes design education the way the field likes it—as practical. The attitude isn't part of some conspiracy, just a mirroring of societal attitudes. But Swanson's article makes no suggestion to dissociate from practice. He simply offers that some students might find design study of interest while not intending to

go on to a career of professional making. In the article, Swanson readily acknowledges problems with his proffer: "Currently, there is no clear role for design scholarship." Subsequently, he has identified the most profound flaw: who will teach the design side of this curriculum? How many design-savvy educators are open to this approach—and have the breadth and depth of knowledge to succeed at it?

There is an oversight in Blauvelt's critique that is reflexive for designers. For them, design education is entirely about producing designers. It's vocational training. There's nothing wrong with that—unless you're claiming to be engaged in something else. Swanson, however, is discussing education, in a design context.

Here is a real-world certainty every design educator must confront: the majority of design students will not go into professional practice. What is our responsibility to them? Does design care about anything other than producing more design(ers)?

An education through design rather than in design should be our goal. If that's not possible, what does it say for all the claims of design's significance to and in the world? Is design just for designers? A shift in education away from a professional emphasis may also benefit students dedicated to a career of making. Designers claim their activity is all about ideas—not software, not formal facility. Educators are called upon to foster a critical sensibility: a questioning mind capable of intellectual discipline. Design's vital aspect of craft is a product of a cognitive awareness. The hand does not act on its own accord, either to move a mouse or pull a trigger.

A liberal arts model isn't a magical solution. There are numerous practical hazards in academia. How it puts that idealistic pursuit into practice—education as a menu of courses—is a major concern. Well-funded design programs being hijacked or infiltrated by sinecure seekers is another. And what do we do for research institutions

and art schools? A liberal arts model may also exacerbate the anti-intellectualism rampant in the field. To be at all cerebral as a designer automatically brings the designation of being a "pseudo-intellectual." Just as any design critique that's not a case study is regarded as "theoretical," i.e., irrelevant.

We might smile at Bierut's proposal, but where are those future patrons going to come from? Designers occasionally talk about "educating the client." But if designers are so dismissive of their own education—by designers—what makes them think clients will take lessons? Here's a cliché: the future of design's too important to leave to the designers. Just as the profession can't form a critical writing, it's unable to best represent its own interests.

We're arguably at a saturation point, even with an improved economy. (Never mind the influx of new designers.) Designers need to convert the mass of people who have the economic means to hire designers but don't believe there's an advantage in doing so. The main strategy so far hasn't been to craft an argument, but an imitation.

Design constructed itself as a professional service—formal speech—to commune with industry. Business styles itself as rational, tangible, and methodical. But a glance at any day's business news shows these are affectations. Enron is the rule, not the exception. Mismanagement, indecision, and fantasy are the prevalent attributes. Corporate America is as much an ego-fueled crapshoot as design is. The relationship between business and design is prickly because of the similitude.

Still, design strives to be taken seriously on the business playing field. The desultory push for certification in the 1990s was part of this drive. It's another hesitation mark on design's wrist. The effort failed less from active resistance than indifference. The claimed benefits were never substantiated and everyone was too busy trying to make a living

to work it out. Certification addresses a professional existence—design as vocation. Design is just a job to most of its practitioners. The majority of studios and corporate art departments are factories. How would certification rectify this?

I've previously suggested that the AIGA should reconstitute itself as a union. The circumstances of a design job—from employment security to conceptual self-determination—won't improve without organized action. If designers believe they are vital, how about organizing a strike to demonstrate it?

Professionalizing design is a mechanism to cover the bizarre nature of the activity. Design is a dislocated art form born out of industrialization. The idea of professional artists is fairly implausible— certainly as a way to consistently generate fresh insight. The activity inevitably becomes routinized and formulaic when required to be done on demand. The product turns distant, abstract, and impersonal. Yes, there are exceptions, but they're rare. Instead, we get a lot of admirable, formally accomplished work. To paraphrase Oscar Wilde, they are works of talent, not genius.

The simple truth is that professional design will almost always fall short of touching hearts because it's secondhand love. Designers love doing design, the client is just a vehicle. (This is why the slur that designers are prostitutes is flat out wrong. But is it better to be a sex addict?) Design is like a Cyrano de Bergerac who speaks irresistible words of love because of a passion for language. Roxane, he can take or leave. If design loves anyone, it's Baron Christian.

It's no mystery that the most celebrated, expressive, and inspiring design is either self-directed or comes from when the designer is truly empowered and entrusted. You must have a personal stake. This is the norm. It's the itinerant artist model that's an aberration. Why else do designers have creative side projects to, as they describe it, gratify

their creative urges? Shouldn't this tell them that they're in the wrong business? Or that design shouldn't be a business? (This does not mean, however, that designers must only do design.) Maybe design should be left to people inspired by the nutrition labels on food packages.

"Blending into the landscape" is the only responsible action for design. Design must join the culture, and abandon attempts to seduce, party with, or ride herd on it. Those projects are doomed to failure, as they should be. The results of the modernist program—decay into formal gestures, creation of "merely a designer-culture"—are proof. (There is no postmodern program.)

These are not theoretical wanderings. They arise from reading designers' relentless laments about the unappreciated, unrewarding aspects of their pursuit. If it's to be more than unfocused bitching, some fundamental assumptions must be challenged. A truth to be faced is that the only problem professional design solves with any demonstrable success is a designer's urgency to get a professional design job.

Professionalism has reigned supreme throughout design's existence—there's nothing else to blame. To have change, design must change. This is a tall order—to go out on an edge, peering into the unknown. Whether we continue the course of professional determination or alternative conceptions of design, in the words of David Lee Roth, you might as well jump.

Jump! ✸

Coda

Life in These Ephemeral States

One function of the [U.S.] Office of the Geographer is ... keeping track of ...
"mythical kingdoms" or "ephemeral states." These are nonexistent countries
that ordinary people periodically claim to have founded or become the
rulers of.

—*David Owen*

On the inner sleeve of John Lennon's 1973 LP *Mind Games*, he and Yoko
announced the birth of a "conceptual country" called "Nutopia." It had
"no land, no boundaries, no passports, only people." The declared laws
were "cosmic." The couple, as ambassadors—though everyone was
granted ambassador status—then asked for recognition from the U.N.
and diplomatic immunity. Presumably, the latter would obviate the
consequences of past improprieties, like, say, drug busts.

But who reads liner notes?

Where does printed matter come from? As most people imagine it—if
they think of it at all—someone pushes a button and it comes out the
other end. Ultimately, at the offset plant, it does. However, the process
is far more complex—and marvelous—than that. And that imagining
neglects all those preliminary design steps, weeks or months in the
making, each just as remarkable, even for the humblest of artifacts. Is
it a triumph or an indignity that most design is knowingly, deliberately
intended for discard—often within seconds after receipt?

Time is a substance, a solid we pass through. When the big bang burst forth, it created *everything*: space, matter, and *time*. Matter is impossible without space emerging simultaneously, to provide a medium in which to exist. Similarly, a measure—a period of occurrence—was generated also. After this, time needed to be *sensed*, to be experienced. That's where we come in.

When she dumped me to go back to her boyfriend, after a dizzying couple of weeks, I never knew such desolation. I moped about, cursed her—and me, for being such a fool—and listened obsessively to brooding music. And got over it. Just in time to get dumped by someone new, when *she* went back to *her* boyfriend, and start the cycle again . . .

Data is sentient and restless, either analog or digital. We think we're devising new, efficient means to contain our music, images, and documents. But it's the *data* propagating *itself* to its own ends—reproduction and travel. The near frantic invention of new storage media serves no human purpose: the constant, irritating shunting of information from device to device. And how often do you bother to erase that info you transferred? Data depends on that to multiply: from magnetic impulses on unwound cassette tape dangling from tree branches to still-accessible hard drives dumped in a landfill . . .

For a million-year stare, look out into the night sky. It takes that long—and more—for starlight to reach us. In fact, when you gaze at all into space, you're seeing what *was* out there, not what *is*. Those worlds are lost to us. What you see is distant, aloof subjects of speculation, all surrounded by a lambent aura. If it's daylight and you want a similar experience, go to an art museum.

I was indignant a lot as an art student (comes with the territory), never more so than when I read how a prominent artist sold his work only to museums. It was *cheating*—short-circuiting the long, happenstance process to veneration. Prior to museums, someone had to love art for it to be saved. It was personal—not a clinical, critical relationship. But it's still a gamble with time to try and go directly to museum. Times and tastes change, and not simply in the brand of art. Change occurs with what's considered worthy to collect, as might the idea of collection itself. And museums have a term: *deaccession*.

We're all *locations* within time: phenomena with endpoints. Time is an expanse while we, individually, are fixed. We're the States of Time.

I used to feel melancholy after reading stories set in the far future. Science fiction triggered a literally *chronic* envy. Wonders seemed possible far "upstream" in time. Here I was, trapped in a temporal backwater. I assuaged the feeling by thinking I was the one experiencing the marvels as my *now* was someone else's far future (a hunter-gatherer's maybe, but still). Physics was agreeable: time is observer-oriented (thanks, Albert). My time was *the* time, wherever I was. Anywhere you go—then you are.

Beatown. Cow Town. Funkytown. Happy Town. Lovetown. Lonesome Town. Ghost Town. Guitar Town. Sugar Town. Swingtown. Womantown. My Little Town. Town Called Malice. A Town Called Walker. Cheekbone City. Drag City. Fist City. Heartbeat City. Meat City. Suffragette City. Surf City. Version City. City of Dreams. Hitsville UK. Coolsville. Margaritaville. Land. Garageland. Jungleland. Loveland. Ignoreland. Shadowland. Land of a Thousand Dances. Never Never Land . . .

Linda, my department chair, called early Monday afternoon with stunning news. "Robert died this morning," she said, speaking of my senior design teaching colleague. I was helping my wife Ellen unpack her mom's belongings that we'd lugged back that Saturday. Agnes had died weeks before after a year-long struggle with cancer. She'd left behind practically everything she'd ever acquired, made, or been gifted. We'd taken only a U-Haul trailer-ful. Each artifact evoked in my wife the desire to tell its story—firstly, to the person who'd most enjoy the telling, her mother. Now, I was hearing how Robert abruptly left his summer class, telling students he felt ill, then succumbed to an aneurysm. The next morning, I was teaching Robert's class, working off the laptop he'd left in his office, the browser listing web searches he'd made in an attempt to identify the abdominal pain that began to double him over. In the days that followed, as I attended to his class, to responsibilities of the design program, and to the search to find his replacement, I would reflexively think, *I need to check this with Robert . . .*

This is the Geographer's "ephemeral states" filing cabinet. Some inspired clerks, naïve artists all, have spent considerable effort decorating the formerly steel-gray, government-issue furnishing, top and sides, as a fanciful planet. Paintings of fantasy landmasses and oceans adorn the cabinet, pasted over with an accretion of equally handmade tags, labels, flags, emblems submitted by the claimants—every country needs its livery—to conjure their countries to life. As with any illuminated map, near the edges of the cabinet (the ends of the earth) are mythic creatures: mermaids—*here be no dragons*—their sweet songs invitations without hazard, just airs to guide you to your own desired paradise . . .

Given radio telescope ears, you can hear the fading power chord of creation. Astronomers hear and groove behind it. The reverb of the big bang suffuses space—a plangent resound of initiation.

I've always felt it lazy of musicians to have songs fade out instead of bringing them to a resolution. Life isn't like that, except for sleep— and death. It's only as a writer that I see the benefit and am envious. I wish that stories could do a slow fade, gradually decreasing in scale, neverending, infinite regress, running off t

Publication Notes

All essays are original to this book, except as noted below.

- *Emigre*: "On *Creem* Magazine 1970–1976" (no. 41, 1997); "Skilling Saws and Absorbent Catalogs" (no. 48, 1998); "The Last Wave" (no. 54, 2000); "Music for Markets" (as "What Culture Wants," no. 62, 2002); "Quietude" (no. 64, 2003); "Professional Suicide" (as "I Have Come to Bury Graphic Design Not to Praise It," no. 66, 2004); "Buzz Kill" (no. 67, 2004).

- *Eye*: an abbreviated version of "Trenchancy" appeared as "Fanfare for the Common Hack" (vol. 7, no. 27, 1998).

- *Graphic Design and Reading*, edited by Gunnar Swanson (Allworth Press, 2000): "Seen and Not Seen."

- *The Means by Which We Find Our Way–Observations on Design*, edited by David Gardener and Andrea Wilkinson (Ramp Press, 2008): "Light Turning."

- *The News of the Whirled*, "Aerosol" (self-published, no. 3, 2001).

- *Voice: AIGA Journal of Design* (voice.aiga.org): "An Instructor of Concern" (February 2005); "The Resistance" (January 2007).

Index

Adversary: An Exhibition (of) Contesting Graphic Design (FitzGerald), 25–26

AIGA Journal of Graphic Design, 34, 56, 77, 233

American Institute of Graphic Arts (AIGA), 19, 58, 64, 77, 87, 183, 207, 228

Anderson, Charles, 233

art
 apprenticeships and, 209
 conflict in, 201–2
 defining, 202–4
 design as end of, 205–8
 economics of, 213–16
 Great Master model and, 209–10
 historical eras of, 205
 personal expression and, 211–13
 presentism and, 222–24
 role of, 224–26

Art of Looking Sideways, The (Fletcher), 84–85

"Axis Thinking" (Eno), 127

Bangs, Lester, 13, 95–99, 101, 169

Barnbrook, Jonathan, 223

Barney, Matthew, 216

Barthes, Roland, 172

Bass, Saul, 30

Beatles, The (band), 109–12, 174

Been Down So Long It Looks Like Up to Me (Fariña), 104

Bell, Chris, 107

Benjamin, Walter, 10, 224

Bierut, Michael, 231, 236

Billboard (magazine), 98

Blackwell, Lewis, 57, 206, 210

Blake, Peter, 110

Blauvelt, Andrew, 31–33, 188–89, 234–35

Blue Note Records, 121

Body Mix (Marclay), 114

Boom, Irma, 132

Bowie, David, 174–75

branding, 59, 63–64, 69, 73, 103, 175–76, 196–97, 223–24

Brodovich, Alexy, 60

Brody, Neville, 57, 85, 211

Brooks, Garth, 175

Bubbles, Barney, 112–13

Buchloh, Benjamin, 219–21

Buckley, Jeff, 106

Buddy Holly and the Crickets (band), 109

Bukowski, Charles, 170

buzz
 creation of, 63–74
 maintenance of, 65
 promotion of, 63–65
 theory and, 72–74

Byrne, David, 120–22, 229

Carson, David, 45, 51, 85, 99, 134, 166, 196, 206, 210

Chantry, Art, 86

chaos, 177–82

Cheese Monkeys, The (Kidd), 72

Cicciolina, La, 46

class
 aesthetic accomplishment and, 29
 awarding of honors and, 39–41
 Blauvelt on, 31–33
 differentiation and, 28–29
 elitism and, 31, 35, 37, 40–43, 57, 84, 127, 164, 181, 183, 187, 220
 language of form and, 32
 money and, 40–41
 professional representation and, 34
 restricted audiences and, 29
 Soar on, 34–36

status quo and, 31

style wars and, 37–38

Class: A Guide Through the American Status System (Fussell), 28

clients

 compromise and, 43, 66

 formidable, 44

 level of involvement of, 42–44

 mien of, 79

 testimonials and, 78

 as vehicle, 237

"Code, The" (Jacobs), 193–94

Colonna, Fra Francesco, 48

Color of His Own, A (Lionni), 79

computers, 14, 25, 58, 83, 150, 180, 187

coolness, 30–31, 43, 87, 228

 branding and, 59, 63–64, 69, 73, 103, 113, 175–76, 196–97

 buzz and, 63–74

 intellectualism and, 63

 intuition and, 63

 subcultures and, 62–63

Cooper, Alice, 120–22

Cooper-Hewitt National Design Museum Triennial, 39, 127, 229

Cornell, Joseph, 163

Cranbrook Academy of Art, 38, 183, 192

creativity

 album covers and, 110–15

 chaos and, 177–82

 design axes and, 127–30, 133–34

 identity and, 171–76

 multidisciplinary approach to, 125–34

 music industry and, 116–24

 self-determination and, 121, 163, 237

 the untrained and, 163–70

Creem magazine, 95–101

Crisp, Denise Gonzales, 56

criticism

 autonomous review and, 66

 awarding of honors and, 39–40

 buzz and, 63–74

 class and, 31

 client testimonials and, 78

 design axes and, 127–30, 133–34

 lack of passion and, 75–91

 merit-based, 38

 money and, 40–41

 multidisciplinary approach to, 125–34

 practitioners and, 66–67

 scorn of educators and, 69–72

 status quo and, 31

 style wars and, 37–38

 theory label and, 72–74

 training and, 66–67

Crumb, R., 98

Crying of Lot 49, The (Pynchon), 198

"Crystal Goblet or Printing Should Be Invisible, The" (Warde), 48

"Cult of the Ugly" (Heller), 38

culture

 album covers and, 110–15

 coolness and, 30–31, 43, 62–64, 87, 113, 228

 design axes and, 127–30

 design in pure, 21

 fission and, 137–38

 interdisciplinarity and, 183–90

 non-discrete nature of, 8, 10

 subcultures and, 62–63

 uniqueness and, 10

Curtis, Ian, 106

Dalí, Salvador, 182

David, Jacques-Louis, 215

Davidson, Carolyn, 60

Dean, Roger, 112

Death in the Family, A (Agee), 103

Debord, Guy, 81, 120

de Kooning, Willem, 210

Derogatis, Jim, 96

Design, Form, and Chaos (Rand), 177

"Design and Business: The War Is Over" (Glaser), 56

designers

artists' disdain for, 216–18

big idea, 85–86

buzz and, 63–74

chaos and, 177–82

clients and, 42–44, 66, 78–79, 237

concessions to, 43–44

cool and, 30–31, 43, 62–64, 87, 113, 228

hacks and, 52, 57–58, 61, 96, 208

identity and, 171–76

marginalization of, 60

middle-age stereotyping and, 67–69

passion and, 50, 75, 86–87, 96, 217, 225, 232, 237

self-determination and, 121, 163, 166, 237

self-expression and, 43

theory label and, 72–74

unions and, 58–59

the untrained and, 163–70

design writing, 39–41

attacks on educators and, 69–72

author titles and, 52–53

Bangs and, 95–101

buzz and, 63–74

escapist literature and, 55

Fletcher on, 84–85

history studies and, 56–58

lack of passion on, 75–91

liner notes and, 241

Maeda on, 82–83

management in, 55

Mau and, 79–82

one-hit wonders and, 102–8

Poynor on, 76–77

process of, 241–45

Rant writers and, 65, 69–74

recent monographs and, 79–91

rhetoric of design and, 146–47

Sagmeister and, 85–88

Schlosser on, 85

Set/Reset program and, 180–81

showcase publications and, 55

success in, 169–70

as transformational literature, 55–56

trench work and, 51–61, 89–90

typography and, 30, 48, 50, 54, 62, 76, 83, 99, 177, 229

the untrained and, 163–70

DiFranco, Ani, 119

Dillard, Annie, 103–4

"Dumb" (Blauvelt), 234

Earls, Elliott, 90

Eating Friends (Holzer and Nadin), 212

economic issues, 26

art myth and, 213–16

branding and, 59, 63–64, 69, 73, 103, 175–76, 196–97

buzz and, 63–74

capitalist system and, 117

class and, 40–41

global images and, 82

music and, 107, 131

music industry and, 116–24

pornography and, 46–47

education

academic life stereotypes and, 70–71

apprenticeships and, 209

balance and, 21–22

critique and, 66–72

goal of, 227–38

guidelines for, 21

identity and, 171–76

indoctrination and, 207–11

interdisciplinary approach and, 183–90

notoriety and, 20

scorn of educators and, 69–72

standards for, 19–20

thesis shows and, 144–45

top schools and, 38

Education of a Graphic Designer, The (Heller), 188

Eggers, Dave, 229

Eicher, Manfred, 121

Ellison, Ralph, 104

El Lissitzky (Lazar Markovitch Lissitzky), 24

Emigre magazine, 8, 11–12, 55–56, 65, 68–70, 74, 101, 216

End of Print, The (Carson), 206, 210

Eno, Brian, 98, 107, 127–30, 133–34, 174–75

"Expressive Fallacy, The" (Foster), 211–12

Eye (magazine), 55, 70, 72–74, 77, 188, 231, 234

factography, 220–22

Fariña, Richard, 104

Fella, Ed, 86

Fellow Readers (Kinross), 232–33

Fior, Robin, 231

"First Things First" manifesto (Garland), 89–90

Flaubert, Gustave, 204

Fletcher, Alan, 84–85

Fonteyn, Margot, 224

Foster, Hal, 211–12

Fountainhead, The (Rand), 43

"From Cassandre to Chaos" (Rand), 206

Fulcher, Colin, 112–13

Fussell, Paul, 28, 30

Gabriel, Peter, 120–22

Garland, Ken, 89–90

Garrett, Malcolm, 112

Gaugin, Paul, 210

Giampietro, Rob, 229

Gilead (Robinson), 104

Gill, Bob, 85

GI: New Directions In Graphic Design (Blackwell and Brody), 57

Glaser, Milton, 56

Glass, Philip, 83, 194

Golden, William, 62, 191

Gonzalez, Paul, 133

"Good Design is Good Business" (Watson), 23

G.P. (Parsons), 106

graphic design, 8

 album covers and, 110–15

 artist's statement and, 146–47

as attitude, 62

awarding of honors and, 39–41, 127, 229

buzz and, 63–74

chaos and, 177–82

class and, 28–41

computers and, 14, 58, 83, 150, 180, 187

cool and, 30–31, 43, 62–64, 87, 113, 228

current evaluation methods of, 126

defining, 25–26

design axes and, 127–30, 133–34

discovery and, 10–11

as end of art, 205–8

history studies and, 56–58, 191–99

identity and, 171–76

modern production methods and, 14

multidisciplinary approach to, 125–34

passion and, 50, 75, 86–87, 96, 217, 225, 232, 237

relevance and, 144–45

role of, 224–26

style wars and, 37–38

ultimate goal of, 227–38

the untrained and, 163–70

Graphic Design: A Concise History (Hollis), 229–30

"Graphic Design Education as a Liberal Art: Design and Knowledge in the University and the 'Real World'" (Swanson), 188, 233–34

"Graphic Design is Immaterial" (Soar), 34–35

Graphic Edge, The (Poynor), 74

Greiman, April, 86

Grievous Angel (Parsons), 106

Guerrilla Girls, 221

Guston, Philip, 176

Haacke, Hans, 218–22, 225

Hall, Peter, 86

Hamilton, Richard, 111

Harrison, George, 111

Harvard Design School Guide to Shopping, The (Koolhaas), 228

Heartbreaking Work of Staggering Genius, A (Eggers), 85

Heartfield, John, 219

Heiman, Eric, 69

Heller, Steven, 38, 46, 48

Hendrix, Jimi, 134

Hickey, Dave, 164, 202, 207–8, 224–25

Hirst, Damien, 216, 223

History of Graphic Design, A (Meggs), 24–25, 29, 49

Hollis, Richard, 229–30

Holly, Buddy, 109

Holzer, Jenny, 120, 212

I.D. (magazine), 55, 231

identity, 171–76, 208–11

Indie labels, 121–22

Inside the White Cube: The Ideology of the Gallery Space (O'Doherty), 215

Institute Without Boundaries, 69

invisibility, 192–98

Invisible Man (Ellison), 104

I Want to Spend the Rest of My Life Everywhere, with Everyone, One to One, Always, Forever, Now (Barnbrook and Hirst), 223

Jackson, Michael, 114

Jacobs, Karrie, 193–94

Jarrett, Marvin, 99

J. Geils Band, 169

Johns, Jasper, 212, 222

Johnson, Samuel, 169

Joplin, Janis, 106

Kandinsky, Wassily, 211

Kann, Peter, 197

Kidd, Chip, 72

Kinross, Robin, 232–33

Koepke, Gary, 99

Koolhaas, Rem, 228–29

Koons, Jeff, 46

Kruger, Barbara, 218, 221

Lasky, Julie, 88

Led Zeppelin (band), 112

Lee, Harper, 104

Lennon, John, 95, 109, 111, 174, 241

Let It Blurt (DeRogatis), 96

Lewis Mumford and American Modernism (Wojtowicz), 66

LeWitt, Sol, 196

Lichtenstein, Roy, 212

Life Style (Mau), 79–82

Lila (Pirsig), 105

Lion, Arthur, 120–22

Lionni, Leo, 79

Lipstick Traces (Marcus), 96

Lupton, Ellen, 221–22

Lydon, John (Rotten), 106

Made You Look (Sagmeister), 85–88

Maeda, John, 82–83

Mainlines, Blood Feasts, and Bad Taste (Bangs), 96

Makela, Laurie Haycock, 50

Makela, P. Scott, 217

Man's Rage for Chaos: Biology, Behavior, and the Arts (Peckham), 178

Many Years From Now (Miles), 174

Marclay, Christian, 114

Marcus, Greil, 96

Mau, Bruce, 69, 79–82, 228

McCartney, Paul, 111, 112, 174

McLuhan, Marshall, 79

Meggs, Philip, 24–25, 29, 49

Merchants of Cool, The (PBS documentary), 62–63

Miles, Barry, 174

Miles, Reid, 121

Miller, J. Abbott, 221–22

Mind Games (Lennon), 241

Mingering Mike, 114

Mitchell, Margaret, 104

Moles, Abraham A., 191

Mondrian, Piet, 213

Morthland, John, 96

Murdoch, Rupert, 197

music, 9, 13
 album covers and, 110–15
 artist control and, 120–22
 artistic credibility and, 118–19
 assembled, 169
 Bangs and, 95–101, 169
 capitalist system and, 117
 celebrity and, 120
 classical, 169
 commercial viability and, 119–21
 corporate, 113, 116–17

Creem and, 95–101
demise of vinyl and, 113, 115
disco, 109
downloadable, 124n
drugs and, 106
economic issues and, 107, 131
end of design and, 139–40
exploitative industry practices in, 119
graphic equalizer metaphor for, 131–34
hip-hop, 168–69
image issues and, 120
Indie labels and, 116, 121–22
jazz, 169
layering and, 168–69
major vs. minor labels and, 116–19
minority labels and, 118
new wave, 105
one-hit wonders and, 102, 105–8
popular, 168
pragmatic business choices and, 118–19
psychedelic era of, 111–12
punk, 104–5, 134
rock and roll, 109–15, 168
as spectacle, 120
style and, 109–15
supergroups and, 107
Woodstock and, 134

Nadin, Peter, 212
Naked Came the Stranger (Ashe), 107
National Association of Schools of Art and Design (NASAD), 19
National Design Award, 39, 127
Never Mind the Bollocks Here's the Sex Pistols (Sex Pistols), 106
Newman, Barnett, 195, 222
Nirvana (band), 118
notoriety, 20, 39, 43–44, 57, 86, 102–3, 229
novelty, 21, 164–65, 192

O'Doherty, Brian, 215–16
Old Dominion University, 133
Oliver, Vaughan, 88, 112, 121
one-hit wonders, 102–8
"On White Space/When Less is More" (Robertson), 30

Outside (Bowie), 174–75
Outsider Art Fair, 165
Owen, David, 241

Parsons, Gram, 106
passion, 50, 75–91, 96, 217, 225, 232, 237
"Paul Rand: The Movie" (Resnick), 207
Peckham, Morse, 178–79, 181, 202, 224–25
Perverse Optimist (Hall and Bierut), 80
Philosophy of the Inductive Sciences, The (Whewell), 201
Picasso, Pablo, 68
Pink Floyd (band), 107, 112
Pirsig, Robert, 101, 104–5
Poe, Edgar Allan, 191–93
Pollock, Jackson, 210
Poynor, Rick, 38, 76–77, 88
Preziosi, Donald, 202, 222
Prince (musician), 119, 175
Prince, Richard, 167, 212
Prine, John, 119
Print magazine, 48, 55, 64, 222
Psycho's Path (Lydon), 106
Psychotic Reactions and Carburetor Dung (Bangs), 96, 99
Pure Fuel (Preston, Miles, Murray, and Sorrell), 80
Pynchon, Thomas, 171, 198, 226

Ram (McCartney), 174
Rand, Ayn, 43, 227
Rand, Paul, 30, 44, 51, 177, 200, 205–7, 223–24
Rashid, Karim, 32
Ray Gun (magazine), 99, 180, 196
Reed, Lou, 86
Resnick, Elizabeth, 207
Richter, Gerhard, 212
Robertson, Keith, 30
Robinson, Marilynne, 104
Rolling Stone (magazine), 96, 98
Rolling Stones (band), 86, 112
Roth, David Lee, 238
Ruder, Emil, 177
Ruscha, Edward, 208, 222

Sagmeister, Stefan, 50, 85–88

Salchow, Gordon, 233

Salinger, J. D., 102, 104

Saville, Peter, 112

Scher, Paula, 213

Schlosser, Eric, 85

Set/Reset program, 180–81

Sgt. Pepper's Lonely Hearts Club Band (The Beatles), 109–12, 174–75

Shaughnessy, Adrian, 70, 72–73

Shields, Kevin, 106

Smith, Roberta, 165

Soar, Matt, 34–36

Society of the Spectacle (Debord), 81

Some People Can't Surf: The Graphic Design of Art Chantry (Lasky), 88

Starr, Ringo, 111

Stations of the Cross (Newman), 195

Step-by-Step Graphics (magazine), 55

Stivers, Lee, 106

style, 37–38

 Bangs and, 95–101

 co-option and, 75

 Fletcher on, 84–85

 life style and, 79–82

 Maeda on, 82–83

 Mau on, 79–82

 multidisciplinary approach to, 125–34

 music and, 109–15

 nonconformity and, 75

 passion and, 50, 75, 86–87, 96, 217, 225, 232, 237

 Sagmeister and, 85–88

 Schlosser on, 85

 status value and, 81

Swanson, Gunnar, 188–89, 233–35

Target with Plaster Casts (Johns), 212

Taylor, James, 120–22

Thinkbook (Boom), 132

"Three Little Words" (Bierut), 231

"Three Wishes" (Heiman), 69

Thrillington (McCartney), 174

Toole, John Kennedy, 104

Tory, Geoffrey, 79

"Towards Relational Design" (Blauvelt), 31

Trace (journal), 77, 89

Tufte, Edward, 36, 179, 230

Tyler, Anne, 208

typography, 30, 48, 50, 54, 62, 76, 83, 99, 177, 217, 221, 229

"Ugliness Is in the Eye of the Beholder" (Poynor), 38

Ugly Cultists, 37–38

universal product code (UPC), 193–94

VanderLans, Rudy, 8–9, 45

van Gogh, Vincent, 210

Vignelli, Massimo, 30, 218

Village Voice (newspaper), 96

Visceral Pleasures (Poynor), 88

Visual Explanations (Tufte), 230

Voorman, Klaus, 111

Waite, James, 68, 70

Walker Art Center, 31, 189, 217

Wallace, David Foster, 104

Warde, Beatrice, 48

Warhol, Andy, 102–8, 213

Watson, Thomas, 23–24

Watts-Russel, Ivo, 121

"Ways of Looking Closer" (Crisp), 56

Whereishere (Blackwell, Makela, and Makela), 50, 87

Whewell, William, 201

Wilson, Dennis, 106

Wilson, Edward O., 201

Winterhouse Writing Awards, 39–40

Wojirsch, Barbara, 112, 121

Wojtowicz, Robert, 66

"Work of Art in the Age of Mechanical Reproduction, The" (Benjamin), 10

Wozencroft, Jon, 211

Zappa, Frank, 120–22